PROFESSIONAL PHOTOGRAPHIC
ILLUSTRATION

Kodak
BOOKS

First edition

Antonia LoSapio	Kodak Editor and Project Coordinator
Tom Lunn, Bob Molnar	Production
Elly Stevens	Editorial Assistant
Erv Schroeder	Photo Research
William Sabia, ES&J Art, Inc.	Design and Layout
Dale Anderson	Lighting Illustrations

Second edition
Published by Silver Pixel Press
21 Jet View Drive
Rochester, NY 14624

Debbie Cohen	Editor
Jeff Pollock	Project Director
Tom Lunn	Production

Writing contributions by Antonia LoSapio, Ted Schwarz, and David Kilpatrick. Mitchell Dannenberg and Nick Vedros, technical consultants.

Kodak, Kodachrome, Ektachrome, T-Max, Prism, Readyload, Ektapress, Gold, Lumiere, Wratten, Panatomic-X, Duraflex, Plus-X, Tri-X, Vericolor, Photo-Flo, Ektar, and Kodalith are trademarks of the Eastman Kodak Company.

Publication O-16
Professional Photographic Illustration
Printed in the U.S.A.
CAT No. E109 9654

ISBN 0-87985-003-5

Front cover photo by George Kamper.
© George Kamper, 1994.
Technical information on page 152.

Back cover photo by George Kamper.
© George Kamper, 1994.
Technical information on page 156.

Contents

SILVER
PIXEL
PRESS

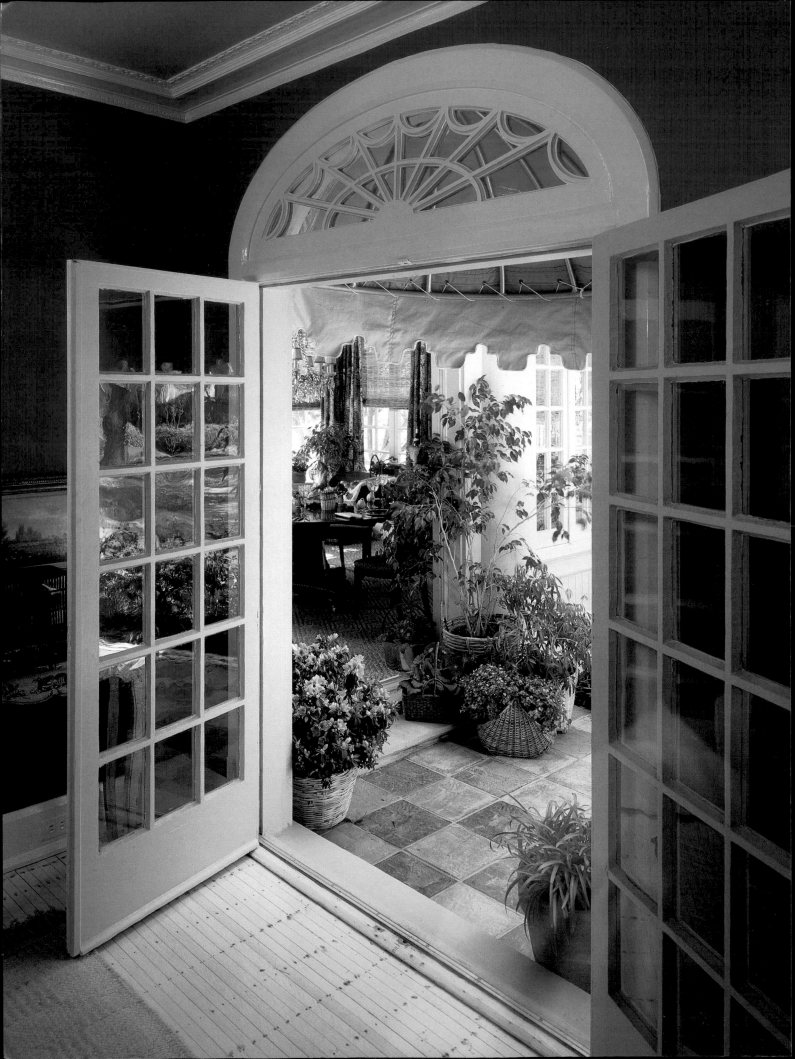

INTRODUCTION

Welcome to the world of professional photographic illustration techniques. In the following pages, some of the best and most innovative commercial photographers working today will share some of their images and secrets with you. They will show you creative ways to photograph a broad range of subjects including food, models and fashions, architecture, consumer products, and high technology. In addition, you will gain a basic understanding of using many of the tools of commercial photography, from cameras to strobes.

This book is a teaching tool no matter what your level of experience. If you are a professional photographer, this book will enable you to compare your work to that of others, and to gain pointers that will help you be more creative. You will be able to expand your abilities, and perhaps acquire a broader client base and increase your income.

Or perhaps you are not yet involved with professional photographic illustration. You may be a skilled, advanced amateur or a student who is contemplating going professional. Or you may be a specialized professional photographer shooting only portraits and weddings. This book is the guide you need to enter new fields and discover new horizons, to increase both your client list and the range of assignments you can handle.

Why Illustration Technique Is Important

As a commercial photographer, your illustrations have an impact far greater than you may realize. Your pictures are crucial to business. Individuals as well as corporations often decide on purchases by viewing illustrations—usually photographs.

An effective photograph can make you crave a particular food or yearn for a coat because the model looks fabulous and you want to look the same way. Photographs help determine the cars you drive, the luggage you take on trips, even the salt-and-pepper shakers you place on the dinner table. Photographs can seduce, entice, enchant, delight, excite, amaze, and, above all, persuade an undecided viewer.

Billions of dollars worth of products are sold each year because of the way people react to effective photographs. Your work is a major factor in influencing the products people buy. The following pages will help you achieve the results that both you and your clients want.

Photo on opposite page by Steve Hogben.
Technical information on page 152.

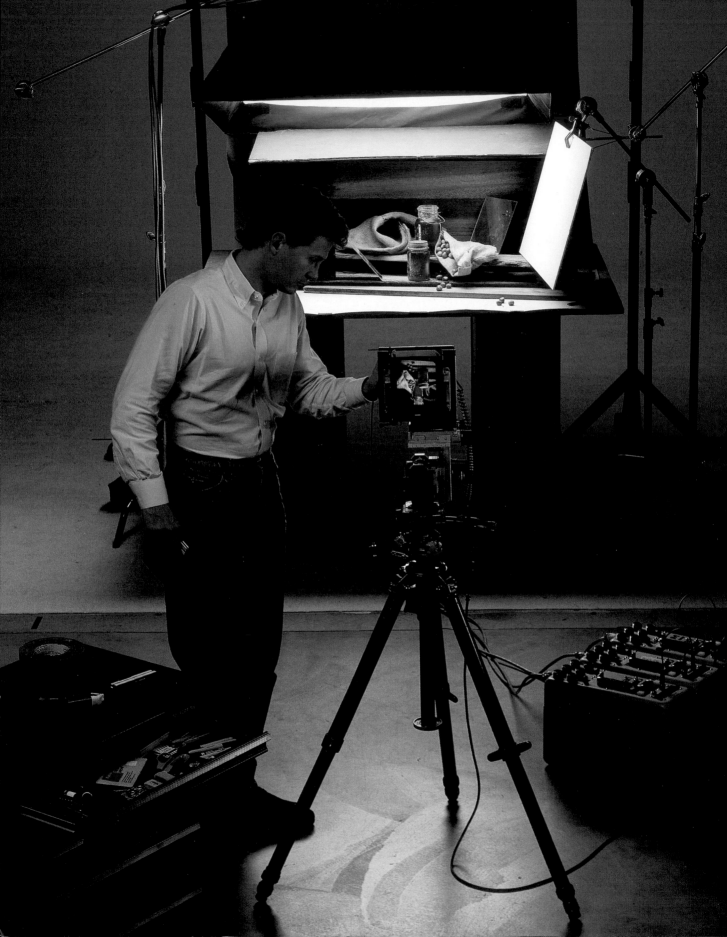

The Tools of The Professional

CAMERAS

Your camera is a means to an end. Advances in design and construction have resulted in high quality among most brands of camera equipment. It can be difficult to choose one particular brand over another. Some of the lower-priced 35 mm camera lenses used today are often superior to the better optics of only a few years ago.

Brand loyalty has become more a sign of personal preference than a mark of which camera is better, or which is for "professional" use and which is not. Therefore, the important point to understand when you choose cameras is which types and formats work best for various situations and why they do.

There is a wide range of cameras available to professional photographers.

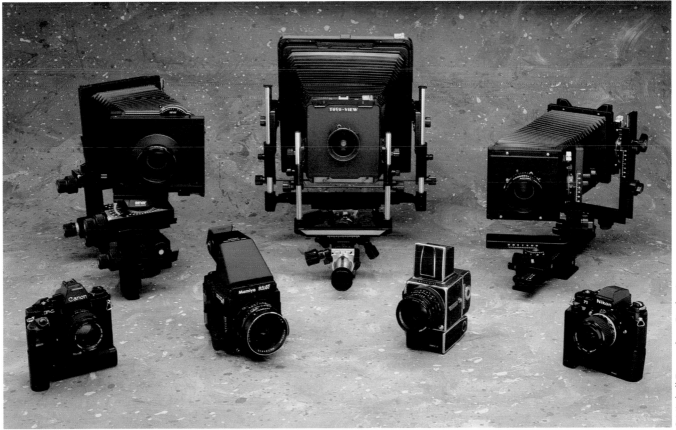

© Mitchell Dannenberg Productions

Photo on opposite page by Jeff Ott/True Redd & Company.

Large-Format View Cameras

A view camera is the most versatile studio camera available. You can use film as large as 20 x 24 inches with some cameras, although most photographers seldom use formats larger than 8 x 10 inches. Large-format film reduces the amount of magnification needed during enlargement, resulting in sharper images. When a particular assignment calls for extremely sharp results, a view camera may be your best choice for the job. Large-format negatives and transparencies are also easier to retouch.

Because of their perspective-correcting adjustments, view cameras are especially helpful in architectural photography and some product photography. You can adjust them to reduce distortion (converging or diverging lines) that can occur when you aim a camera at an angle and don't keep the film plane/camera back parallel to the building or product you are recording. Such distortion is readily noticeable in photos of buildings taken with a fixed-lens camera aimed upward. Although you may also have to aim a view camera upward, you can tilt both the lens board and the camera back to prevent distortion and maintain sharp focus. The various adjustments possible with a view camera enable you to work effectively with subjects that would be impossible to record without distortion with a camera that lacks such adjustments.

Simplify location shooting by using the KODAK READYLOAD Packet Film Holder with KODAK EKTACHROME 100 PLUS Professional Film READYLOAD Packets. With a single, reloadable film holder and a supply of film packets you can photograph your entire assignment easily. You won't have to carry traditional, bulky film holders that must be preloaded in the dark. Ten READYLOAD Packets weigh less than 1/6 the weight of ten traditional holders, and you can load them in daylight.

Adjustments with a View Camera

Tilt is a the term for pivoting the front or back of the camera downward or upward. **Swing** is the term for angling the front or back of the camera to the left or right. A **rise** or **fall** occurs when you raise or lower the front or back of the camera on the vertical plane. A **shift** occurs when you displace the front or back of the camera to the left or right.

When you photograph a building from a low angle, first position the camera with the film back perpendicular to the horizon. Most view cameras have a built-in level to indicate when the film board is perpendicular. Then move the lens standard upward by using the rise until the top of the building is included. Sometimes the lens board rise will be inadequate and you will have to angle the entire camera upward; then you can tilt both the lens board and the camera back to bring them back to parallel vertical positions to control the focus. Swings and tilts are used most often to change the plane of focus. The camera back controls the shape of the subject and the lens board controls the focus.

In the studio, the camera will often be higher than the subject you are photographing and you will use the fall when you aim downward. This will prevent your subject from appearing as though it is bulging outward at the top of both sides of the picture.

Use the shift to eliminate unwanted reflections or glare in a scene. For example, if you are shooting a scene with a window and the camera is reflected in the glass, you can move the camera out of the angle of reflection and then shift the lens to obtain the same viewpoint as before.

Medium-Format (Roll-Film) Cameras

There are three types of roll-film cameras: rangefinder, single-lens-reflex (SLR), and twin-lens-reflex (TLR).

Because rangefinder cameras usually do not allow for interchangeable lenses, they are of limited use for professionals. The single-lens-reflex (SLR) roll film camera lets you view the subject through the same lens that records the image, providing the most accurate composition possible. Many roll-film SLRs have rapid-change film backs. Almost all have motor drives or power winders and can accommodate interchangeable lenses. Twin-lens-reflex (TLR) cameras have separate viewing and taking lenses. Some brands also allow you to use interchangeable lenses ranging from wide-angle to telephoto. Most are very versatile and rugged. But these cameras may lack some of the desirable features of SLRs, such as interchangeable backs or motor drives.

The most versatile roll-film cameras accept interchangeable film backs for different film sizes. You can use 120 and 220 roll film to obtain 2¼ x 2¼-inch (6 x 6 cm), 2¼ x 2¾-inch (6 x 7 cm), or 1⅝ x 2¼-inch (4.5 x 6 cm) negatives or transparencies. The choice of film backs available depends on the camera manufacturer. Backs for 70 mm film, instant film, and electronic still images are also available for many cameras. You may find backs that will adapt to the normal 35 mm format (24 x 36 mm), wide-angle format (36 x 54 mm), and square-format (super slide— 4 x 4 cm) size, depending upon the camera line.

Although not so conducive to top quality reproduction as 4 x 5-inch or larger-format film, medium-format film is still large enough to be studied without magnification, and it can still be retouched easily by experts. A roll-film camera has some disadvantages when compared to its rival, the 35 mm camera. Camera lenses of comparable focal lengths for roll-film cameras weigh more and cost more than those for 35 mm cameras. Motor drives and power winders are faster and lighter for 35 mm cameras, and sequence photography is easier with 36 exposures per magazine than with a mere 10 or 12 exposures on roll film. While a few roll-film cameras have focal-plane shutters, many have leaf-shutter lenses. These cameras are far more expensive than both 35 mm and roll-film cameras with focal plane shutters. A leaf-shutter camera has a complete shutter mechanism built into each lens, which greatly increases the lens cost. An advantage of leaf shutters, however, is the ability to synchronize with flash at all shutter speeds.

Adjustments With a View Camera

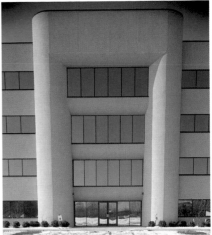

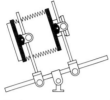

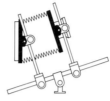

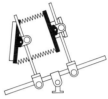

When you tilt the camera upward to view the entire building, it produces the normal effect of convergence. Cameras with no front or back movements will produce results like this.

When you tilt the camera upward, you can also tilt the camera back forward so that the film plane becomes parallel with the plane of the building to correct the converging vertical lines.

If you tilt the camera back even more toward the building, the verticals become over-corrected. This causes a divergence of the building's lines.

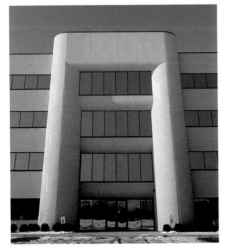

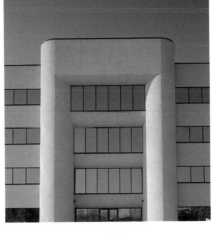

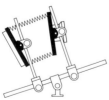

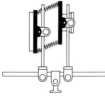

If you tilt the camera back **away** from the subject plane, it exaggerates the convergence.

With the camera level and perpendicular, simply elevate the front lens standard (a rise adjustment) to include more of the top of the scene.

If you move the camera back toward the right (a shift adjustment), you'll include more of the left portion of the scene. (Remember the image is inverted on the ground glass.)

Erv Schroeder

Small-Format (35 mm) Cameras

Most 35 mm cameras used by professional photographers are single-lens-reflex (SLR) cameras. The 35 mm camera size is popular with professionals on location. It is lightweight, and can often accept a motor drive and interchangeable lenses. It is usually less expensive than larger-format cameras, and is often the format in which technological innovations are first introduced. In recent years these innovations have included sophisticated spot and matrix-computing light meters that read the light striking the film plane, high-speed motor drives, auto-focus lenses, date backs, and programmable exposure. Rangefinder cameras are of limited use to professional photographers because they are not as versatile as SLR cameras.

The 35 mm camera sometimes has controls similar to those on larger-format cameras, but on a limited scale. Perspective-control, wide-angle lenses allow you to tilt and shift the lens while you keep the film plane parallel to the perpendicular lines of a building. Bellows attachments allow for extreme close-up photography.

The most important of all technological improvements for the 35 mm camera may be in the variety and quality of films currently available. Massive mural displays of excellent quality can be produced from current KODACHROME and KODAK EKTACHROME Professional Films. Fine-grain 35 mm black-and-white films, such as KODAK T-MAX 100 Professional Film, are so good that someone viewing an enlargement made from a 35 mm negative may think it was made from a 4 x 5-inch negative. Of course, many new and improved Kodak materials are available also in roll- and sheet-film sizes.

Electronic Still Cameras and Backs

You can now use electronic still adapters and video-monitoring systems in conjunction with most formats in commercial photography. Still video backs for 35 mm cameras allow you to record an image on a computer disk instead of a photographic emulsion. However, you cannot yet obtain professional-quality prints from such images.

Special video cameras (rather than adapters) offer greater versatility. They record the image on a disk to transmit it across town (or halfway around the world); some also let you to record the image on film simultaneously. The KODAK PRISM Electronic Previewing System, designed mainly for portraiture, provides a way to record a conventional film image and an electronic image simultaneously. This is very useful when you want your client to preview images and approve them before you finish the assignment.

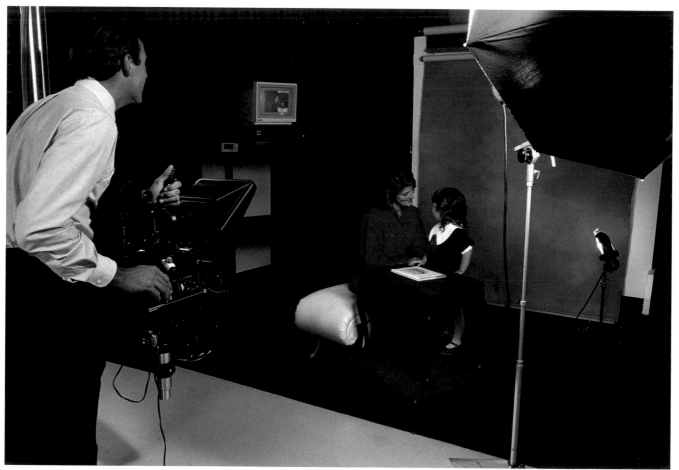

With the KODAK PRISM Electronic Previewing System, you can capture an image simultaneously on a still video floppy disk and on film.

Other systems can scan processed 35 mm or roll-film images and then transmit the detailed images to another location.

In the advertising studio, you can use a special stop-frame video camera with a view camera. You can view the images on a monitor during the shooting session and the art director can approve them on the spot, without having to view an inverted image on the camera's ground glass. Or you can store the images on videotape or disk and transmit them to another location for approval.

LIGHT METERS

Although increasingly sophisticated, built-in light meters can't yet match the versatility of a handheld systems meter. The basic unit has many controls: settings for film speed, shutter speed, and aperture; settings for average, highlight, or shadow readings; settings for continuous-light, flash, multiple flash and mixed-source (flash/ambient) readings. Also, keep in mind that a built-in meter may handle the camera's dedicated flash, but it will not work with studio strobes. At the very least, you will need an electronic-flash meter to supplement your camera's built-in meter.

You can attach an incident-light receptor (for recording light falling on the subject) or a reflected-light receptor (for recording light reflected off the subject) to the basic systems meter. With other attachments, you can adapt it to read selected spots in a scene; read low-light levels; meter at the film plane or viewfinder of an SLR camera; meter at the ground glass of a view camera; or meter through a microscope. You can also obtain full integration with electronic remote controls for studio flash with some advanced cameras.

Spot metering allows you to take individual readings of various tones of the subject—e.g., face, hair, dark suit, white shirt—and store them in memory. In some cases the meter computes the overall contrast and the best average exposure. With some other meters you must do the calculation yourself.

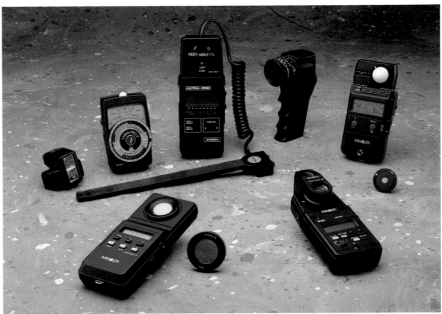

There are many types and brands of light meters to choose from, many with specialized attachments.

Some meters also have attachments for color-temperature metering or programs that tell you how much to adjust your flash power for good results in mixed lighting conditions (flash and daylight).

The term **Kelvin** (formerly degrees Kelvin) denotes a scale used in the measurement of the color temperature of light. You can measure the color temperature in Kelvin (K) with a color-temperature meter when you want a critical balance between the light source and the film, or when you want to control the color temperature of the scene to obtain a particular effect. For example, if you are photographing a room with light pouring in from a window, you may want a slightly warm balance in the photograph.

Once you have made the reading, you can make adjustments by using appropriate filters. The chart on page 13 shows approximate values and how to balance light source and film when a critical match is not necessary. For critical applications, it is best to make some test exposures with filters, using the same emulsion you intend to use for the final photographs.

FILM

The film you choose can affect the sharpness of your results, the amount of light you will need, and the rendition of colors in the scene. Become familiar with the wide range of Kodak films; you will find that each has its own special use. The finer-grain films are excellent for making extremely sharp images, and produce the best results in enlargements. High-speed films are often a necessity in low-light-level situations.

Most professionals use color transparency (reversal) films for color photography. You can display transparencies easily to clients by mounting them in mattes, inserting them into pocket pages, or—as with color slides—by projecting them. Processing color transparencies costs less than processing and printing or proofing color negatives. Also, color transparencies can be easily duplicated to make multiple portfolios. And it costs less to mail a potential client a portfolio of transparencies, than to mail a container of bulky, mounted enlargements.

Most photomechanical separations are made directly from color transparencies because they provide the best possible quality and the cost is lower than making separations from negative films. This alone is a good reason to shoot on color transparency films.

For more information on Kodak color films, see KODAK Publication No. E-77, *KODAK Color Films and Papers for Professionals*. For more information on black-and-white films, see KODAK Publication No. F-5, *KODAK Professional Black-and-White Films*.

LIGHTS
Electronic Flash

Electronic flash, often called strobe lighting, is popular among professionals. It is a high-speed light (with a duration of 1/200 to 1/30,000 second) that gives off little heat (sometimes an important factor, especially in food photography). You can take thousands of images before you'll have to replace the flashtube, unlike continuous light sources such as quartz-halogen lamps or photoflood lamps which have life spans of 6 to 75 hours of continuous use, depending upon the type of bulb.

Studio electronic-flash units usually come with "modeling lights"—tungsten or quartz-halogen bulbs with light coverage that approximates the coverage of the electronic flash. You can use the modeling lights to determine placement of the flash units. In some cases they are also usable as tungsten lights on their own with the correct film or color filter.

You can connect multiple electronic-flash units to the camera with several cords or you can attach your main flash to the camera with one cord and attach slave units to the fill lights. The slave units will fire the fill flashes when they sense light from the main flash. One advantage of slave units is that you can place your flash units several feet apart without using dangling cords that can be a safety hazard.

Stroboscopy is the photographic technique of using successive flashes to record a moving image at different places on the film. Suppose you are recording a display of tennis clothes and want to have a tennis ball bouncing in the picture. With a completely blackened room, an open shutter, and the stroboscopic light, the camera can record the path of the bouncing ball. Then you can make an additional flash exposure of the clothing alone. The total effect will be more dynamic than a conventional photograph made with one exposure.

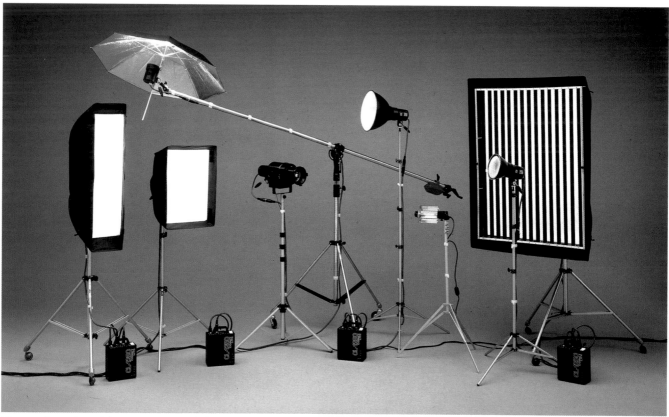

Here are just a few of the many types of lights available to the professional photographer.

Other Light Sources

The color temperature of quartz-halogen lamps closely matches the color balance of tungsten film. Incandescent lamps, photofloods, and tungsten lamps intended for photography have color temperatures that closely match the color balance of tungsten film, but will appear slightly warm when recorded. These continuous light sources are usually lower in cost than electronic-flash units. However, heat from powerful lamps can make you and your models uncomfortable and can make it difficult to preserve some foods during shooting.

Unlike normal fluorescent lights, which have a more apparent green cast, daylight-fluorescent bulbs approximate daylight. Either type will need some filtration during shooting to correct for color balance, even with film balanced for daylight. Fluorescent bulbs remain much cooler during use than the light sources described above.

High-intensity lights (tungsten halogen) are small bulbs that give off bright light. They are more compact than even "dinky" lights, the tiny, low-powered spotlights sold for photographic use. You will find that they are extremely helpful in revealing the texture of small objects. The color temperature is close to that of tungsten lighting, and you can usually use these lights with tungsten films without corrective filters.

LIGHTING ACCESSORIES

Light Blockers: If the lighting is too bright, as it might be when you take a model into the bright sun, your model may squint. Or in the studio, you may want to feather the light or control its reach. A black umbrella, black sheet of posterboard, or other similar device will block the light. Or you can purchase professional light blockers—usually large, flat-black opaque umbrellas called "gobos" or "flags."

Reflectors: If you need to lighten shadow areas of a subject, use reflectors or "flats." You can make reflectors with white posterboard, white construction paper, or aluminum foil wrapped around cardboard. Or you can purchase commercially available foam core material. If you are on location and find yourself without a much-needed reflector, you can improvise.

You can also purchase umbrellas in various sizes to use with strobes. Umbrellas are available in white or in highly reflective silver, gold, and blue materials. White umbrellas reflect

Conversion Filters for KODAK Color Films

Film	Balanced for	Daylight	Photolamp (3400 K)	Tungsten (3200 K)
EKTAR 25 Professional EKTAPRESS GOLD 100 Professional EKTAPRESS GOLD 1600 Professional EKTAPRESS Plus 400 Professional VERICOLOR III Professional VERICOLOR 400 Professional	Daylight or Electronic Flash	No filter	No. 80B	No. 80A
VERICOLOR II Professional	Tungsten	No. 85B	No. 81A	No filter
FKTACHROME 64 Professional EKTACHROME 100 PLUS Professional EKTACHROME 100 Professional EKTACHROME 200 Professional EKTACHROME 1600 Professional EKTACHROME LUMIERE 100 Professional EKTACHROME LUMIERE 100X Professional EKTACHROME 64X Professional EKTACHROME 100X Professional EKTACHROME 400X Professional KODACHROME 25 Professional KODACHROME 64 Professional KODACHROME 200 Professional Pro 100 Pro 400 Pro 400 MC	Daylight or Electronic Flash	No filter	No. 80B	No. 80A
EKTACHROME 64T Professional EKTACHROME 160T Professional EKTACHROME 320T Professional	Tungsten	No. 85B	No. 81A	No filter

soft, white light and the silver ones reflect more specular light. The reflective gold material will add warmth to a subject, while the blue material will create a slightly bluish or cold feeling.

Diffusion Materials: Placed between the light and the subject, diffusers soften the light, reducing or eliminating shadows and smoothing skin tones. You can purchase commercially made, translucent diffusion panels (silks), or you can make your own by attaching white fabric or frosted plastic to a frame. Numerous diffusion devices for electronic flash, including special hoods, are available. If you do not want to work with a silk or a similar device, you can obtain soft, nondirectional lighting by bouncing the light into a reflector. Umbrella reflectors for this purpose are commercially available.

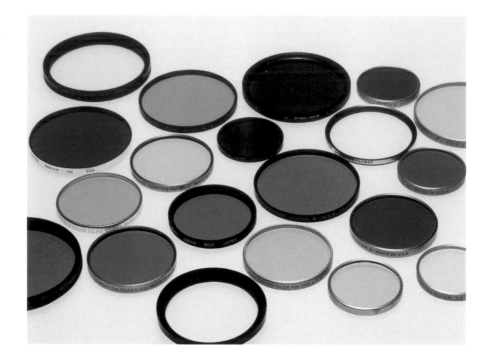

FILTERS

The range of filters available is extensive. Some have important technical uses, such as achieving precise color balance in photographs. Others have more creative uses, such as altering the image or creating special effects. The following list provides information on some of the commonly used filters.

Light-Altering Filters

An important use of filters is to alter the color temperature of the light striking the film so that the color balance of the image is correct. You can use light altering filters to balance film and light sources and to fine-tune the color balance of film emulsions. Conversion filters, light-balancing filters (LB), and color-compensating filters (CC) all adjust the color temperature of light. These filters are manufactured by Eastman Kodak Company in the form of KODAK WRATTEN Gelatin Filters and KODAK Color Compensating Filters. Normally, slight differences in color temperature will still produce acceptable results. However, when you photograph subjects such as interiors,

artwork, or clothing, an exact color representation may be critical to your client. You will want to use correction filters under such circumstances.

For example, if you have only daylight film on hand but are working with tungsten illumination, you will need to use a No. 80A conversion filter over the camera lens. It will adjust the color temperature of the light striking the film so that it records properly on daylight-balanced film. By contrast, if you are using daylight illumination with tungsten-balanced film, use a No. 85B filter.

If you remember from the Kelvin temperature chart, household tungsten bulbs are generally slightly warmer than tungsten and quartz lighting designed for photography. To use household bulbs with tungsten film, use a No. 82C filter; with tungsten-halogen lights, use a No. 81A filter.

Correction filters for fluorescent lighting come in two types. The Tiffen FL-B® Filter corrects fluorescent

lighting for tungsten-balanced film; the Tiffen FL-D® Filter corrects fluorescent lighting for daylight-balanced film. If color balance is critical to your client, you may need to use color correction filters for either of these situations, or when you use daylight fluorescent bulbs with daylight-balanced film. Tungsten-balanced film requires a No. 85B filter plus CC filtration under daylight fluorescent lights.

Light balancing filters (amber or blue) are designed to balance light to the equivalent of 5500 K. Amber filters in the 81 series add warmth to photographs taken in the shade, on cloudy days, or with other cool light sources. Blue filters in the 82 series correct photos taken outside under light sources that are too warm.

Color-compensating filters are available in the primary colors. You use them most often to fine-tune the color balance of a particular film emulsion or to correct for slight color shifts in processing. Together, light-balancing and color-compensating filters used in a "pack" can correct almost any color bias fully.

Other Types of Filters

The following is a list of some of the filters that produce special effects. Different manufacturers may have equivalent filters with different names. For example, a "star" filter, "star-cross" filter, and "star-effect" filter all provide the same effect. They create long rays (stars) from any strong, single point light source in a scene.

Center-Spot Filter: This filter has a clear center spot that maintains a sharp image, while the surrounding area is diffused. This filter helps focus attention on a person or a product while softening everything around it.

Diffusion Filter: This filter slightly scatters the light (most noticeable in the highlight areas), creating an overall soft-focus effect. It decreases sharpness to a degree that varies with the filter intensity. This type of filter is excellent for portraiture because it minimizes wrinkles and blemishes.

Fog Filter: You can use this type of filter to create a range of effects, from a misty atmosphere, ideal for enhancing a romantic setting, to a thick fog. The effect depends upon the density of the filter.

Low-Contrast Filters: These filters mute and desaturate colors. You can combine them to blend a model's make-up, smooth skin tones, or enhance outdoor scenes where the lighting effect is too harsh or contrasty. These filters also help bring out shadow detail when shadow density is too great. They are useful in slide duplicating as well as in original photography.

Skin-Tone Filter: Sold under a variety of names, this is different from both diffusion and low-contrast filters, but it provides some of the same effects. It is meant to soften and warm an image, ideal for portraiture. This filter is available in a variety of densities.

"Softnet" Black Filter: This is one company's designation for a filter that has black net material laminated between optical glass. It creates very soft diffusion without highlight halation and does not alter the shadow areas. It is a commercial version of the photographer's trick of taking a stocking and stretching it as tautly as possible over the camera lens before taking a photograph.

"Softnet" White Filter: This filter is similar to the "Softnet" Black Filter, but uses white material that reduces density in dark areas while causing halation in light areas. It creates a foggy, diffused look.

Polarizing Filter: You can use this filter to reduce glare from reflective, non-metallic surfaces and to darken blue skies. It is effective with both color and black-and-white films. In landscape photographs, the color saturation or density of foliage can be enhanced significantly by a polarizer.

Neutral-Density Filters: These filters reduce the amount of light striking the film but do not affect color or contrast. You can use them to reduce the level of light striking the film—for example, to prevent over-exposure with a high-speed film in bright light, or to use a large aperture to achieve selective focus.

Sepia Filter: The sepia color of this filter creates a nostalgic, turn-of-the-century mood in color photographs.

Split-Field Filter: Half close-up lens and half clear glass, this filter allows you to focus on near and far subjects in the same scene. It gives the illusion of a lens with extreme depth of field. It is available with the close-up portion in a wide range of diopter strengths.

Multi-Image Filter: This special-effect filter creates multiple images of the same subject. The pattern it creates may be circular, triangular, or some other pattern determined by the prism design and placement.

A working studio. Photo by Neal Molinaro.

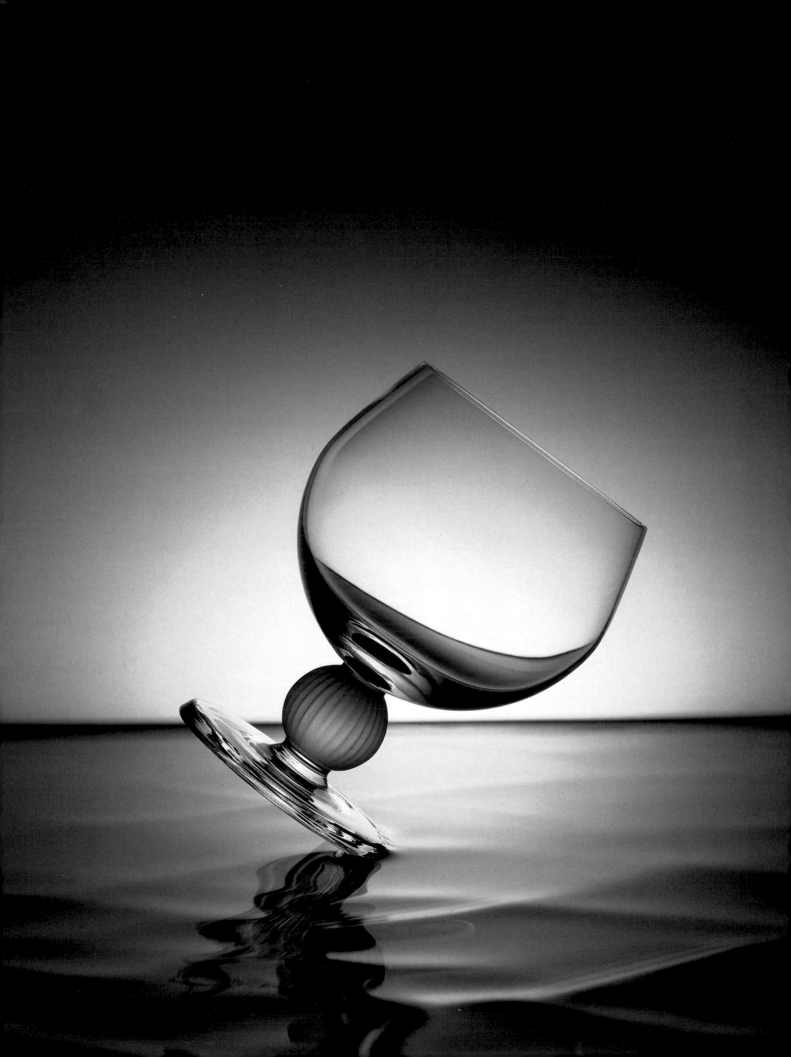

CHAPTER TWO

Lighting

Every photographic assignment is an exercise in lighting, whether you are arranging flash units around the subject or arranging the subject within the limitations of available light. In the former case—which applies to most studio photography—you, the photographer, must determine the best way to light the subject. You may receive a layout or an idea from an art director that shows nothing more than a rough sketch of the product and its surroundings in the photograph, giving no indication of shadows, reflections, or final image quality.

To achieve the impression your client wants, however, you must know about effective lighting techniques and how to use them. The lighting you choose can help make the subject appear subdued or dramatic, wet or dry, smooth or textured, steaming hot or refreshingly cold. The lighting you choose—from a soft, romantic ambiance to a high-tech thrust—is critical in establishing the mood of the photograph.

BASIC LIGHTING

Good studio lighting creates mood by association. The color temperature, angle, and quality of the light you choose creates atmosphere in your pictures.

With exposure control and color-balancing filters, your studio lights can create the impression of a hazy afternoon, a fireside glow on a cold winter morning, or evening street lamps streaming through a window-blind. You can make products appear three-dimensional by drawing out texture and form; you can make their settings appear light and airy, cold, warm, nostalgic, mysterious, or charged with a high-tech glow.

Electronic flash units usually have modeling lamps. When you adjust the flash output, most current modeling

Photo on opposite page by Christopher Lawrence.
© Christopher Lawrence.
Technical information on page 152.

lamps vary in brightness to give true proportional modeling. Units of different powers within the same system have modeling lamps with wattages matched to the units. With true proportional modeling, you can assess your lighting setups visually before shooting.

Though electronic flash is the most popular form of studio lighting, tungsten-halogen and theater spotlights remain useful for special effects.

A key light is the main light or dominant light source. The quality of light can be soft, hard, or anything in between, and you can alter it with special accessories. Secondary light sources are referred to as fill lights.

Lights are best classified according to the quality of the source; diffuse or point source. The types of diffused light sources vary greatly. They include flash bounced off reflective flats or umbrellas, flash aimed directly through a translucent panel or umbrella, and flash enclosed totally in a light box with reflective inner surfaces and a translucent covering. Light boxes that range from about 16 inches up to several feet across are called soft boxes or light banks.

Point sources or spotlights have miniature flashtubes that project a narrow beam through a condenser or fresnel lens. They provide a very sharp, focused beam of light.

The quality of light of any source is based upon the size/distance relationship to the subject. The closer the light is to the subject, the broader and more diffuse the lighting will be. As the light source is backed away, it becomes more of a point light source producing specular highlights and contrasty lighting. The quality of light falling on the subject is not only determined by the distance of the lights but also by the size of the subject. Fall-off in illumination with distance is inversely proportional (double the distance from source to subject, quarter the illumination).

Lighting for Three-Dimensionality

By positioning the main light to one side and sometimes slightly to the back of a product, you cast shadows toward the camera and reveal form and texture. Be careful, though, not to aim the light into the camera lens or you may create lens flare. To help prevent lens flare, you can use a lens shade or a light blocker between the main light and the camera lens. Your main light may be a point source or diffuse light source.

Use reflectors to fill in the shadows slightly or to change the lighting ratio (contrast level). The reflectors may be white or silver cards, flats, or foam core. All will reflect light back onto the subject without creating the appearance of multiple light sources.

You can use additional fill lights to illuminate especially dark areas such as the background, or add colors by covering the fill lights with gels.

To display a subject with diffuse lighting (such as catalog illustrations), create a soft, single light source by placing a 3- to 4-foot soft box above the subject. For some scenes you may choose to position it slightly behind the subject, aiming toward the camera. Place reflector cards around the subject to provide fill. This lighting technique is well suited for straightforward food, product, and small-item photography. (When photographing people, place the soft box above and slightly in front of the subject.)

In the past, backgrounds with gradations of tones were created by controlling the angle of the main light source and feathering off the light behind the subject with a light blocker. Often this restricted placement of the main light. Instead, you can illuminate the background separately with a small, subtle light that you can feather. Or you can purchase seamless backgrounds with the changes of tones or gradations painted onto them.

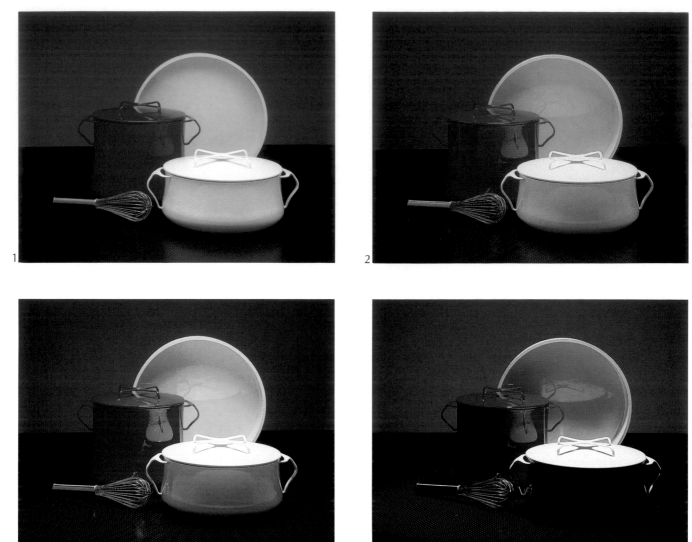

This still life was photographed using four different lighting techniques, to show you the effects you can achieve. (1) Diffused light with a light bank. (2) 85-degree light with an aluminum reflector. (3) 45-degree light with an aluminum reflector. (4) Point light source.

PHOTOGRAPHING CLEAR AND HIGHLY REFLECTIVE PRODUCTS

Clear objects are difficult to photograph. They seem to disappear, in whole or in part. Mirrors and other highly reflective surfaces can appear completely black if you do not light them properly. You may see distracting objects from the studio reflected in the surfaces of glass or polished objects, which detracts from the center of interest. You must plan your lighting carefully to obtain the results you and your client want.

Glassware

Because glassware is usually transparent, it can become nearly invisible in photographs. You can show its form only by the way in which it refracts, blocks, and reflects light. The simplest way to show the shape of glassware is to create a separation between the edges of the glassware and your background by using special lighting techniques. A basic technique for illuminating glassware is to create black edges to outline the glassware against a light background, or to create white edges against a dark or colored background. For either effect, you must create the black or white edges on the glassware by reflecting those tones onto the glassware.

The easiest way to do this is to make black/white flats or cards from poster-board or seamless background paper, which you can place at angles to the object. Attach the flats to a frame or a light stand so that you can adjust their position while shooting. You can prop up small cards around the subject. Place the flats or cards along with the lights at angles from the main subject and, while looking through the camera, adjust them until you achieve the effect you want. Your background can be seamless paper, or you can use translucent material and shine light through it towards the subject.

The photograph by Bruno is a good example of glassware with white edges against a dark background. The reflections also help to show the beautiful design in the vase. In the photograph by Dirk Douglass, you can see the effect with black edges. Either presentation can be very successful, and the approach you choose depends on the look you want to create in the photograph.

Other advanced techniques include creating a combination of dark and light edges, such as a glass with dark sides and a white rim on top. In such a case, you would graduate the background lighting to complement the glass as in the photograph by Christopher Lawrence on page 16. Another technique is to place colored gels in front of your lights and shine them onto white flats, so that the glassware picks up the colors. You can create a silhouette by placing the glassware on a thin shelf in front of a flat, seamless background and illuminating the background only. This technique is well-suited to black-and-white catalog illustrations of crystal or tableware.

When photographing colored glassware or glassware filled with liquids, you can make a small reflector in the exact shape of the subject, only slightly smaller. Then place the reflector behind the subject. The reflector will help to brighten the glassware or liquid inside. You can make the reflector from white, silver, or gold materials.

Mirrored Surfaces

Mirrored surfaces present their own special problems. When you photograph silverware or other highly polished objects, they can appear completely black or absent, or they can reflect every object in the studio—including your camera. To bring a mirrored surface "alive" you must reflect white light off the surface by using a white flat or white "tent." A white tent is usually made of a flexible, reflective material such as seamless paper, large sheets of mounting board, or fabric.

Commercial light tents consist of a cone of white sail cloth that you can suspend over the subject from a cantilever stand, with a zipper or Velcro opening to admit the camera lens. Tents that enclose a subject

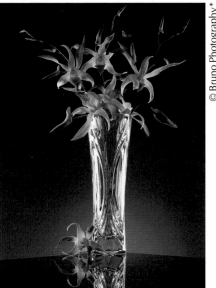

© Bruno Photography*

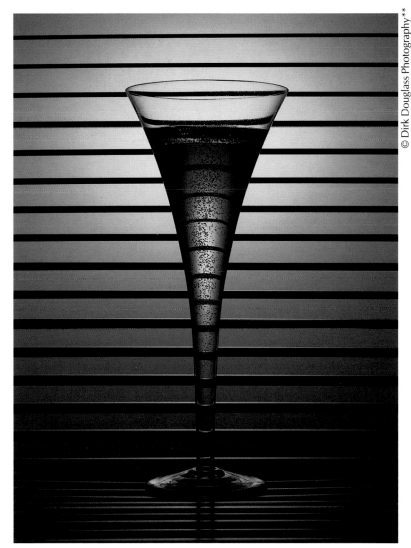

© Dirk Douglass Photography**

*Technical information on page 152.
**Technical information on page 153.

completely without any joins or gaps not only give your subject a white surface but also keep out unwanted reflections from other objects in the room.

The zippered hole in the tent should be just big enough to accept the camera lens without reflecting the camera image into the scene. Be sure to check for signs of the camera reflection when you make your test shots. If the camera does show, you can change the camera angle or move the subject to make the reflection less noticeable. Spraying part of the surface of the object with a dulling spray can help reduce the reflections, but don't overdo it or your silverware will look as if it's been sandblasted.

In most cases, especially when the subject is curved or has an etched design, an apparently solid plane of white will work well. However, when you work with a completely flat surface, you may want to add an extra dimension to the subject by creating a graduated tone.

To do this you can aim your light at a large white seamless paper or a sheet of foam core board. Position the paper or board so that it reflects the light onto the flat subject. The subject will appear uniformly white. Add gradation by shading or aiming your light to create fall-off on the seamless, or angle the seamless itself so that it does not reflect the light onto the product uniformly.

Other ways to create graduated lighting include using a small spotlight (dinky light) to make a diagonal streak of light across the seamless, and airbrushing (or hand painting) a stroke of soft-edged gray paint diagonally across the seamless. Make sure these streaks appear out of focus when you photograph them. You can also drape strips of paper across the seamless or create some other out-of-focus pattern. The ways to create certain effects in any photograph are limited only by your imagination.

*Technical information on page 153.

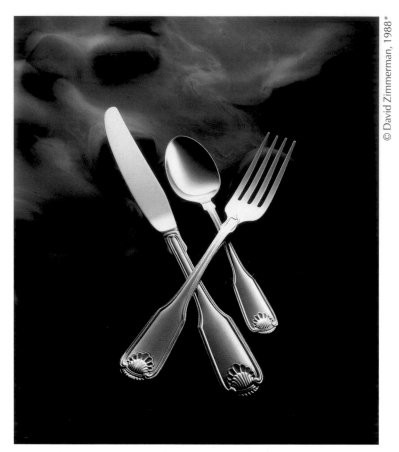

© David Zimmerman, 1988*

In this photograph by David Zimmerman, gradation in tone was created on the spoon and all three handles to add dimension.

UNWANTED REFLECTIONS ON HIGHLY POLISHED SURFACES

The most common ways to reduce unwanted reflections from pots, pans, chrome, and other highly polished surfaces that can cause flare and distracting highlights in your photos include adjusting the angle of your lights or camera, or moving the subject slightly. However, adjusting your lights may affect the illumination of the rest of the scene. Moving the subject could give you a less pleasing composition. You can use the shift adjustment on your view camera as mentioned in "Adjustments with a View Camera" on page 8. But you may sometimes be constrained from moving the camera or you may have to move it to a viewpoint less appealing. With nonmetallic objects, a polarizing filter may reduce some of the reflections.

Another simple approach is to use diffuse lighting. See "Basic Lighting" on page 17. This will cut down on specular highlights that can be distracting. Reflected or bounced light also works well. You can achieve this by using white flats or a tent as described in "Mirrored Surfaces," page 19.

Other methods include using a commercially available dulling spray. It is easy to use and removable; you can wipe it off with a cloth. Also you can dab a small ball of glazier's putty onto the surface, then blend it with a soft cloth. Unfortunately, both the glazier's putty and the dulling spray may dull not only the unwanted reflections, but also the entire finish. They may create the appearance of a burnished surface when the client wants to show that the surface is highly polished.

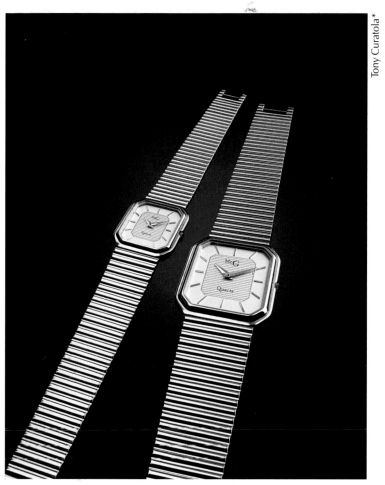

Tony Curatola*

When you photograph a watch, the crystal must appear both "invisible" and as a "reflector of light."

Windows and Laminated Surfaces

At times you may have to photograph framed and laminated pictures, television sets, computer screens, microwave ovens, or lacquered cabinets. When it is practical, position the subject at an angle to the lens and use the technique for photographing mirrors—placing a large seamless panel so that it is reflected by the glass. To eliminate unwanted reflections, use a black panel with no light on it; to show the presence of a shiny surface without obscuring it, use a gray panel.

Another way to eliminate reflections or glare is to use the shift adjustment on your view camera, as described in "Adjustments with a View Camera" on page 8. Also, a polarizing filter will often help. When you must photograph the subject head-on, perhaps for use in a catalog, drape the complete camera and tripod in black fabric. You may even choose to wear black clothing or use a remote shutter release so that your reflection doesn't appear.

Mixed Bag of Tricks

There are times when an object should be both "invisible" and a reflector of light. A watch crystal is a good example. The crystal must appear transparent so that the viewer can see the face of the watch. At the same time you may want part of the crystal to reflect, to give a hint that it is there or perhaps to show beveled edges or a date-panel magnifier. In this case you will have to experiment with your reflectors for the best results. This photograph by Tony Curatola is a good example of excellent technique.

If your client is a watch manufacturer, you will probably have some alternatives. Many watch companies will supply a carefully prepared dummy without a crystal. The remaining casing and hands should be identical to the assembled product. If the crystal was not removed by the manufacturer, you may be able to obtain permission to remove the crystal yourself. Since this would affect the market value of the watch, it must first be approved by the manufacturer. Highlights can then be retouched into the finished photograph to simulate a crystal. For catalog photography, you may find that showing the crystal is not as important as showing the watch face clearly.

One tip for good lighting is not just to know good lighting techniques, but also to go with your instincts about the subject. Look at your subject, think about it, get a feel for it. Decide how the photograph should look based on the intended use. Then use lighting to obtain that effect. The subject often dictates the lighting setup. Don't let preconceived notions of "proper" lighting dictate what you do with the object. You must make the ultimate decision.

Note: When photographing more than one watch, pay close attention to details. All watches shown on the same page should have the same time showing on their faces for consistency; usually ten minutes before two o'clock or ten minutes after ten o'clock. In this position, the hands appear balanced.

Technical information on page 153.

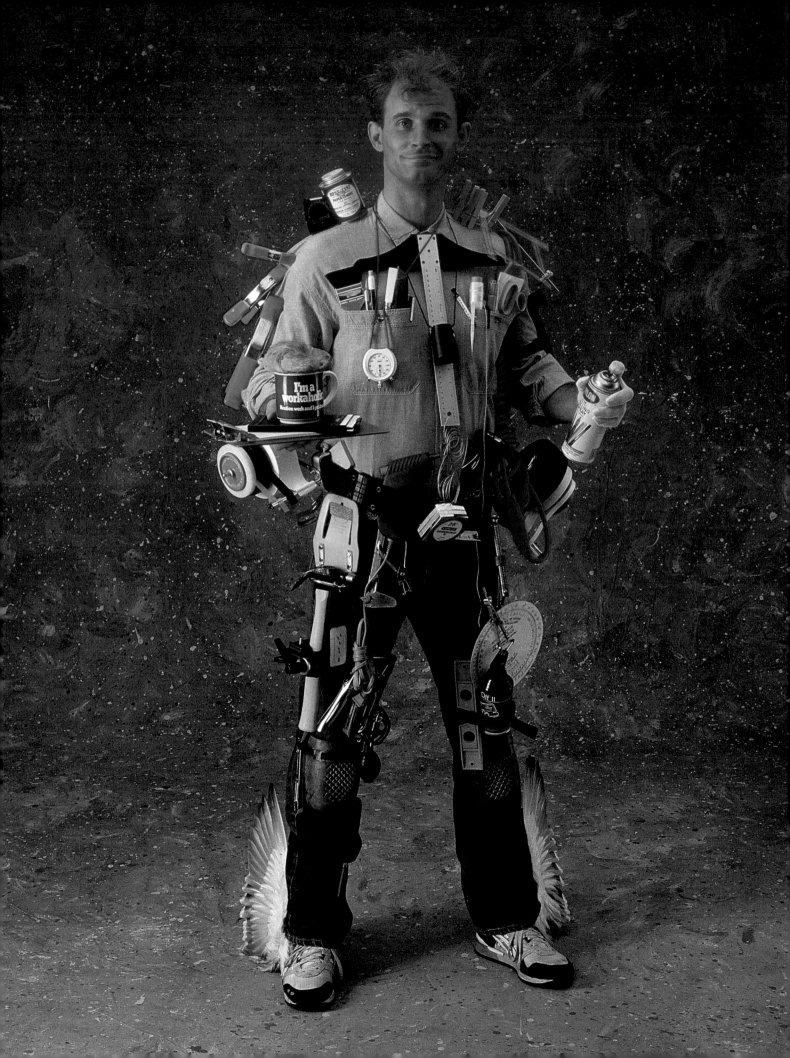

Getting Started

The Perfect Photographer's Assistant

Here is your perfect photographer's assistant, ready for work. Some of the items you may want to have on hand in your studio are pictured here:

dulling spray	utility knife
loupe	clothespins
canned air for dust	power cord
scissors	dust/static gun
hammer	duct tape
"A" clamps	black photo tape
25-inch tape	masking tape
measure	camel's-hair brush
proportional scale	air release
super clamp	tweezers
tape dispenser	½-inch ratchet
staple gun	compass
12-inch T-square	protractor
running shoes for	micrometer
speed	scaleograph
calipers	paper cement
level	clipboard
hole punch	cotton gloves
rechargeable	ratchet screwdriver
flashlight	work belt
4-inch "C" clamp	stopwatch
knee pads for	monofilament line
crawling	seamless
hot-glue gun	background
4 x 5 film holder	coffee cup
burnisher	croissant
plastic cleaner	the Perfect
X-Acto knife	Photographer's
wings for flying	Assistant, of course!

Photo on opposite page

*Photographer, Mitchell Dannenberg,
 Mitchell Dannenberg Productions
Photographer's Assistant, Shawn Green
Model, David Sitler
Hair, Makeup and Styling, Richard Price
Art Director, Erv Schroeder*

The fact that you are reading this book is an indication of your intentions in professional photography. But, pause for a while and consider your underlying motives. Are you in it to become rich and famous? Or do you simply want to express your creative abilities and live comfortably at the same time?

Set your goals. You may already know whether you want to be an architectural, portrait, wedding, commercial, landscape, or fashion photographer. Each one has its own appeal. Landscape or nature photography can form the basis for a lifestyle that is somewhat private, but it can be difficult to make a living with it. Portrait and wedding photography may give you a high profile and much contact with people. Commercial illustration is likely to involve intense pressure to meet important deadlines and the high expectations of clients, but it may also lead to a higher income. If you are not yet a professional photographer and you are unsure of the path you want to take, it may be a good idea to start out as a photo assistant and find your niche. The experience in working with a seasoned pro can be invaluable. Not only can you polish your technical skills, but you can learn about running a business at the same time.

When starting your business, hire assistants by the job and pay them hourly rates. Later, if business requires it, hire a full-time assistant. You will also need a list of possible models or model agencies, a food stylist, a makeup and clothing stylist, and resources for clothing and props.

Most photographers hire a photographer's representative (rep), although initially you may not be able to afford one. You may spend most of your time contacting potential new clients and visiting them with your portfolio yourself. Eventually, when the business is going strong, you may choose to hire a rep and possibly a studio manager too.

It would be helpful to have some background in business management before starting your business. You may want to take a few courses at a local school before diving in. You'll need to know procedures for obtaining credit and loans, invoicing, paying bills, bookkeeping, writeoffs, employee benefits, and income taxes. You'll have to decide if you want to run your business as the sole proprietor, or form a partnership or a corporation. You'll most likely hire the services of an attorney to handle any legal aspects. You will have to open credit accounts with photographic suppliers and processing laboratories. They will check your credit status carefully.

Before obtaining clients, survey the market in your area to find out what your competition offers and the approximate prices charged. Your clients will very likely expect the same quality and delivery time, even if your prices are competitively lower.

THE PORTFOLIO

Prospective clients will want to see a portfolio of your work. Your portfolio does not have to consist of commissioned work. Many clients will be willing to try a newcomer with a good portfolio. Remember, your portfolio is a demonstration of your abilities. Make sure the samples in your portfolio are your best work.

If you do not yet have a portfolio, select ten photographs in this book that match closely the type of work you would like to handle, and use each one to inspire you. Study them. Then try to make photos with a similar style, but be sure to choose different subject matter and provide your own interpretation. A good portfolio should contain at least ten different shots, preferably with a common style or theme.

Starting with smaller subjects has many advantages; you can more easily control the subject and lighting, and the set can be small. A simple close-up with a few props would be the easiest to try.

Presentation of your portfolio matters almost as much as content. A 12 x 16-inch art folio is an easy size to handle; anything bigger can be cumbersome. Special mattes for displaying both prints and transparencies are available from your local photographic supplier. Use them. Spend the time to make the best presentation possible; it will make a good impression on prospective clients.

YOUR FACILITIES

When getting started, you can use the basement or living room in your home as a temporary studio. Another option is to rent a studio by the hour or day. Consider these options carefully before you sign a lease for a studio or take out a second mortgage on your home to purchase a studio. It is not important to have your own personal studio at first, as long as you have an efficient office at home. Many photographers must create simple to elaborate sets in the studio, so make sure you have adequate space.

You can rent equipment on an hourly or daily basis also. Your goal should be to own your equipment eventually though, because it is most economical in the long run, and using the same equipment each time increases your efficiency. As a commercial photographer, you should be prepared to shoot in all popular formats: 35 mm, medium format, and large format.

When shooting on location, a location lighting kit is a necessity. This usually consists of at least three portable lights, stands, and accessories. You can also use these lights for small-product photography in the studio, for fill-in lighting when you shoot interiors, and for portraiture—when high output is not needed. When shooting larger sets in the studio, you will need lights with much greater output.

THE SHOOT

Compared to the cost of models, props, a stylist, an assistant, and so on, film is probably your smallest expense. For this reason, you should stock plenty of Kodak film. If you are using a large-format or roll-film camera, first shoot the scene on instant film. This will allow you to check the placement of the lights, exposure, and composition. Often you can show the instant-film pictures to your client or the art director for approval before making the final shoot. Obtaining client review of a shoot in progress ensures that you're on the right track and that both you and your client will be satisfied with the final shots. If you shoot 35 mm film without use of an instant-film back, have the client approve the setup or a test shot before you tear down the set. To cover yourself further, bracket exposures, shoot from different angles, and vary lighting setups.

Once you have established the right look in your test shots, you are ready for the final shoot. Do not assume that with the perfect setup, a trusted light meter, and a familiar camera your first exposure will be a perfect one. Many variables in photography can prevent the perfect exposure.

Use five sheets (or exposures) of film for every scene when you use a view camera. Expose one at what you think is the proper exposure; a second at ⅓ stop over; a third at ⅔ stop over; and the fourth and fifth exposures at ⅓ stop and ⅔ stop under, respectively. These exposures should result in two photographs with clean whites (the overexposures) and two with added color saturation (the underexposures). The five images provide you with the bracketing you need to ensure a good exposure. Equally important, the exposures will be so close in quality that if the client damages one of the images, you will have a replacement that is nearly identical.

Your final insurance, with whatever format you use, is to make additional exposures on color negative film because of its greater exposure latitude. You can make transparencies from large-format negatives that are almost indistinguishable from originals. And you may also find that the negative will come in handy for making layout or display prints.

Film processing is very important. Most professionals shoot a film test—one set of exposures that are processed and checked before the final shoot. Keep in mind, though, that your final film should be processed on the same day as the test film to ensure consistency in the process.

Try different laboratories until you find one that gives you high-quality results and good service consistently. While cost may be a factor, giving your client the *best possible processing* should be your primary concern. Work with the lab that provides the best service in your area. If you process your own film, be certain to maintain tight quality control. Slight variations in density or color balance may seem minor, but they can affect the procedures for making separations for photomechanical reproductions and increase your client's costs.

Error Rates

Despite all the precautions and planning, you may find on occasion that the results were not what you aimed for. When this occurs, you must reshoot—usually at your own expense. You should not give your client less than the best work of which you are capable. You may encounter a processing problem, or you may have overlooked something minor during shooting, such as clothing that does not hang quite right or an electric lawn mower that does not display the power cord as prominently as the client would have liked.

On occasion you may even meet the client's request exactly, only to discover that the client failed to give you adequate information or to visualize the results. Or perhaps your client's marketing strategy changed halfway through the shoot. If you are charging a daily or hourly rate, your fees will be covered. However, if you quoted a job rate, you will have to renegotiate the price.

PROPER VIEWING CONDITIONS

The client's reaction to your work will be determined, in part, by the way he or she views it. If you deliver the work to your client's office, your client may view your transparencies on a light box, or with a slide projector, or simply hold them up to the window or room light. The type and brightness of the viewing light, the ambient light in the room, and even the color

of the walls can affect the appearance of the images.

To maintain control over how your photographs are viewed, you must plan the presentation. Prepare two black masking boards, each in an L-shape, for any large-format transparencies. These help block out any extraneous light from the light box and enable you to crop unwanted areas of the transparencies while viewing. You can carry a portable light box with you with a proper 5000 K light source.

If you are shooting the job in the 35 mm format, you can mount the slides in display mattes of 6, 12, or 24 windows—or you can project them. If you expect to project the slides, you may have to carry a projector with you, and you'll want to find out ahead of time if there is an appropriate viewing room. Projecting slides in an office with daylight streaming in will not show your slides to their best advantage; however, many excellent small back-projection models with about 12-inch screens are now available; some also permit wall projection if you have a screen and can darken the room. Before presenting prints to your client, have them retouched if needed.

It's also a good idea to mark your name, address, and phone number on every matte board so that your work can be identified easily if circulated in your client's office.

MAKING PICTURES FOR NEWSPAPERS AND MAGAZINES

Black-and-white photographs reproduced in a newspaper are usually halftones of 85 to 100 dots per inch. The density range of a newspaper halftone is much lower than that of a high-quality photograph. According to David Cohn, Senior Technologist at the Technical and Education Center of the Graphic Arts at RIT, "To obtain the best possible results, it is important that any detail that you want reproduced in the final picture is shown clearly in the original photograph. Avoid contrasty lighting during shooting, because the full range of tones may be difficult to reproduce in the newspaper. The original should be as sharp as possible. In

short, provide the best possible black-and-white photograph."

In full color, the film separations can be the key to the quality of your published work. As with black-and-white images, start with the highest-quality color image possible to ensure the best results. This again means you should avoid contrasty lighting during shooting.

The separator can manipulate an individual print or transparency in almost any way required, but with some possible degradation of quality. Remember, too, that if you are working with a catalog, magazine, or similar publication requiring several pictures on one page or throughout, your work needs to be as consistent as possible. In this way, the separator will be able to gang and shoot the photographs at one time. Also, using the same film emulsion for the entire job will ensure the most consistent results. Such planning can save you and your client money.

Recent improvements in color scanning mean that it is easier to get good reproductions from color prints. Litho printing from color print originals is becoming popular. This is because it is now much easier to make a matched set of C-type color prints from a series of negatives than it is to match the densities of transparencies, and far easier to print them to final scale for pasteup of the layout. The savings can be enormous, but you must be certain your negatives and prints are perfect. Don't expect excellent reproduction quality from machine-print proofs.

YOUR FEES

What should you charge for and how much? Some professional photographers charge a flat fee for the job, while others charge an hourly or daily rate. Even if you decide to set an hourly fee, your clients will usually want an estimate of how long a job will take. Most clients, even large companies, will have a limited budget. Whether or not you itemize expenses is up to you. Usually, providing an estimate and a final bill showing a breakdown of hours and expenses will benefit both you and the client. Itemizing expenses can prevent the client from thinking you are working at an inflated hourly rate,

and can help the client justify the cost to his own management.

Keep in mind, though, that if you make a mistake and must reshoot, your client should not be picking up the extra charges (except perhaps for film and processing). If you underestimated the time to complete a job, try to work out an equitable arrangement. Try to renegotiate the fee, but don't expect the client to agree automatically to a higher cost. You could even risk future business with that client by renegotiating. You will have to develop your own business style and learn to deal with each client on an individual basis.

If you come up with an alternative to the client's layout that you feel has more impact, try discussing it with your client before shooting. If you decide to try the alternative without client approval, the cost of experimenting will come from your own pocket. If the client turns down your alternate shot, you may have a nice addition to your portfolio instead. Many photographers do not shoot on speculation, because it may not be cost-efficient in the long run.

Fees vary with the type of work you are producing. Editorial work pays the least; however, it provides excellent exposure to build your reputation. Most magazines pay a page rate or per-photo rate. Corporate work is the second most lucrative with rates ranging from $850 to $2500 per day. Advertising photographers command the highest fees, with day rates of $1500 and up. Many of today's superstars are earning $5,000 to $10,000 per day. Of course that's not all profit; assistants, reps, the bank, the electric company, and so on must all be paid.

The amount that you charge for your work will depend on your reputation and what the market will bear in your area. When you are first building a list of clients, you will want to set your fees competitively. Be sure not to undersell yourself, though, because it will affect the way your clients value your abilities. As your reputation and list of clients increase, you may be able to get more for your work. If you become really successful, you may even be able to pick and choose your jobs and clients. Your talent will be in demand.

Working from a Layout

In many cases a client will come to you with an artist's rendition of a layout. It may be anything from a rough sketch to a detailed drawing, but you will be requested to follow it. This will often be the case when you shoot for an advertisement, catalog, brochure, or anything where a composite of photos will be dropped in or where there will be an overlay of text.

You will develop an eye for artists' visuals rapidly and learn to recognize those that will work well and those that have unrealistic perspective, size relationships, or angles. It is important to point out these concerns when you discuss the plans, rather than after you have taken the photographs. You may have to emphasize to your client that you'll need some freedom to adjust the layout. On the other hand, follow closely any layouts that display good photographic perspective and composition. In either case, the artist or art director will expect you to connect with the feeling or impression he or she wants to create. When the concept isn't apparent, be sure to ask questions until you have full understanding.

Type overlays are a different matter. You may be provided with a photostat of the typesetting and given overall dimensions with instructions to make an illustration fit. You will often have no leeway to move the space for type around or change its size.

One way to plan for the overlay when you're using a large-format camera is to set up your camera, focus on the text, and trace the layout onto acetate taped to the ground-glass. Then arrange your subject matter to fit around the text marked on the acetate. Make an extra test shot on instant-picture film to simulate the layout. You can tape the acetate tracing over the instant picture and show it (via fax or in person) to your client for approval.

SIZING PHOTOGRAPHS FOR REPRODUCTION

Although you can size multiple layouts (an extension of the above process) with any camera format, large-format cameras work best. It is important to size the images relative to each other so that you can obtain the economics of gang proofing and gang separating.

On your client's layout, draw rectangles to show the position and size of the photographs. Also indicate blocks of copy. Set up your camera as an accurate copystand, parallel to the artwork, and fill the ground glass with the largest rectangle in the layout. (Be sure to leave a ½-inch margin on all sides for processing clips and handling.) Trace the outline of the rectangle onto a piece of acetate taped to the ground-glass. Or, mark the corners of the rectangle and then draw the rectangle itself on a lightbox with a ruler. Indicate any text that will overlay the image. Be sure to mark the subject, page number, and any instructions on the acetate.

While leaving the camera in the same position, trace the smaller rectangles onto separate acetates. Mark any pertinent information on these acetates also. Now you have a tracing to size of each picture area that you can use during shooting.

Before you photograph each subject, tape its corresponding acetate to the ground glass. Adjust the image size on the ground glass so that it matches the rectangle on acetate. You can now be sure that all images you shoot for this spread will be made to the same scale. As you finish each shot, you can clip the acetate to your instant-print test shot. The acetates can actually help you organize and run the shoot.

Of course, this means there may be times when you are using only a very small area of the film. This may go against all that you've learned about using the entire frame or sheet of film. Remember, though, that you are shooting for reproduction purposes; the sizing method is designed to work efficiently for both the layout and the separations. Using the same film size and emulsion throughout the shoot will also help during the making of separations.

SHOOTING CONSIDERATIONS

Try to take all the photographs for a specific project on the same day. Many photographers find that their work from a single shooting session has a certain look and feel to it from the moment they take their first photograph. When you work on larger projects, however, it may not be possible to finish all the shooting in one day. Keep in mind the risk that photos taken for an extended project may differ subtly in mood and could disrupt the harmony of a catalog or other publication. Also, film processed on different days may vary in color balance. Make a mental note of these concerns and do what you can to minimize them.

Keep your lighting consistent within a catalog spread or within the entire catalog if you want it to convey the same mood throughout. If the main light is on the right side for one photograph, it should be on the right side for all of the photographs. This means you'll have to plan the lighting for all the products and models at the same time.

Photo on opposite page by Nick Vedros.
Technical information on page 154.

Some photographers believe they need pay attention only to this type of detail with each double spread of the catalog—not with the catalog as a whole. However, art directors talk about the "feel" of a catalog and, increasingly, clients want catalogs that are consistent in atmosphere and theme. You can reinforce this consistency by using the same lighting, the same type of props, and the same viewpoint or perspective. Sometimes you can use one particular (special) prop in each photo to tie the photos together. Catalogs can be more than just a photographic record of products when time and budget allow.

The consistency of style and feel becomes even more critical if your client offers the same products each year, adding only a few new pages. You'll have to keep accurate records of your lighting setup, camera position, subject position, and exposure. The new work must match the previous work closely so that the viewer cannot detect "add-ins." This would not apply, of course, if you plan to reshoot the entire job for a totally new look.

POINT OF VIEW IN CATALOGS

In catalog photography, the angle of the camera to the products should approximate the angle of the reader to the page. You must know which products and models will be viewed at the top, middle, and bottom of the catalog pages. Those images that will be viewed at eye level should be taken at eye level. Take photographs that are used at the top of the page with your camera angled slightly upward. Take photographs to be used at the bottom of the page with the camera angled down.

What happens if you do not follow this rule of thumb? Theoretically, very little. Many art directors and account executives may not even notice it. Most viewers will not be conscious of the differences. However, studies of reader reactions to catalog layouts have shown that there is a subconscious reaction to the photographic angle. When the photo angle differs greatly from the reader's angle, the reader seems to feel uncomfortable looking at the photo, which may lead to fewer purchases. The bigger the page, the more the angle selection matters.

For similar reasons, the camera angle should be the same for all photos in a horizontal row on a page. If it isn't, the visual effect can be disconcerting. This discomfort is almost imperceptible, but it may be enough to affect the viewer's perception of the product.

Do not assume that your client is aware of these visual problems and techniques. It is your job to work to the layout, planning angles so that each page will be comfortable to view. The art director may never see the full page with your photographs until the separations are made. He or she may see only the individual images out of context. This may mean that only you will be able to keep a running check on your work.

Your job is to maintain the photographic integrity of the catalog as a whole. Consider each photograph as a part of the whole, not as an assignment in itself. The images must relate effectively in style, mood, camera angle, and so forth. Discuss the catalog theme with the art director before shooting. If the catalog lacks a theme, standardize the lighting and camera angle to unify the photos.

When you photograph diamond jewelry, you'll have to match readers' expectations. Most viewers will expect diamonds to look blue-white. This can be difficult to convey in your photos and may require experimenting with filtration during shooting.

If you decide to use food as a prop, look to good-quality plastic food. It is less expensive in the long run because it won't spoil, and it can look as real as genuine food when it's not the main subject.

Usually your job as a catalog photographer is to create photographs that simply show the products for sale—it's not to make super-creative photographs. Great art may be appropriate for some upscale department stores, who publish catalogs that are visual delights. But budgets like those are a rarity. The bottom line is to produce photos that will motivate the viewer to buy the products shown. The catalog must move the merchandise, not serve as your portfolio.

Bruno Joachim

"The photograph was conceived to illustrate the ad headline: 'Run faster. Jump higher. Again.' We all remember PF-Flyers from our childhood days. Here, we wanted to put the sneaker into a contemporary visual that would combine the nostalgia of the 'PF-Flyer' name with the feel of 'Jumping higher. Again.' A wire was inserted through the lace, and I manipulated the bending to achieve the fluid 'flying' effect. I used no special tricks or effects other than clamping the sneaker and lace to a studio stand."

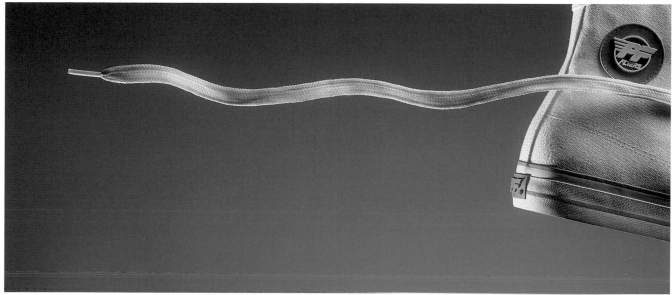

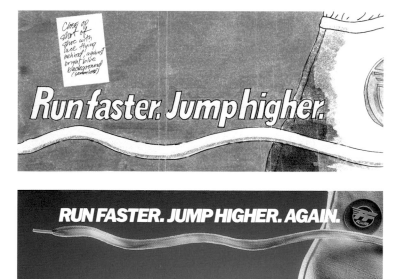

Title: PF-Flyers

Purpose/Client: Advertising illustration for PF-Flyers

Camera: Sinar p

Film: 4 x 5 KODAK EKTACHROME 100 PLUS Professional Film / 6105 (Daylight)

Lighting: Norman 4000 WS strobes

Welch, Currier, Curry; Boston, MA, ad agency
Jon Pietz, Kent Collins, art direction

Steve Myers

"We wanted to indicate stressful conditions that crops are subjected to during the growing season and what treatments may be applied. I exposed the window and sill set with apples with a four-foot-square bank light, using a single 5000 WS strobe overhead at *f*/45. I used a second 2400 WS diffused strobe to light the area behind the moistened window to create the out-of-focus impression of greenery outside."

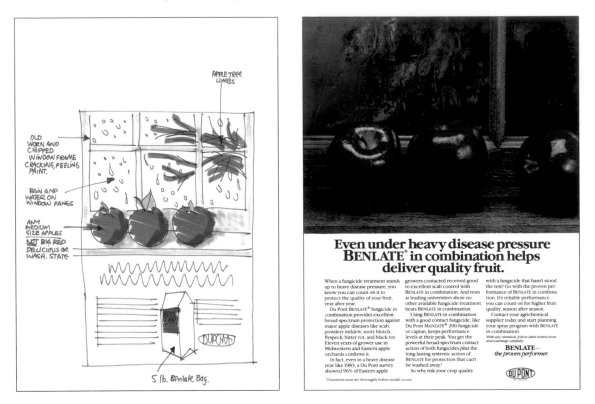

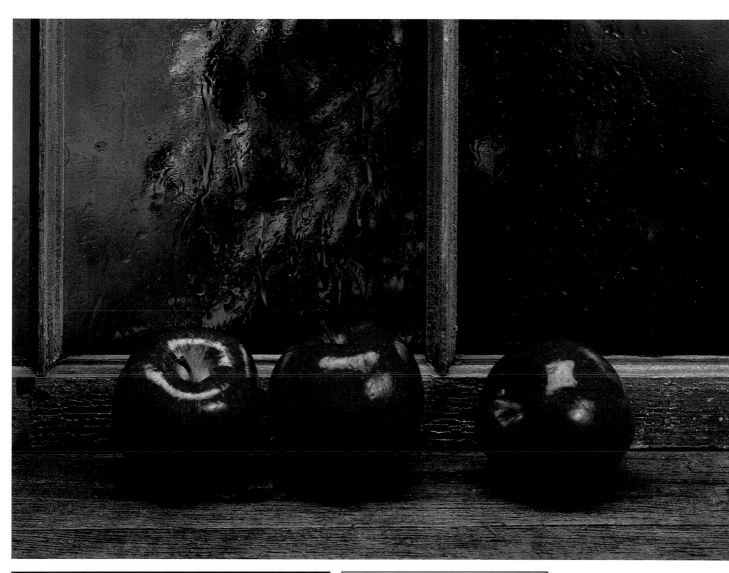

Title: Apples on Windowsill

Purpose/Client: Ad for Dupont-Benlate

Camera: Deardorff

Film: 8 x 10 KODAK EKTACHROME 64 Professional Film / 6117 (Daylight)

Lighting: Speedotron strobes, 5000 WS and 2400 WS

Exposure: f/45

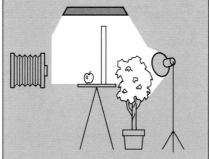

George B. Fry III

"This set was built to the camera with a cropping mask that fit the poster proportions. The corner was opened up from 90 degrees to allow the camera to see more of the room. The walls were built just high enough to clear the poster crop. All the breaks were done and secured in place, including the broken glass (actually cut Plexiglas). The lights hanging from the ceiling were wired with strobe pencil lights. We used a smoke machine behind the door to enhance the feeling of NBA basketball player Alex English of the Denver Nuggets exploding into the room. After the shot was done, we digitally added a Puma swoosh to the cheerleader's shoes and removed a couple of fish-lines."

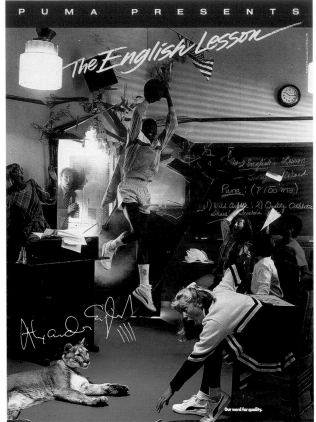

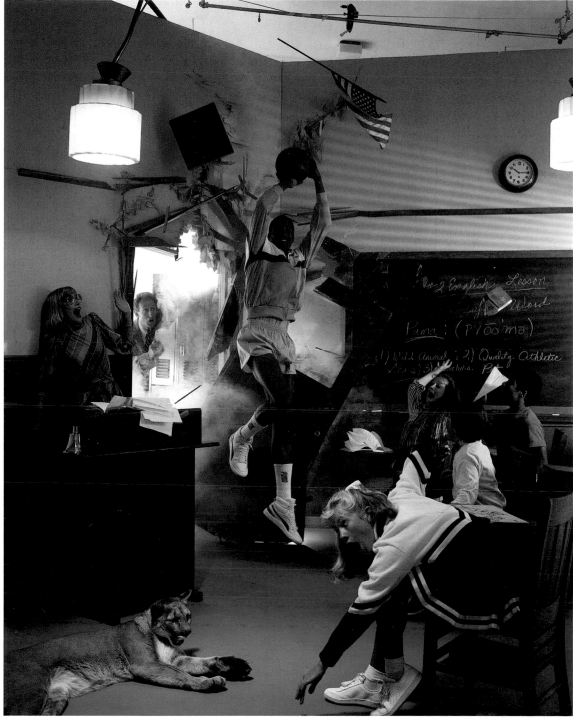

Title: The English Lesson

Purpose/Client: Promotional poster for Puma shoes

Camera: Sinar p

Lens: 210 mm

Film: 4 x 5 KODAK EKTACHROME 100 Professional Film / 6122 (Daylight)

Lighting: Balcar strobes, 5500 K

Exposure: 1/60 second at f/32

Nick Vedros

"This photograph is one of a series made for a Unitog Clothing Company ad campaign entitled 'Promises Kept. . . .' Each image in the series was designed to convey a particular attribute such as quality, longevity, dependability, etc. Both the location and the props were carefully chosen to establish the mood. Casting convincing actors was essential to the success of the shoot. The finished piece was accompanied by copy, written in dialogue form intended to underscore the connection between attributes we admire in people and our feelings about the clothing company."

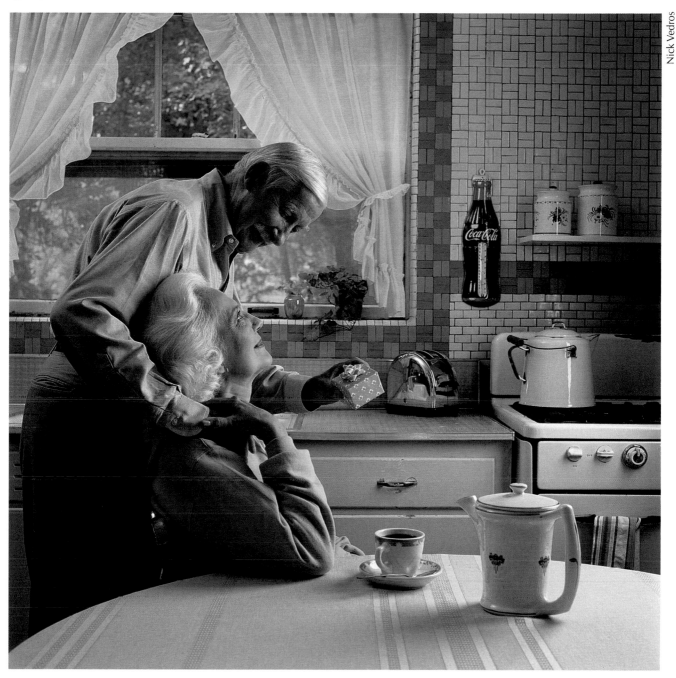

Title: Promises Kept

Purpose/Client: Clothing-company advertising series

Camera: Hasselblad 500 ELX

Lens: 80 mm

Film: 120 KODAK EKTACHROME 64 Professional Film (Daylight)

Lighting: Two Speedotron 2401A power packs and heads. Models lit by one head in a Silver Plume Wafer; second head bounced off ceiling.

Editorial Work

Editorial photography is available both nationally and locally. Proliferating regional magazines offer the largest market. Although national magazines may seem more prestigious, they also tend to be more conservative. Not so the regionals. Staffed by energetic newcomers, they fight for the advertising dollar through creativity.

It is more difficult to obtain assignments from top national and international magazines than from local ones. You will rarely get your foot, let alone your portfolio, through the art director's door. If you do, the first two pages he or she turns to in your book will have to impress the art director. If they don't, you will get no further.

At first glance, the low fees (probably half your normal rate) from regional magazines may not seem worth it. What may seem like a good arrangement at first ("we will guarantee you five days of work every month") may seem like a burden later on if you become busy with other assignments. However, working for a magazine can be the foundation of your success. The magazine knows the advertising agencies and may put in a good word for you. They know which clients pay well, which don't pay so well, and which don't pay at all. Your contacts with the staff and advertising agencies can only help.

GETTING IN

You can draw attention to your talents by exhibiting at local galleries. You may even sell some of your photographs and cover your expenses. If you exhibit in a gallery with an opening night, your talent may be discovered by an art director or editor (they sometimes come to see their colleagues and rivals).

An alternative is to produce speculative editorial work. London photographer Derek Berwin decided to shoot, on speculation, a fashion series under water. On location in the Red Sea, he outfitted his models in high fashion and then made them take the plunge to be photographed. The expenses included professional models able to scuba-dive and expensive outfits designed to look good under water. His investment paid off many times, not only in syndicated magazines sales but also (and significantly) in publicity and reputation.

EDITORIAL CONTENT

Most editorial photography is not, of course, news photography. The hard-nosed skills of the paparazzo and bravery of the combat photographer are not required to photograph a fashion-page set or illustrate a feature on fine wines. On some assignments, such as environmental portraiture of celebrities, the professional illustrative photographer and the news photographer may compete.

An editor or art director will often guide your work. The copy, perhaps already written, will be sized to the layout. Your final photos must fit the layout. Editorial art directors are usually concerned with the photos—their style and feel, and whether they support the article—while advertising art directors rely heavily on the message in the words and layout, along with any accompanying photos.

Some magazines send out "need" lists and specify film type, film size, fees, etc. Review the magazines that you want to shoot for. Get a feel for their style and content. Then submit to the editor photographic ideas that support potential stories.

Editorial photography often offers page-rate payments and bonuses for cover use. Some photographers who work for big-name magazines are paid repeat fees when their work is reused in books or foreign-language editions. They may be paid according to the life expectancy of the magazine (day, week, month), as well as by the size of the illustration and circulation. Although initial fees may be low, good photos garner more fees through additional use or larger coverage. But, if your photographs are successful, you may achieve several spreads and possibly a cover, a byline, and worthwhile payment. Contact the American Society of Magazine Photographers (ASMP) for rate schedules and copyright information, and as a general resource.

EDITORIAL STYLE

In magazines, the distinction between advertising pages and editorial pages should be clear. Do not provide photographs that look like ads. Editorial photos need humor, drama, human interest, surprise—above all, imagination.

Editorial photographs need the polish of commercial shots and the vigor of photojournalism. You will be more likely to shoot in the 35 mm format, and less likely to use elaborate studio lighting. The sharpness of your camera lenses is important, and some magazines still insist that you use only fine-grain films, such as KODACHROME 64 Professional Film or KODAK T-MAX 100 Professional Film.

For black-and-white photography, find out the magazine's standard print size. Many national publications prefer to review contact sheets first.

Finally, remember that magazine art directors are often innovative. You may want to try some special, creative techniques that will make your photos different from all the others.

Photo on opposite page by Hans Neleman.
© Hans Neleman, 1988.
Technical information on page 154.

Walter Wick

"I first made a photograph of a man standing with head down, slightly hunched. He was lit softly with details of his face and clothing visible. An 8 x 10 C-print was made of this, spray-mounted to thin cardboard, and cut out to form a silhouette of a man about eight inches tall (with photographic details). I draped a nine-foot-wide white seamless background paper on the floor, and positioned five real people on the white paper. I then stuck the eight-inch cutout to the paper in a standing position with beeswax. A fog machine provided the smoky atmosphere, and a single strobe light placed behind the people provided the lighting."

Loneliness

WHETHER BEING LONELY IS A SOMETIME THING
OR A SAD WAY OF LIFE, UNDERSTANDING
ITS CAUSES CAN HELP. BY JEFF MEER

Bill is a graduate student in architecture at a major university in the Northeast. He is shy, and when he speaks, he does so softly, with a slight Alabama drawl. Bill spends Monday through Friday going to class, chatting with friends and doing course work. Weekends, he is alone.
Sarah is a midlevel executive in a *Fortune 500* company. She is a bright, take-charge person who on any given day is as likely to be in Dallas as in New York. She has dozens of acquaintances, friends in five cities

PHOTOGRAPHS BY WALTER WICK

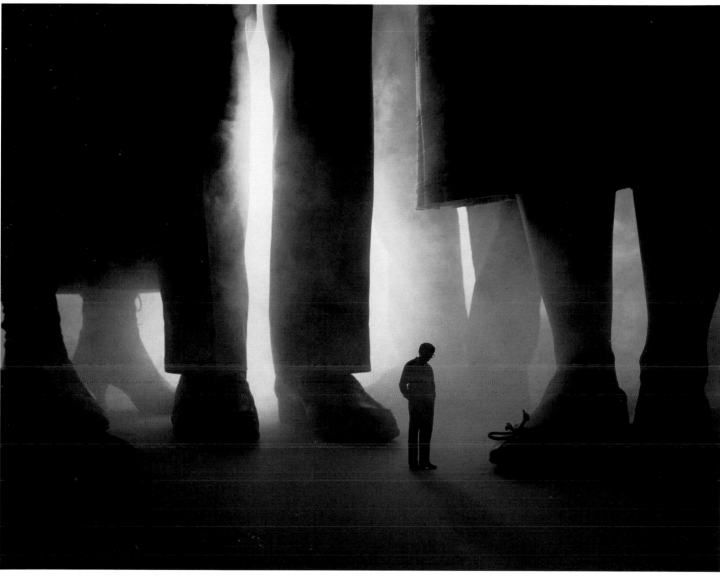

Title: Loneliness

Purpose/Client: To illustrate an article for *Psychology Today*

Camera: Toyo

Lens: 90 mm

Film: 4 x 5 KODAK EKTACHROME 64 Professional Film / 6117
(Daylight)

Lighting: Strobe with 11-inch reflector

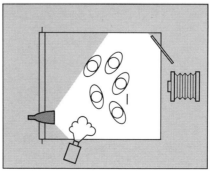

Carl Fischer

"The photograph is a portrait of Joe Sedelmaier, a television-commercial director known for his comedy routines (some of which are slapstick). To illustrate slapstick comedy, I used the old Hollywood device of building a room set on its side; that is, the wall in the photograph is really the floor, and the floor is the wall. This permitted me to place one of Sedelmaier's actors on his back actually propped up slightly to keep his shadow away from his body. The director was lying on his side, pretending to be sitting in a chair. He held still for a double exposure, during which the falling actor was moved to indicate motion. The banana was hung in midair with a monofilament line."

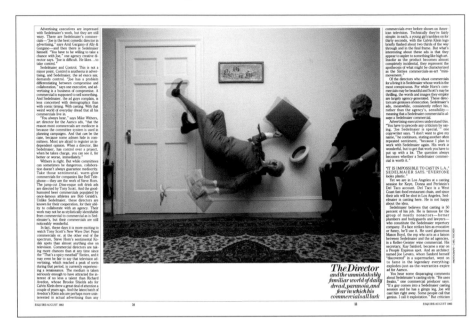

The Director and the unmistakably familiar world of daily dread, paranoia, and fear in which his commercials all lurk

40

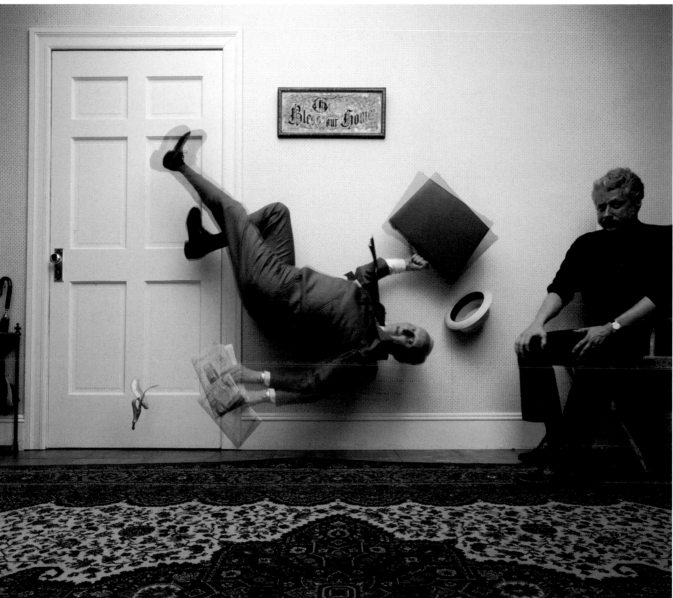

Title: The Director

Purpose/Client: *Esquire* magazine

Camera: Hasselblad

Lens: 40 mm Zeiss Distagon

Film: 120 KODAK EKTACHROME 64 Professional Film (Daylight)

Lighting: Strobe bank, 6400 WS

Exposure: f/22

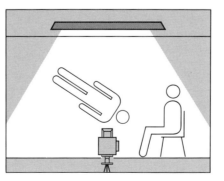

Richard Izui

"The shot was assigned as a full-page drink feature. Jim Larson, Picture Editor, wanted the shot to have a warm antique feeling. It is a lifestyle shot that had to be carefully propped. The props came mostly from an editor's private collection. I felt that the lighting should be dramatic, yet clearly powerful. I wanted to enhance the glass and decanter and still have a realistic warm quality to fit the environment. I didn't use real liquor to avoid etching the acrylic ice cubes. (Since then, I've changed to Pyrex cubes which are unaffected by alcohol.) The shot took one-half day. I always try to get a shot to 'feel good' before I submit it. This particular shot felt just right."

BEST OF THE BROWNS

raise your glass to
scotch, bourbon, irish and the blends

drink By EMANUEL GREENBERG

TODAY'S DISCERNING drinkers are returning to sturdy, aromatic world-class whiskeys. These rich liquors, known in the trade as "brown goods," range in hue from tawny to a deep, lustrous mahogany. They're spirits of taste and character, with unmistakable organoleptic impact; one sip tells you you're into something special. Taken neat, over ice, with a splash or in mixed drinks, these whiskeys retain definition

and individuality.

Popular wisdom notwithstanding, whiskey has never been out of style in the United States, nor has it been superseded by vodka. Surprised? Just run your eyes along the back bar of any decent tavern and note the array of whiskey labels. If you need further convincing, the latest edition of *Jobson's Liquor Handbook,* an authoritative liquor-marketing annual, says that Americans still consume more whiskey

PHOTOGRAPHY BY RICHARD IZUI

Title: Best of the Browns

Purpose/Client: Editorial photo for *Playboy* magazine

Camera: Deardorff

Lens: 305 mm Nikkor

Film: 8 x 10 EKTACHROME 100 Professional Film / 6122 (Daylight)

Lighting: Speedotron 4800 WS and 2400 WS packs and lights, 2 heads in overhead, softlight with diffusion, scrim below

Exposure: f/45, five pops

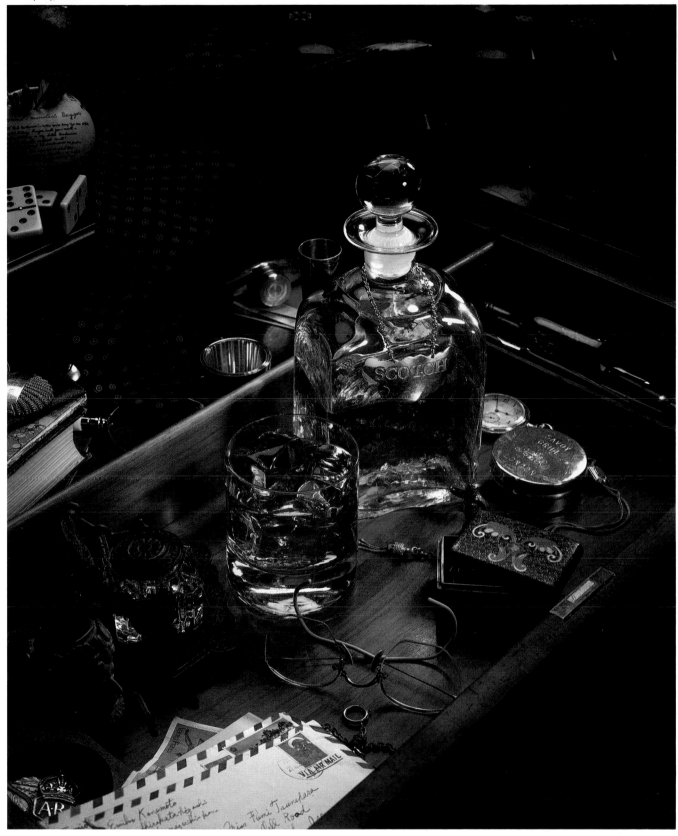

Elizabeth Watt

"I used a side light with no diffusion and a top bank to bring out the highlights on the oiled shrimp. The surface was an old tin ceiling we found in the dumpster outside. Beautiful texture works well in food photographs. We found the platter and paired it with the background because of the compatible textures and colors. The original photograph was later cropped and blown up, giving it a stronger impact. The food is more the focal point. With hard side light and soft top light, the food has texture without being too contrasty."

ENTERTAINING WHEN THE HEAT IS ON

Cool Advice for the Summer Cook
By Leslie Newman
Photography by Elizabeth Watt

E ach summer we regain our gastronomic innocence, only to lose it all over again. We wander through June like Adam and Eve in the garden, picking cherries here and berries there, tasting everything as if for the very first time. We rediscover fire and the primitive pleasure of gathering around it in the dark (it still takes us a while to get the thing going) to eat burnt meat with our garden greens. Give us a jug of wine with, and a bowl of fruit after, and we've had a feast.

By midsummer we know better. We're mastering marinades, mesquite and margaritas. When naked berries become boring, we dress them with cream. When perfect peaches start looking plain, we tart them up with glossy glazes and set them in golden crusts. We turn pears and plums into cobblers and crumbles and then into buckles and grunts. And when those become household words, we make ice cream: peach and blackberry and cherry (homemade cherry vanilla!). That keeps everybody happy all through July.

But when you offer frosty dishes of fresh strawberry ice cream and people have to *think about it*, then you know it's August.

Still, we're not putting away the fruit bowl or the ice cream maker yet. We haven't run out of ideas, we've only run out of *easy* ideas. This is when the real creativity begins. If we think about it, we can quickly come up with some sweet combinations that are more than the sum of their parts. Lemon ice cream, for instance, has a natural affinity for blueberries, while a scoop of lime sorbet on a wedge of honeydew melon looks as fresh as it tastes. And dark sweet cassis sorbet seems twice as rich when it's

At left, spicy Tandoori Shrimp, hot off the grill.

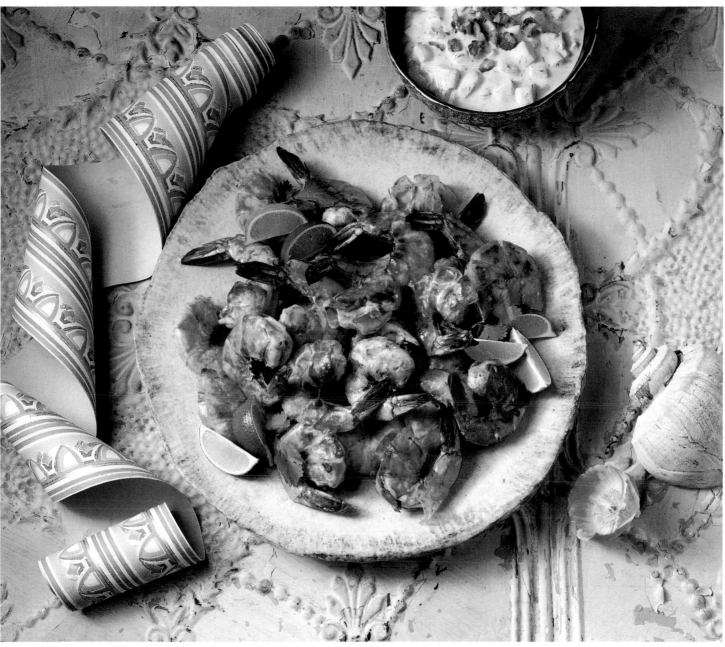

Title: Tandoori Shrimp

Purpose/Client: Food and Wine magazine article "Entertaining When The Heat Is On"

Camera: Deardorff

Film: 8 x 10 KODAK EKTACHROME 64 Professional Film / 6117 (Daylight)

Lighting: Speedotron head, 2400 WS

Ryszard Horowitz

"The photo is a part of an essay entitled 'Forecast For Disaster.' It deals with climatic changes caused by man-made pollution that may prove catastrophic. This particular image suggests my vision of what might happen should the ozone depletion melt mountain glaciers, raising ocean levels along the Eastern shore of the U.S.—Manhattan under water—frightening thought! The photo is a composite made in the darkroom from three pictures: the Manhattan skyline; a sky taken in Cuzco, Peru; and waterfalls taken in the Brazilian jungle."

Title: Manhattan Under Water

Purpose/Client: Sports Illustrated magazine

Camera: Various

Film: 8 x 10 KODAK EKTACHROME Duplicating Film 6121

Judy Olausen

"This photo was part of a series I did with designer Eric VanDenBrulle. We were in a large rambling factory down South trying to find photos that would put more emphasis on the people than the machinery. We had to work fast. I saw a pile of fiberglass drain pans on the cement. Eric and I agreed that they had potential. We set two on end and put two 1000 WS Lowell lights with silver umbrellas behind the drain pans. We asked a worker to come over and drill in the drains. I decided to print this photo full frame to include the Hasselblad signature (two notches)."

KYSOR PEOPLE:

PROFITABLE BUSINESS GROWTH

Kysor employees are playing the leading role in helping the company meet its profit goals. They are working harder, faster, and more efficiently as a result of productivity and performance-related programs. Specific programs are in place which measure the company's effectiveness in shipping orders on time and producing products efficiently. Monthly success rates are tabulated, published, and all employees are advised of the results. These are key measures of Kysor's productivity and its ability to serve customers because Kysor employees understand the bottom line. They know that higher productivity and improved customer service mean more profits – and a stronger Kysor.

11

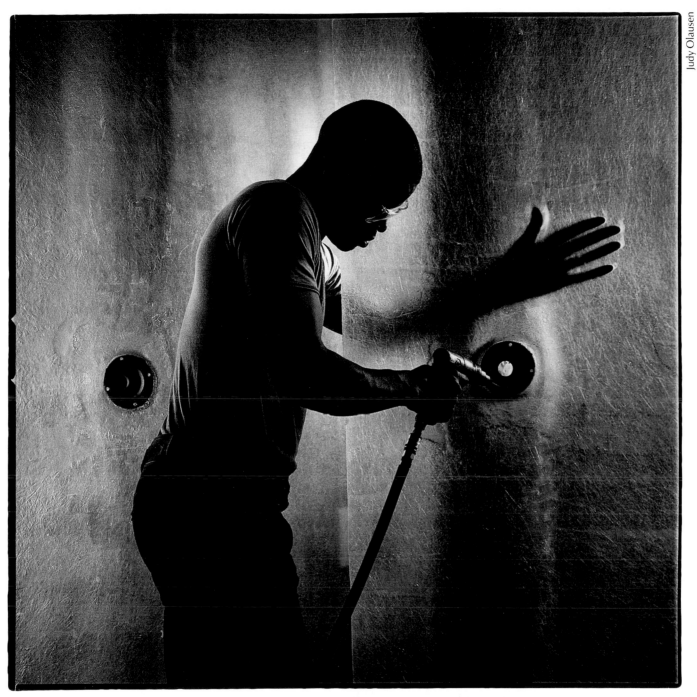

Title: Fiberglass Drain Pans

Purpose/Client: Annual report

Camera: Hasselblad

Film: 120 KODAK PLUS-X Pan Professional Film

Lighting: Two Lowell lights with silver umbrellas, 1000 WS

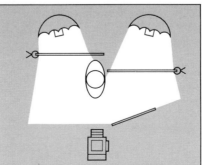

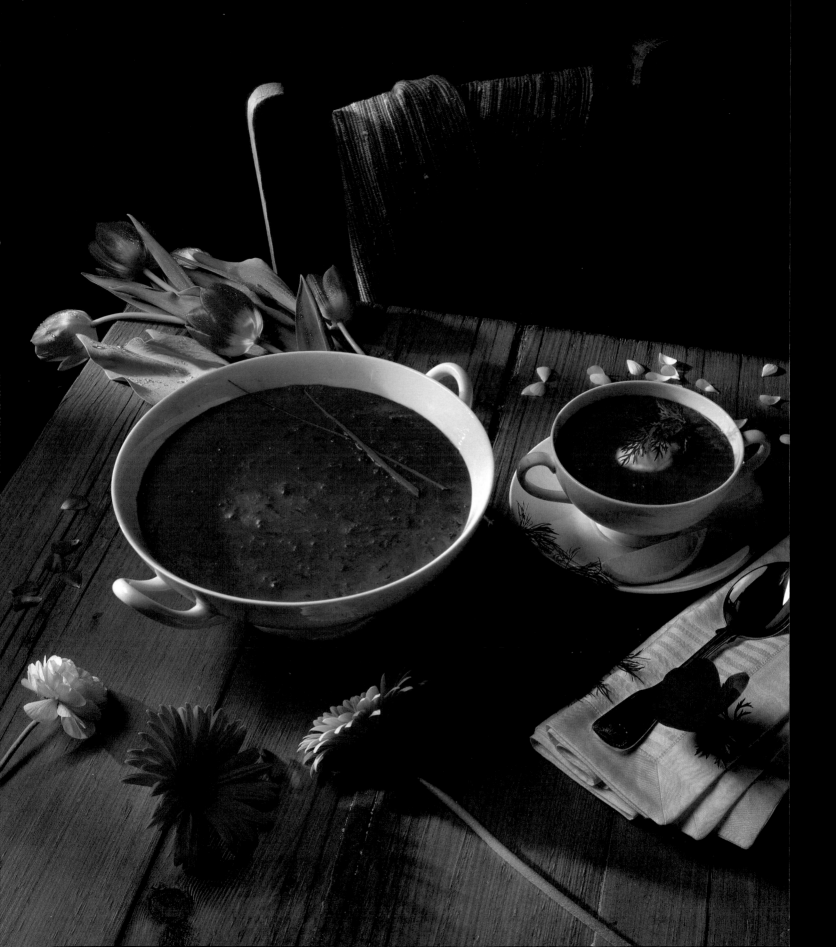

Food

FOOD STYLING

Food looks different to the camera from the way it appears to the eye. The human eye, seldom objective anyway, sees food as it desires it. The camera, free of such desires, sees only what is before it.

Preparing and arranging food is an art in itself. You are not misleading the viewer when a food stylist arranges and perhaps alters the appearance of food. You are changing it only so that the final image appeals to the viewer. Whether or not you hire the services of a food stylist, the following information will be helpful in planning your shots, and during the actual photography.

The more involved the setup, the less time you may have to arrange each item and shoot. Watercress dies quickly—in five minutes. Other foods may stay attractive for ten to fifteen minutes. Be ready to shoot quickly when the setup is complete.

Andrea Swenson is a New York-based food stylist who works for major food photographers and major publications. She and other stylists like her must anticipate the results to ensure that the images of the food match the viewer's fantasy and satisfy your client. "A turkey is a good example," explains Swenson. "It is an ugly bird when fully cooked. It can appear dry, with the skin pinched together. But you're hungry and you imagine the smell of the delicious meat and all the trimmings. You use all your senses and your mouth begins to water. Yet, if you use your eyes only, that fully cooked turkey would not appeal to you. That is why a stylist will cook it only about 40 minutes, browning it just enough to look fully done but not enough to show the problems."

A food stylist is not necessarily a good cook. The stylist knows food chemistry and what will change the appearance of food. He or she is frequently more artistic than a chef or home economist, understanding not only the aesthetics of food but how the camera sees the food. The stylist's concern goes beyond mere food preparation to photographic reproduction of food.

FOOD AND THE LAW

How much you can legally alter the appearance of food depends on the use of the photograph. Before 1962, a photographer could do anything to make the advertised product more appealing. If the vegetable soup had more water than vegetables, the photographer could fill the bottom of the bowl with marbles, then pour the soup on top, forcing the vegetables to the surface. The resulting photograph made the soup appear to be thick with vegetables—a deliberately deceptive maneuver.

In 1962 the Federal Trade Commission began taking a harder look at advertising practices, including deceptive product photography. Today such tricks as the marble technique are illegal. The photographer must, in general, play it straight when food is the main subject (not just a prop in a scene). That is why you may now see glass soup bowls, and low-angle photographs of a ladle pouring vegetables into the broth to keep everything stirred within the bowl. Such tricks make the vegetables look more numerous than they are without adding anything to the broth.

Certain other techniques are legitimate as well. When you see a perfect hamburger bun used in an advertisement for a national fast-food chain, that bun did indeed come from a package used by the chain. What is not obvious is that the stylist may have looked through hundreds of buns to find a perfect top and bottom. The sesame seeds on the bun are original, but they may have been carefully glued to the surface in a pattern meant to have stronger eye appeal.

You are sometimes limited in the amount of food you can show pouring from a package. You cannot show the total number of meatballs in a can of spaghetti and meatballs, for example. This is to prevent anyone from feeling that you are visually promising more than can be delivered. Also, when the product contains several different items, such as the ingredients in a TV dinner, you must show the food exactly as it comes from the original package. However, stylists will go through dozens to hundreds of packages of frozen food until they find the example that has the greatest visual appeal. What makes this legal is that it *is* possible for the customer to find such food, even though you have shown the exception (not the average quality).

EDITORIAL LICENSE

Fortunately, there is a difference between the demands of food photography for advertising and that for editorial purposes. A bag of carrots might have only two beautiful carrots, the rest being pedestrian. For an ad, you must either work with what you find, or go through bag after bag until the ratio of good to bad is much greater. You cannot pick the best from several bags and create your own bunch, because that could be considered improper representation. By contrast, if you are using the photograph editorially, you can sort through the bags to cull only the best carrots.

Photo on opposite page by Diane Padys.
© Diane Padys, 1988.
Technical information on page 155.

SPECIAL PROBLEMS

Sometimes your client may insist that the product has more volume or is bigger than shows in the photograph. You can increase the visual size of products such as chickens or fruit by using a short focal-length lens and moving the camera closer to the subject. Viewed with a long focal-length lens, as is normal for still-life work, the cooked chicken appears skinny. By using a wide-angle lens from a close viewpoint, you can plump up and round out the same bird.

When you include people in a photograph, you risk de-emphasizing food. If you move the camera back far enough to include the people, the food is reduced to an indistinguishable lump on a dish. To emphasize the food when you include people, shoot from a low angle. You can focus on the food and let the people in the background go out of focus, or you can show the people reaching for the food to emphasize its desirability.

Food used as a small prop in a larger scene need not be real. An entire industry in Japan is devoted to producing highly realistic, complete dishes; some of them impossible to tell from the real thing. They are used commonly by agencies in many major cities. The only risk in this approach is that someone else's photograph may show the same carefully arranged meal.

THINGS YOU SHOULD KNOW

Fruit: Select whole fruits with an eye for total perfection. Avoid fruit with splotches, bruises, and other marks. Look for a consistency in size when you photograph more than one piece. Good coloring and shape is important also.

Most fruit is wax-sprayed for the store. Polish the fruit until it glistens; then spray it with glycerin and water to enhance the surface. This may actually appear more appetizing than natural fruit that has not been sprayed.

Fresh peaches may appear colorless inside and out. You may have to add two different cosmetic blushes to the outside to achieve the "peach" tone most people expect. Likewise, you may have to hand-color the inside of a sliced peach to ensure redness near the pit.

Many fruits and some vegetables (avocados, potatoes, etc.) turn brown when you cut them open. You can prevent this by dipping them in either lemon juice or a product called Fruit Fresh (ascorbic acid and sugar) that is used in canning. Different fruits will brown at different rates. For example, Granny Smith apples take much longer to turn brown than Red Delicious apples. Underripe bananas and avocados take longer to discolor than those that are fully ripe.

Use the worst fruit and vegetables in the bunch as stand-ins when you arrange the setup and experiment with your lights. Then replace them with the best-looking fruit and vegetables for the final photograph.

Turkeys: Sew the turkey's skin to make it look taut and more appealing. Then brush it with a mixture of angostura bitters (usually sold where you find maraschino cherries) and Kitchen Bouquet browning and seasoning sauce. Place the turkey in an oven preheated to 375 or 400 degrees for twenty minutes, brush it again with the mixture, and then cook the bird approximately twenty minutes more. When you are done, you will have a beautiful, seemingly fully cooked turkey with no wrinkling, shriveling, or puckering.

Breakfast Foods: To prepare an egg for cooking, separate the yoke from the white. Then cook the white, avoiding bubbling and burned edges. When it is partially cooked, place the yolk in the center of the white and finish cooking.

When you photograph orange juice, add a little KODAK PHOTO-FLO Solution or beaten egg white to enhance the bubbles. Use this technique for coffee as well, because coffee has bubbles when first poured in the cup—bubbles that will disappear without the additive if the coffee

sits for more than a minute. (When you eat, you may not study food closely enough to notice such details. But if you see a photograph of "freshly poured" coffee without the bubbles, you will realize something is wrong with the photograph.)

Bacon can be a challenge to photograph because slices may have too much fat, the edges may curl, and it may not appear crinkly or crisp enough. While the bacon is frying, work it between spoons or knives to make it crinkle but not curl. Once the bacon is cooked, photograph it quickly before the fat congeals and makes it look cold and unattractive.

Hamburgers: Sort through as many buns as necessary to find a perfect top and bottom with no puckers, rips, or creases. The color should be an even brown. The bottom should be as high and as evenly brown as possible.

Once the edges of the hamburger are cooked, sear the entire hamburger in a very hot pan to make it look brown. Patties cooked naturally look slightly gray. Color enhancement is possible with a mixture of Kitchen Bouquet, angostura bitters, and water to match our perception of quality meat. The cooked edges must look perfectly even.

Oven-melted cheese looks dried out. Cheese melted with a steamer gains moisture from the steam and looks more appetizing. You can add mayonnaise, catsup, etc., with a pastry bag and cake-decorating tip. Carefully droop the cheese, place the bacon at the correct angle, and slice the perfectly red tomato to the proper thickness. You must handle the lettuce delicately. Keep it in ice water until you use it. As a result, the "simple" hamburger takes extensive work.

Other Meats: Undercook beef slightly. If you want the beef to appear medium, cook it to medium rare and then take it off the heat. It will continue to cook long enough to reach the proper color. Cut it before it starts to cool; otherwise the meat may dry out and get a crusted look.

Turn barbecued meat only once on the grill. Make sure that the grill marks go in only one direction. You can baste accidently overcooked meat with maraschino cherry juice to redden it.

If the art director wants to show a slice of turkey from an undercooked bird, take the slice, put it in a damp towel, and finish cooking it with an iron. It will look as if it had come from a fully cooked bird.

Alcoholic Beverages: Since wine absorbs light and tends to look darker in photographs than it actually appears (dark burgundy, for example), you may want to lighten glasses or bottles of wine with reflectors or dilute the wine with water. If you are aiming for a dark, nostalgic look in photographs with low-key lighting, you may have to use both techniques —dilute the wine with water and use reflectors to lighten it.

To make champagne stay bubbly longer, coat the inside of the glass with a thin layer of rubber cement before pouring. In addition, you can siphon champagne regularly from the glass and add fresh champagne to keep the bubbles flowing. An older method used by some photographers is to add a little Alka-Seltzer to increase the bubbles. Or you can use ginger ale as a substitute for champagne if it is not the main subject in the photograph.

You can drop salt into beer and sodas to enhance the foam. Depending on how prominent the beer has to be in the photograph, frothy egg white or soap suds can enhance the foam. However, these additives usually slip into the beer after a few minutes, so you'll have to work quickly. If you're shooting a close-up, remember that these tricks can cause the head to look bubblier than normal.

Desserts: When you photograph cakes and pies, have double or triple the normal number of layers, because they always appear smaller in photos. The icing layer in the middle of a cake should be perfectly even. The icing on top should be as close to perfect as possible. The art director will tell you whether it should be smooth, swirled, combed, or whatever.

You may want to photograph a cake or pie with a slice cut out. Or you may want to show the slice separately on a plate or spatula. You will need two or three identical cakes or pies, so that you can cut a normal-size wedge from the one to be shown, and then a larger wedge from another one to use in the photograph. You should go past the center when cutting your wedge, because it will appear slightly smaller on film than it really is. A larger-than-normal slice, one fourth to one third of the cake or pie, will look like an average wedge in the final photograph.

Level the icing on the cake after cutting. Remove crumbs from the layers of icing; then resurface it. Remove bits of icing from the layers of cake after cutting. Fill in any holes with petroleum jelly, and use a toothpick to fluff the texture so that the cake does not look flat and dense.

Hot spots may appear in a large white area, such as whipped cream or white frosting, and the frosting may give unwanted reflections. You can help reduce this by putting sprinkles on the whipped cream or frosting. And, of course, you can use some of the lighting techniques described earlier for photographing highly reflective surfaces.

You may have to lighten the color of chocolate pudding or frosting to make details more visible in the photograph. You can lighten it by mixing it with less cocoa or by adding whipped cream.

When you photograph cookies, file the edges to make them smooth and even. Cookies photographed in a group should all appear approximately the same size.

HOT AND COLD FOODS

Although a camera does not record hot or cold, you can suggest either by condensation or steam or by the viscosity of some liquid subjects. For example, coagulated sauce suggests cold to the viewer. However, if you thin the cold sauce and make it appear runny, it will give the impression that the sauce is hot. And you can add steam to reinforce that concept.

You can photograph ice cream most easily by using a substitute. Unless your client is an ice-cream company or dealer, you may want to make "ice cream" from Crisco shortening, confectioner's sugar, and Karo syrup, or try using mashed potatoes. You can use food coloring to simulate different flavors. Use yellow food coloring to make vanilla. Strawberry jam in place of the Karo syrup makes strawberry. Basic flavors are all fairly simple to imitate.

When you will be photographing real ice cream, set the temperature in your freezer below its normal setting two days before the shoot. The day before the shoot, put the ice cream in the freezer. When you remove it, it will remain firm longer.

As you work, you can scoop the ice cream, take the photograph, then scoop it again. You can also take dry ice, hammer it in a towel, and empty it into a strainer held over the ice cream. The dry ice will keep the ice cream hard for a few extra minutes, giving you extra time to shoot. It's important to allow the top surface of the ice cream to melt very slightly to make it look more appetizing. You can take a series of shots at slightly different stages of melting so that your client can pick the best effect.

When you photograph beverages that must look cold, it is easiest to use ice cubes made from acrylic, so that you don't have to worry about melting. You may have to glue them together to make them look like real ice cubes. Also, you can place beverage glasses in the freezer before shooting. When you bring a glass out under the lights, it will have moisture on the sides to suggest "cold." Special model makers supply acrylic cubes and beverage glasses with realistic-looking condensation, and tiny glass spheres that you can pour into the drink to form bubbles.

Elizabeth Watt

"The client gave me full creative control. I created the feast-like feel with many small props. There was a single light source at the side of the set with a reflector dish. I painted the background and partially lit it to create fall-off. I used a slight diffusion filter (Harrison #2) to soften and enrich."

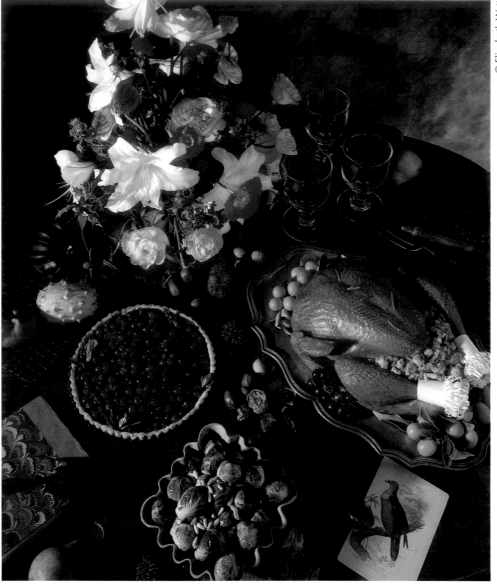

© Elizabeth Watt

Title: Turkey Banquet

Purpose/Client: Cookbook proposal for Prentice-Hall Press/Betty Crocker

Camera: Deardorff
Film: 8 x 10 KODAK EKTACHROME 64 Professional Film / 6117 (Daylight)

Lighting: Speedotron heads, 2400 WS

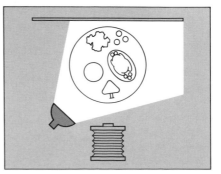

David Zimmerman

"The whole orange was brushed with water before each exposure. Water was sprayed onto the glass. The orange juice was not diluted or mixed with any food coloring. I placed a small white card behind the orange so that the light would go through it and bounce back. Since orange juice is like milk or tomato juice in that it is reflective rather than translucent, the key light was a front light. (For translucent liquids, the key light will often be a backlight.) The backlight used for this shot simply gave definition and dimension to the orange juice and helped focus attention on the point of interest, the drip."

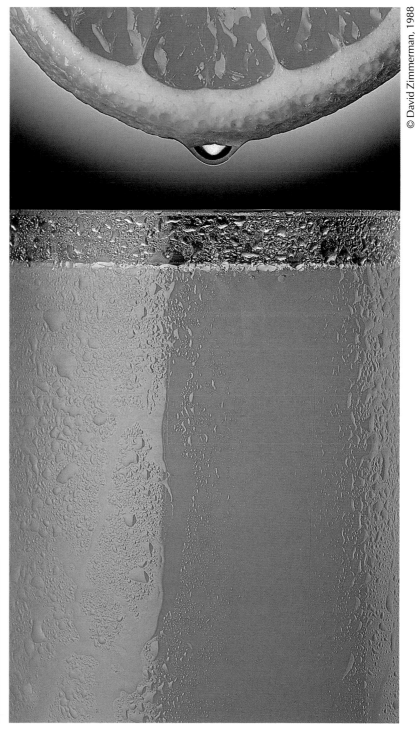

Title: Orange Juice

Purpose/Client: Self-promotion

Camera: Toyo G

Film: 8 x 10 KODAK EKTACHROME 64 Professional Film / 6117 (Daylight)

Lighting: Norman strobes, 800 WS for key light, 400 WS for the fill light

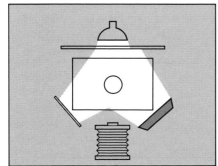

Jim Hansen

"In this image, I was trying to use the color contrast of the yellow corn and red chicken against the bright blue plate. I also wanted to give the impression that the plate was resting on hot coals. In reality, the coals were simply sprayed with gray powder and placed over a light with a red gel to simulate fire. I placed a three-foot-square light bank, at 1200 watt-seconds, over the set. I placed one head, at 2000 watt-seconds, under the set. I added a red gel over the bottom light."

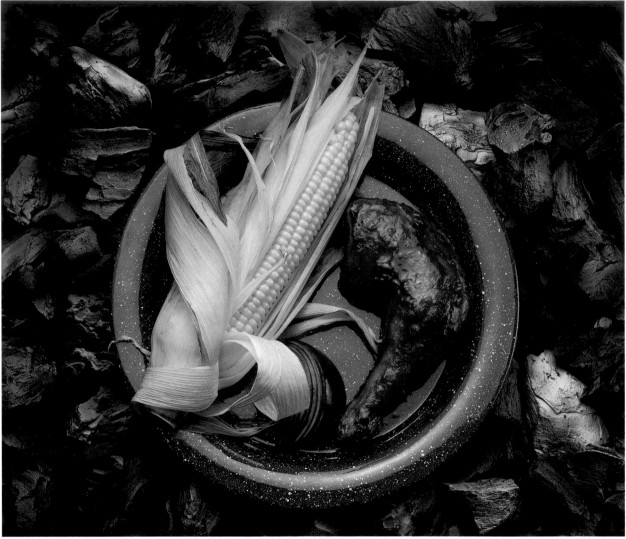

Title: Corn and Chicken on Blue Plate

Purpose/Client: Self-promotion

Camera: Sinar p2

Lens: 210 mm Nikkor

Film: 4 x 5 KODAK EKTACHROME 100 Professional Film / 6122 (Daylight)

Lighting: Two strobes, 4950 K

Exposure: f/22

Nancy Palubniak

"I worked on this shot to develop the idea of arranging food in an overall pattern. I decided to shoot straight down on the subject and to light it in an even manner to emphasize the design. While playing with the food, I began to see the many varieties of colors and shapes within each vegetable. I find this pattern makes us look at food in a different way, focusing on the inherent qualities of the food and allowing it to speak for itself rather than relying on techniques of lighting, background, props, etc."

Title: Vegetable Pattern

Purpose/Client: Portfolio piece

Camera: Calumet

Film: 8 x 10 KODAK EKTACHROME 64 Professional Film / 6117 (Daylight)

Lighting: Balcar strobes

Pierre-Yves Goavec

"This shot is part of a series that I did for Jello Gelatin. The purpose was self promotion. All of the shots in the series included a gelatin cup, the Jello powder, and the black spoons. Within the restriction of these three elements, each shot was very different."

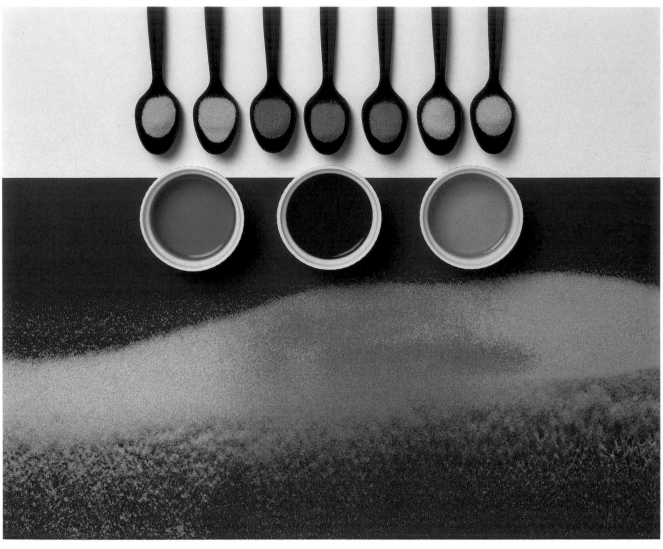

Title: Jello Gelatin No. II

Purpose/Client: Self promotion

Camera: Sinar p

Film: 4 x 5 KODAK EKTACHROME 64 Professional Film / 6117 (Daylight)

Lighting: Strobe with 11-inch reflector

Richard Fukuhara

"The concept was to represent the supermarket's private label brands. The lighting setup included one light projected through diffused material and a single white foam core reflector board. To achieve a high shine on the can 'lips,' each can was polished and new labels were attached. Contents of each can were arranged with a pair of chopsticks. Liquid from the individual cans was applied to each item with a small brush to prevent dryness. The 135 mm lens created a distortion that added dimension to the image."

Title: Private Labels

Purpose/Client: Promotional mailer and double-sided hanging mobile for Lucky Stores

Camera: Sinar p

Lens: 135 mm

Film: 4 x 5 KODAK EKTACHROME 64 Professional Film / 6117 (Daylight)

Lighting: One 4800 WS Balcar strobe and a single head on a boom stand

Exposure: 1/60 second at f/32

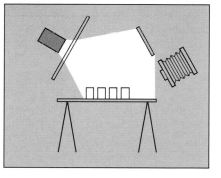

Louis Wallach

"I designed the lighting to solve two problems. First, I had to make the meat look as appetizing as possible. Second, I had to keep the supporting elements soft and slightly dark to keep the emphasis on the meat. To do this I chose a Luma-lux scrim and a 9-inch reflector covered by Luma-lux diffusion material. The combined effect was to give a spot of hard light surrounded by a softer, broader light, simulating natural light. I used various screen and solid gobos to limit the exposure on secondary areas of the image."

Louis Wallach Photography

Title: Prime Rib

Purpose/Client: Portfolio

Camera: Toyo

Lens: 240 mm Schneider G-Claron lens

Film: 8 x 10 KODAK EKTACHROME 64 Professional Film / 6117 (Daylight)

Lighting: Two Comet 2400 WS packs at full power in a custom-made four-tube flashhead with silver reflector covered with Luma–lux diffusion material, 4600 K

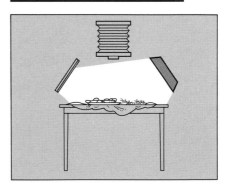

Louis Wallach

"The subject matter was decided on by meeting with the food specialist to discuss various visual and promotional goals that needed to be met. The props here came from retail outlets rather than antique stores. We used new pieces to maintain a fresh, bright atmosphere appropriate to the dessert/bistro look we were after. The lighting was a very straightforward application of the head and reflector with a Luma-lux scrim. It was designed to give a window-like effect."

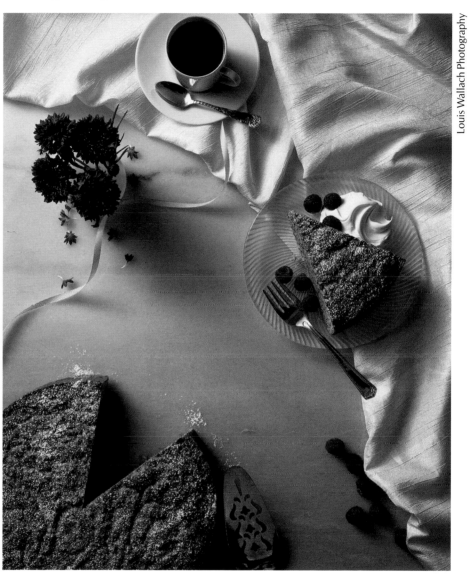

Title: Nut Torte

Purpose/Client: Portfolio

Camera: Toyo

Lens: 240 mm Schneider G-Claron

Film: 8 x 10 KODAK EKTACHROME 64 Professional Film / 6117 (Daylight)

Lighting: Two Comet 2400 WS packs at full power in a custom-made four-tube flashhead with silver reflector covered with Luma–lux diffusion material, 4600 K

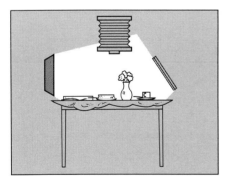

Carl Zapp

"The surface was granite tiles, and the background was frosted Plexiglas with a head behind it. One of the most difficult aspects of the shot was to keep the detail in the white areas without the black areas getting too dark. There was a small card above the sugar bowl, to keep the light from burning it out. The blackberries were oiled with a brush to increase the highlight in each round segment. The front bowl is actually a shallow plate, enabling each berry to sit above the milk. I used KODAK PHOTO-FLO Solution to produces the bubbles in the milk. I filtered the film with a CC.075M filter and shot at f/64 for maximum depth of field."

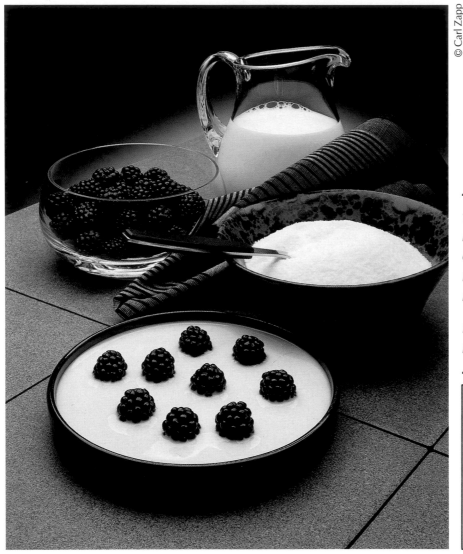

Title: Blackberries in Milk

Purpose/Client: Self-promotion

Camera: Toyo G

Lens: 240 mm

Film: 8 x 10 KODAK EKTACHROME 64 Professional Film / 6117 (Daylight)

Lighting: Speedotron strobes

Exposure: f/64

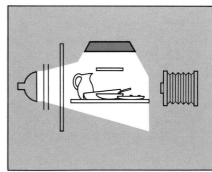

Carl Zapp

"The surface was a piece of white Plexiglas. The background was frosted white Plexiglas. The most difficult part of the shot was getting the glow to conform around the subject. I created the glow with light from one head behind the Plexiglas, shaped by black cards. The main light source was a 3 x 3-foot bank placed above and behind the glass. I made the shot with a 240 mm lens, using a CC.025Y filter. In addition, the film was pushed by + 1 full stop to increase contrast. For the greatest depth of field, I used f/64. I needed several jars of cherries to find one with the stem curving in the right direction. The curl was essential in the design."

Title: Whiskey Glass with Hand

Purpose/Client: Self-Promotion

Camera: Toyo

Lens: 240 mm

Film: 8 x 10 KODAK EKTACHROME 64
Professional Film / 6117 (Daylight)

Lighting: Speedotron strobes

Exposure: f/64

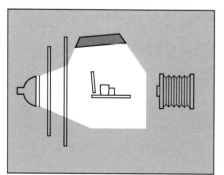

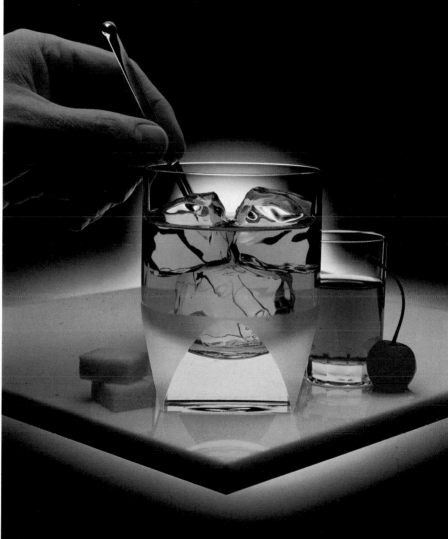

John Campos

"First I drilled a hole through the Formica. Then I wiped the surface of the Formica with Armour-All to give it a sheen and to help the water bead up. I placed a pencil-tube strobe through the hole in the Formica and wrapped a foil reflector around it to keep any light from hitting the background. I placed the frosted dish in front of the flashtube. I placed each grape in glycerin to keep it glossy-looking and placed them all on the dish to look like a bunch. I placed the stem as the final piece. The main and only light was the pencil tube with one white card reflector. I placed a piece of clear 8 x 10 acetate six inches in front of the lens and applied Vaseline to a confined area of it. The Vaseline created the misty effect."

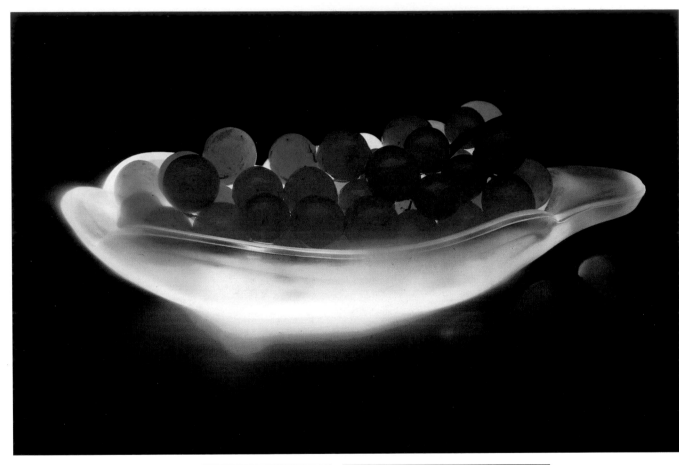

Title: Grapes

Purpose / Client: Self-promotion

Camera: Toyo

Lens: 240 mm Nikkor lens

Film: 8 x 10 KODAK EKTACHROME 64 Professional Film / 6117 (Daylight)

Lighting: Speedotron 2400 WS pack, one pencil tube at 1200 WS

Dennis Galante

"I shot this photograph for self-promotion. I wanted to create a photograph that would grab the viewer's attention. The rear light was a Speedotron strobe head aimed right at the center of the strainer. The top light was a Elinchrome T strobe head pointed down at the potatoes through a small white matte lux screen. The strainer was supported from the top handle in front of the lux screen."

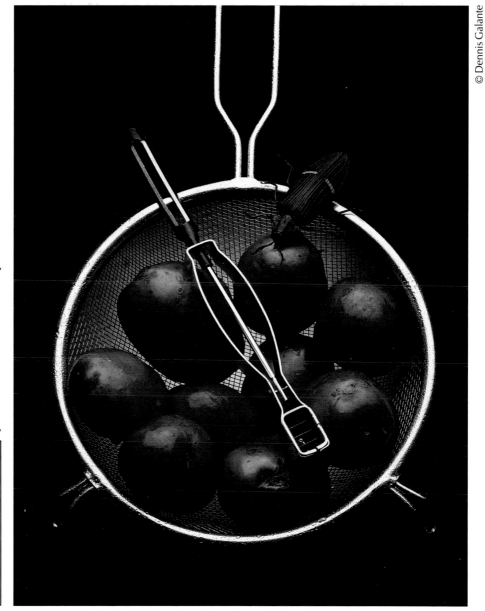

Title: Red Potatoes

Purpose/Client: Self-promotion

Camera: Toyo

Film: 8 x 10 KODAK EKTACHROME 64 Professional Film / 6117 (Daylight)

Lighting: 1 Speedotron head (rear), 1600 WS; 1 Elinchrome head (top), 4000 WS

Hank Benson

"The eggs Benedict shot is part of a series of photographs using various repeating graphic shapes—in this case, circles. To give the shot a bright, early morning feel, I placed two Comet strobes behind a 72-inch-wide sheet of drafting paper. To show raw-light 'highlights' on the subject, I tore small holes into the scrim in front of one strobe head. I then placed a 103 Lee gel over that head. This warm, raw light, combined with the softer light from the other head, gives a modeled early-morning light. By bringing a gold fill card in from the front right side, I was able to control the warmth and strength of the shadows. I used a CC10R filter with a coating of hairspray to soften and warm the image."

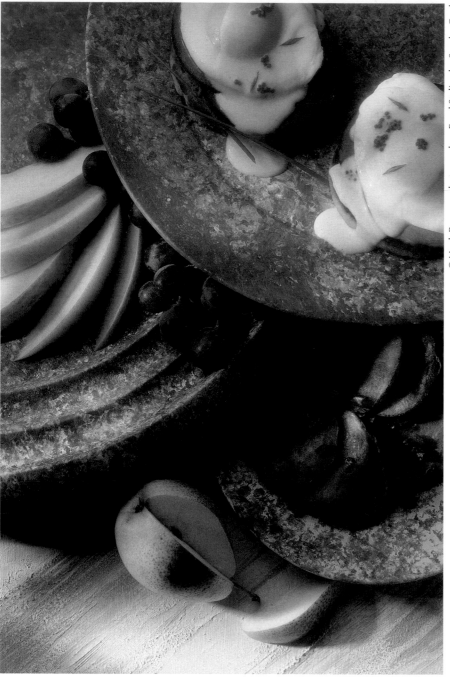

Title: Eggs Benedict

Purpose/Client: Series on food and graphic shapes

Camera: Toyo

Lens: 240 mm

Film: 8 x 10 KODAK EKTACHROME 64 Professional Film / 6117 (Daylight)

Lighting: Two 2400 WS Comet Strobes

Exposure: f/32

Abby Sadin

"I wanted to come up with a different way of shooting a commercial stove, so I thought of showing the shadows of the pots and pans and the actual food flying out of it. Quartz lights seem to work better than strobes for throwing shadows in a small area. We hung the pots and the food with monofilament line. It took forever to hang all the stuff the way we wanted, using super clamps as counterweights. The most difficult parts were getting the pasta just right and lighting everything so that the monofilament line didn't show. We dull sprayed the monofilament line to help subdue the reflections."

Title: Flying Food

Purpose/Client: Sample photo for Majestic Stoves

Camera: Sinar f

Lens: 150 mm Rodenstock

Film: 4 x 5 KODAK EKTACHROME Professional Film / 6118 (Tungsten)

Lighting: 3200 K quartz photogenic inky lights, 200 watts and SV SA scoops, 250 and 500 watts; eight lights, seven inkies, and one scoop

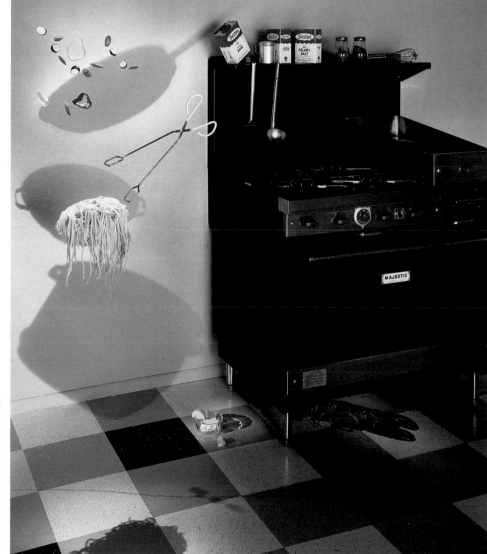

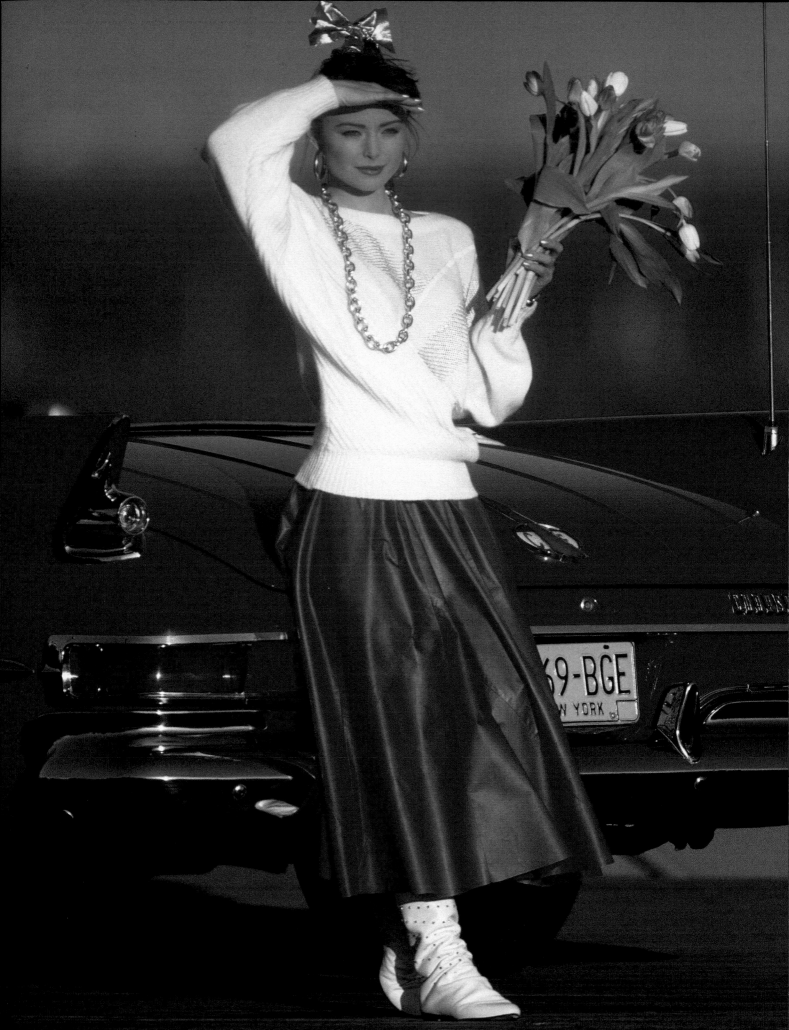

Models and Fashions

Perhaps the most challenging of all commercial photography involves working with models. Many professional photographers are uncomfortable with models—uncertain about directing, posing, lighting, and interacting with the models. If you fall into that category, the following information should help.

PROFESSIONAL OR AMATEUR MODELS?

Professional and amateur models both have their advantages and disadvantages. If you hire professional models through an agency, the agency not only will have screened the models for appearance but also may have trained them in modeling skills. In addition, an agency can often provide a backup if a model becomes ill, is a "no-show," or proves unsuitable. Of course, professional models command high fees, and the agency takes its cut too.

The amateur model is someone *you* find and train to work with you. This can be time-consuming. You will spend many hours looking for and interviewing candidates. Because they will be untrained, they will require more direction from you, which translates into longer shoots. In spite of these disadvantages, some photographers prefer to train their own models because they can mold them to suit their specific shooting needs and temperament. Also, inexperienced models usually mean lower fees. In fact, many people are thrilled to be asked to model, and will often "jump" at the chance for the experience no matter what the pay. Some will even agree to model in exchange for copies of the work for their own portfolios.

Keep in mind, though, that if the model becomes ill, you may be in a pinch to come up with a replacement at the last minute. That could be costly in the end if you have already hired a stylist and an assistant, rented props, etc. You could even lose the client if you are unable to deliver on time. And once the models become more experienced, they may either demand higher fees or simply move on.

Whether you choose to hire through an agency or find your own models is a personal choice. As long as the model is effective in your photographs, use whatever type of model works best for you.

Avoid the agency or charm school that also advertises as a model school and charges for enrollment and training—you may get amateur models, sometimes without any real photogenic qualities or acting ability, at professional rates. Limit your dealings with such agencies to offering to test-shoot their pupils if you find their existing photographs promising.

Selecting the Model

What do you want to convey in your photograph? A model selling toothpaste with "sex appeal" projects a message differently from that of a model showing conservative office attire. Describe to your agency the type of look you want the model to convey. The agency should let you look through their file of portfolios or screen a few models. Select the model who best conveys your message, both by appearance and in acting ability. If you decide to find your own models independently,

remember that the model's ability to move well and respond to the camera can be more important than experience. You may want to conduct a screening or casting session by shooting some test shots of each applicant. If any of the models you interview claims to have modeling experience, ask to see a portfolio.

The Relationship

Do not be afraid of your models. Many photographers become quite nervous when planning for a model, feeling as though they have to play the "pro." Chances are that your model is more nervous than you—after all, the model is in front of the camera. If you are tense, it may project onto your models and they may look tense. Relax your model with casual chat while you are preparing the set. This will also help relax you. Go over the assignment to prepare for the poses required. Helping your model to feel at ease and enjoy the shoot are important in obtaining natural-looking poses and successful photographs.

The more you praise while you work, the better the reaction. When your model feels good, he or she will *look* good. It helps to build a good rapport.

You are the boss; you must remember this when you work with the model. While he or she may have learned how to pose, it is your job to direct the session.

Remember that you are not only selling your client's product, you are making a statement to our society. When a model appears on the cover of a magazine or in an advertisement, the model is seen by many as the prototype—the role model of what other men or women "should" look like. (This, of course, is one of the main reasons why others will purchase the product.)

Photo on opposite page by Butch Hirsch.
© Butch Hirsch, 1988.
Technical information on page 155.

When things go right, you'll obtain the results you want quickly, but during that short period, it should be as if a tunnel exists between you and the model. Nothing else intrudes. This is the magic that happens when you've mastered good interaction with your models.

Children

Working with children is usually more difficult than working with adults. Above all, it takes patience. Have an assistant available to entertain the children or to keep them occupied when you are not shooting. A child's attention span is short. If you learn to work well with babies and children, you can probably handle adult models with ease. You will have learned to work quickly, both in creating reactions and in taking the photos.

Be prepared for a child who might get tired and cranky from the excitement and the many required poses. Also, be certain that the child has gone to the bathroom shortly before shooting, so that no "accidents" will occur on the set due to excitement.

When your young models have to stand in a certain spot, you may want to remove their shoes and nail the shoes to the floor. Another less permanent technique is to use hot glue. Then the child can step into the shoes and remain in place while you photograph. You can prefocus on a stand-in, and substitute the child when you are ready to shoot.

A mother can be a bane or a blessing when you work with a baby or young child. If you want a baby's look to be quizzical or upset, remove the mother from sight. Want a smile? Bring the mother back. You can obtain the same reaction by using a toy the child has been playing with.

Just be certain you don't go so far as movie directors once did to get a reaction from a child star. The classic story is that of the director who wanted Jackie Cooper, then a small child, to cry during the filming of the movie "The Kid." Cooper wouldn't cooperate, not knowing how to shed tears when he felt quite well. As a result, the director informed Cooper that he was going to shoot the boy's pet dog. The fear generated tears that allowed the director to get the shots he wanted.

Sometimes you or your assistant will have to get down on your hands and knees and communicate at the child's eye level. You'll sometimes even have to make a complete fool of yourself. But the indignity can be well worth it when you capture that special, selling photograph.

SHOOTING FOR FASHION

The clothing your model wears can be critical in a photograph. This is true whether the clothing is the subject of the photograph or incidental to the scene. Most often you will hire the services of a clothing stylist to choose or handle the clothing. But it is still important for you to know the basics.

When the clothing is the subject of the assignment, several concerns arise immediately. The first is the care of the garments. The clothing will usually be off the rack, and will have to be sold as new after the shoot. Any damage to the clothing may be charged against you.

With any clothing assignment, it is a good idea to request that a representative of the manufacturer, the specialty store, or the fashion department bring the clothing to your studio or location. This individual will transport the clothing, oversee the dressing (when possible), and help protect the garments during the shoot. You greatly reduce your personal liability when you have such assistance.

Your model must never wear the clothing while traveling to a location or do anything to wrinkle or soil it. He or she must wear sweat shields to protect the underarms of the clothing. Your model must also stand when not posing; sitting or reclining in the garment is permitted only if such positions are required for the photographs. The clothing supplier will not want to have to clean or press a garment when you have finished.

Professional models normally prefer to work in the morning, when their figures have the best tone and hair and skin are refreshed. Your model should have an even suntan for swimwear, backless, or lingerie shots. Never assume that a model will not have a birthmark, freckles, or a scar that's normally hidden but that may be exposed by the pose you want. Check with the agency.

Have plastic spring-type clothespins available; your stylist will need them to adjust the fit of the clothing. Since the model will be wearing a standard manufacturer's size, alterations to the waist, the bust line, etc, may be necessary. By bunching the clothing together in back, out of the camera's view, then clipping the material with the clothespins, you can alter the garment for the best visual effect.

Another trick is to use tissue paper to fill out any portions of the anatomy that may be lacking naturally. When the modifications are complete, the model will look perfect in the outfit. Remember that your goal is to make the model look terrific, so that the viewer of your final photograph will feel that he or she will look great in the same outfit!

Facial cosmetics are a constant danger for clothing. Your model should put on makeup before dressing. If the garment has to be pulled over the model's head, place a

towel or pillowcase over the model's head before putting on the garment. The stylist or store representative should help the model to ensure that the clothing is not soiled. If a touch-up of cosmetics is needed later, your model can either remove and replace the garment in the same way or use other large towels to cover the clothing while the touch-up is applied. Most makeup artists bring along capes to wrap over the model's shoulders without disturbing the clothes.

Many of the same precautions apply when your model brings personal clothing to use in the shoot. Damage to the clothing in transit is not your responsibility. But any damage, especially from cosmetics, may show in your photos. The care of the clothing should be the same as that for clothing supplied by a manufacturer or department store. Ask the model not to wear the clothing to be used in the photo session when traveling to your studio or to the location. If you're shooting in the studio, you can easily iron the garments, but on location, pressing the clothes may not be possible.

Whenever possible, employ hair stylists and makeup artists to assist your models. The hair stylist can be crucial, because many female models do not know how to vary their hairstyle effectively. They may know one or two of the latest styles, but they may not know how to use them most effectively for the photographs *you* want to take. A makeup artist is valuable for similar reasons.

The Color of Clothing

The color of clothing affects the viewer (and the wearer) psychologically. Warm colors, such as red, orange, and yellow draw the eye. Cool colors, such as blue and green do not. Colors convey messages. For example, black can be seductive and red can be fiery (more mature

colors), while pastel colors are soft and soothing (romantic or youthful colors).

To see how perceived distance is affected by color, take two identical objects—one blue, the other red—and place them side by side. Then step back from them and you will see that the red object seems closer than the blue one, even though they are at the same distance. This has important application when you are working with a model in commercial photography.

For example, suppose the model is holding some towels and the object of your photograph is to sell those towels. If the towels are cool in color and the model is wearing warm-colored clothing, the viewer's eye will be drawn to your model's clothing, not the product. Or suppose you have an array of similar products all on the same visual plane. By varying the colors you can create a three-dimensional effect.

If you are uncertain about using a color in a set, close your eyes as you position yourself at the camera viewfinder or ground glass. Then open them suddenly. What is the first object you notice on the set? If you are drawn to any area that is not what you are trying to sell, you must rework the colors.

Keeping the Fabric Attractive

You or your stylist must check for the fit of the model's clothes. You may need as much as thirty minutes after the model is positioned on the set before you start to photograph. This is a time when you will be removing wrinkles, checking the way the fabric hangs, checking the relationship of front and back hems, and other details.

Suppose your model is wearing a skirt. If she stands with one leg slightly in front of the other, her knee will inadvertently create a small bulge in the fabric (known as a "bell"). This is an awkward line that may look exaggerated in the photograph. Adjust this to make it smooth.

When your model poses, inspect the folds of the fabric. When he or she bends an arm, a fold will naturally form at the elbow. Readjust this carefully until the fold seems to create a fluid motion from one part of the body to another. If you ignore this, that natural fold can look like a crease or appear as stiff as armor. It will take a few minutes to work with the fabric, but the result will put your work ahead of those who don't bother with details.

Some photographers or stylists buy a few yards of fabric, and practice making folds that are soft and smooth, without stiffness or sharp creases. You can use pins and tape to hold the fabric together, practicing until you achieve the effect you want. This will give you some experience before you actually have to work with a model.

Detailing

Place your model so that he or she is in the approximate position for the final photograph. Determine your camera angle. Then use spring clothespins, straight pins, and tape to correct problems with the details of the clothing as it hangs on your model. Remember that even if it takes twenty or thirty clips out of the camera's view to make the garment fit properly, it's important to do the job right.

The hemline of a dress or skirt may be uneven. Look for the back hemline drooping below the front hemline or one side reaching lower than the other. Because it is your job to portray the garment at its optimum, you must adjust the hemline until it looks even. Use spring clothespins or straight pins to adjust the problem area, and make sure the pins are out of view.

Men's permanent-press slacks represent one of the greatest challenges you will face in fashion photography. The simple act of bending a leg will inevitably crease or bunch the fabric.

One way to fix this problem is to cut off the pant leg on the side where the model's leg will be bent. This means that when he comes onto the set, he will be wearing a pair of pants with one leg attached to the fabric, the other leg held on by hand. Then drape the loose pant leg the way it should look, tucking and pinning the cut line into what would normally have been the fold. Remember to first check with the manufacturer before you destroy the pants. And, of course, if the pants are rented, this technique is out of the question. An easier approach is to use poses in which the legs don't bend. This may be simpler than cutting the pants, but it may not be so effective for the look you want.

If the model has a pocket that must show, you may want to have the model's hand in the pocket. Most people will rest the hand inside, pushing down and creating wrinkles. Instead, have your model's hand positioned lightly so that the proper line is maintained.

Backlight the hair when appropriate—for example, to add form and separation of the head from the background. However, be aware that strands of hair will suddenly appear where they do not belong. Have the stylist ready with a comb, brush, and hair spray. Or you can quickly correct this by cutting off the loose strands (with permission, of course).

Shoes are always a concern, even if they are not part of the scene, because of the damage they can do to the seamless background paper. Unless the shoes are brand-new, they can leave dirt marks. If you are not showing the model's feet in the photograph, ask the model to remove shoes before stepping onto the background. If the shoes must show in the picture, you can prevent damage by covering the bottoms with masking tape and making sure the model doesn't step off the clean seamless paper before the shoot is finished. When taking a break, ask your model to take off the shoes and leave them resting on the background.

If shoes are featured in a photograph, your lighting should include a highlight along the instep to give the shoes a three-dimensional look. If you are photographing shoes alone, do whatever is necessary to give them proper form. This may mean stuffing the toes, using stiff wire and masking tape, or any other technique that gives the proper effect.

If you include the model's ankle in the photograph, one way to keep veins from showing is to place the model's bare feet in a bucket of ice water. Do this approximately ten to fifteen minutes before you start photographing. Between shots, have your model lie down with feet in the air. The colder the feet remain, the more time you have before the veins start to show again.

Ice water also prevents veins from showing on a model's hands. Have the model hold his or her hands in the air, shaking them lightly between photographs. When the model lowers them for the photograph, they will appear smoother. Hands are especially important in fashion photographs because they are often prominent. Your model must be trained to use attractive hand positions and to avoid fists, claws, "banana bunch," and limp-hand poses. The actor's technique of closing the fist with the thumb held straight and then uncurling the fingers progressively, starting with the forefinger, produces good hand position.

You can build a frame with 2 x 4-inch boards wrapped with foam rubber for your model to lean against when you are recording just feet and ankles. This makes the shooting more comfortable for the model.

Helpful Tips

Place a mirror near the camera so that the model can make last-minute checks. Then remove or completely cover the mirror while you work. Otherwise the model might watch the mirror and respond to the reflection rather than to you and the camera.

If you have a video camera, mount it in tandem with your still camera, letting it run while your model poses. Do not hook up the monitor immediately, though. When you take a break to alter the set, change film, or take a break, let your model see the playback. The model can review the poses to see which ones worked best.

Is there a clothing store or boutique near your studio? If there is, establish a relationship with the owner so that you can borrow or rent clothing inexpensively in case you need to supplement your model's wardrobe when he or she is bringing the clothing.

Use low-level modeling lights. This will increase the dilation of the model's pupils, usually enhancing the model's appearance.

Keep a fan on the set to keep the models cool.

Butch Hirsch

"This photo was a special challenge because of the very unusual wedding dress by a new, young, creative designer just graduated from F.I.T. Because it was not a traditional dress, I could not shoot it in a "traditional" setting. The Rolls is a flower car from the Queen Elizabeth procession (only one of five left). The doors of the church were hand-carved and are very ornate, but not overpowering to the design of the dress. I created a very delicate balance; I did not shoot it in the usual way that a wedding dress would be shown, but I still created a fantasy that would appeal to women."

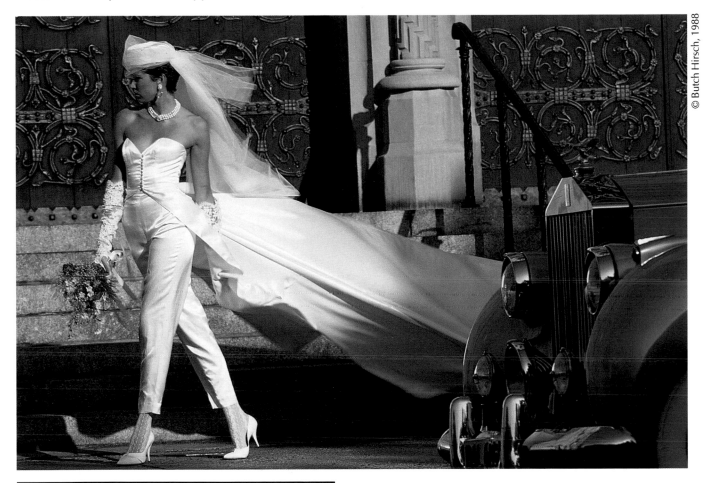

Title: Wedding Dress at Church

Purpose/Client: Debut of a new designer

Camera: Nikon

Film: 35 mm KODACHROME 64 Professional Film (Daylight)

Lighting: Available light; late-afternoon sun for warm color temperature, light reflected into the subject with gold reflector

Beth Bischoff

"We had just finished a day of shooting in the Italian countryside for a fashion editorial. While stopping for gas on the way back to the hotel, I noticed an abandoned farmhouse at the side of the road. We ran in and, just as the sun was slipping away, captured the last bit of golden light."

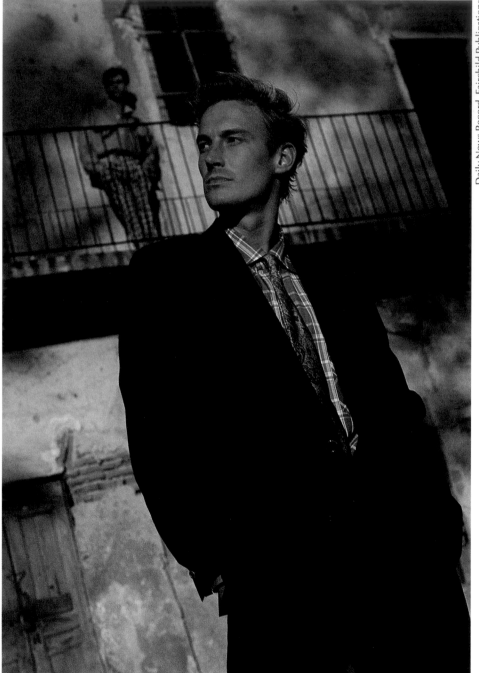

Daily News Record, Fairchild Publications

Title: Untitled

Purpose/Client: Editorial to show Italian collection

Camera: Nikon

Film: 35 mm KODAK EKTACHROME 200 Professional Film (Daylight)

Lighting: Sunlight

Oudi

"The mountains were built with chicken wire and plaster of Paris. The backdrop was painted in the studio and draped a few inches above the floor. There was space between the mountains and the sky to put lights that illuminated the horizon line. I used three fans: one for the hair, one for the skirt, and one for the laundry line. In all, there were ten light heads—for the background, behind the mountain, for the horizon, on the model's head, on the model's lower body, and on the laundry and the foreground."

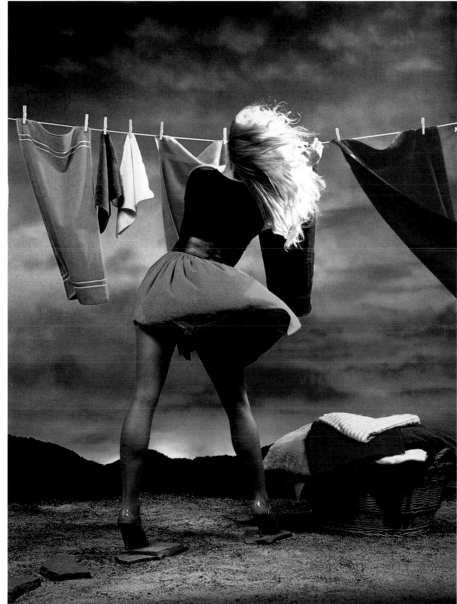

Title: Hanging Out

Purpose/Client: Poster Company and self-promotion

Camera: Nikon FM

Film: 35 mm KODAK EKTACHROME 64 Professional Film (Daylight)

Lighting: Two Speedotron packs, 2400 WS each, ten lights, four umbrellas

Dean Collins

"I made this photograph to test the new KODACHROME 64 Professional Film. The image was to be colorful and saturated to show off the qualities of the film. The photo was done by using spot grids almost exclusively, with the exception of a medium Chimera soft box overhead to provide separation from the background."

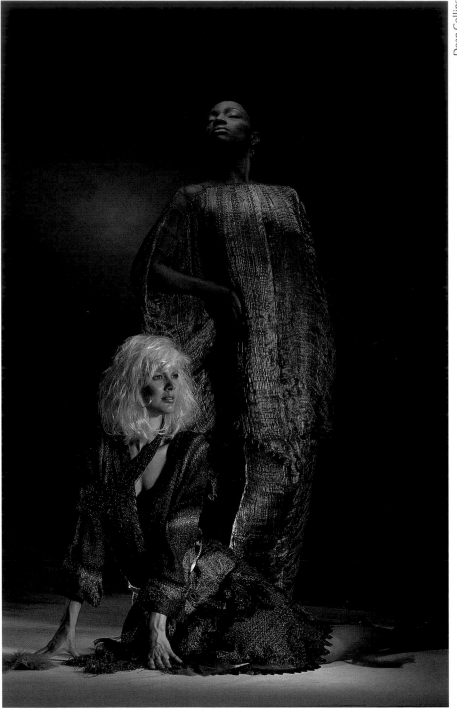

Dean Collins

Title: Denise & Nicolene

Purpose/Client: Test new KODACHROME Film for Kodak

Camera: Hasselblad 2000FCW

Lens: 150 mm, f/4, Zeiss

Film: 120 KODACHROME 64 Professional Film (Daylight)

Lighting: Broncolor Pulso 4 (two packs), five heads totalling approximately 4000 WS

Exposure: 1/60 second at f/11

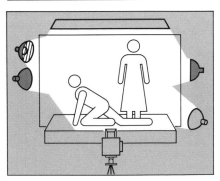

Hans Neleman

"I shot this photo on a merry-go-round in New York City. I surrounded the scene with five white umbrellas on two 2400 WS packs, and shot it in a very straightforward way, without filters."

Title: Children's Fashion

Purpose/Client: Ad for Yves Saint Laurent

Lens: 60 mm

Camera: Hasselblad

Film: 120 KODAK EKTACHROME 64 Professional Film (Daylight)

Lighting: Two 2400 WS packs, five heads

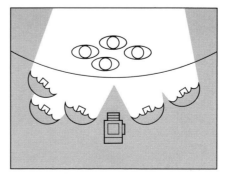

Struan Campbell-Smith

"The main light with one umbrella was above the camera and directly in front of the model. There was a smaller umbrella under camera level with one-half the power of the top main umbrella strobe. The model held the lipstick with her elbow resting on her knee for steadiness. Wind from a fan blew into her face to brush her hair back. I turned off the modeling lights and the first exposure (strobe) was made (approximately f/8 on 'B'). Once the strobes had fired, and with the model still not moving, I removed the Softer II filter from the lens. Immediately, my assistant (dressed completely in black) jumped in behind the model with a penlight covered with a red gel and drew a zigzaggy line from the lipstick to the model's lips. Then I closed the shutter."

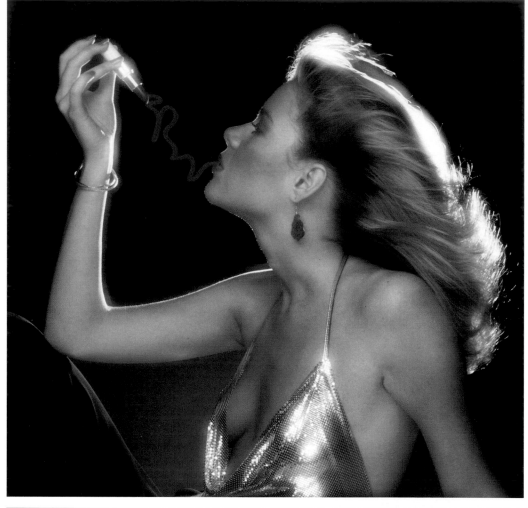

© Struan

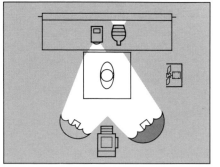

Title: Lipschtick

Purpose/Client: Idea for Avon Cosmetics in New York

Camera: Hasselblad

Lens: 150 mm

Film: 120 KODAK EKTACHROME 200 Professional Film / 6176 (Daylight)

Lighting: Speedotron 2400 Packs and four heads; 800 WS on main, 400 WS on small umbrella, 400 WS on background, and 800 WS on hair

Exposure: "B" at f/8

Struan Campbell-Smith

"I had planned to shoot fashions for Wardair and Ports International at a cock-fighting arena in Sosua. It was so crowded I decided to wait until the crowds thinned. To pass the time, I walked around the town photographing the models following me through the streets. At one point, I stopped in front of this colorful shack that was a bar. I placed the male model in the doorway. I had him remove his white jacket, shirt, and tie and put on an undershirt. As we prepared the shot, the female model bent over to have the hairdresser brush her hair. When she straightened up, I noticed the hair fly up and decided to use the hair action. I liked the way the hair partially covered the male model, adding mystery. I decided to use a slow shutter speed to add extra motion to the hair. The model had to stop her head abruptly to freeze the face while her hair continued its motion."

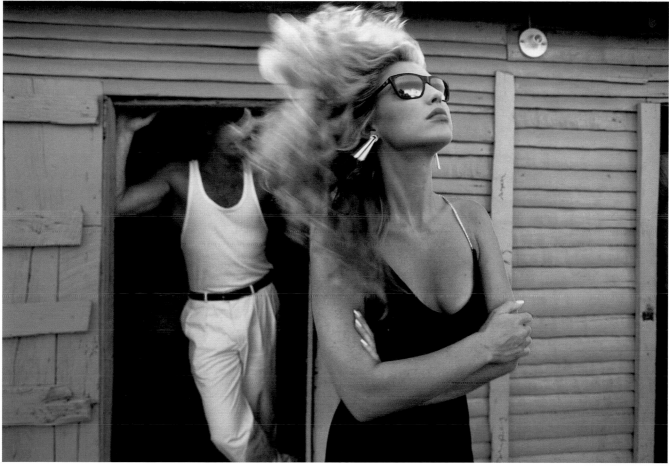

© Struan

Title: Sosua

Purpose/Client: Self-promotion (in *Applied Arts* magazine)

Camera: Nikon F3

Lens: 24 mm

Film: 35 mm KODACHROME 64 Professional Film (Daylight)

Lighting: Available light with help from a silver reflector

Exposure: 1/60 second at f/4

Struan Campbell-Smith

"I had to be careful how I handled this. I not only had to put a woman in the shot, but also had to depict the world of commercial photography, illustration, and design on an international level. I didn't want it to look like a fashion magazine cover or something too contrived or busy. I thought of paint brushes, film strips, etc. In the end, I decided to keep it clean and simple. I had intended to put the dove on the model's head much like pigeons on a statue but found it to be too much. I took one shot with the dove in hand for the record."

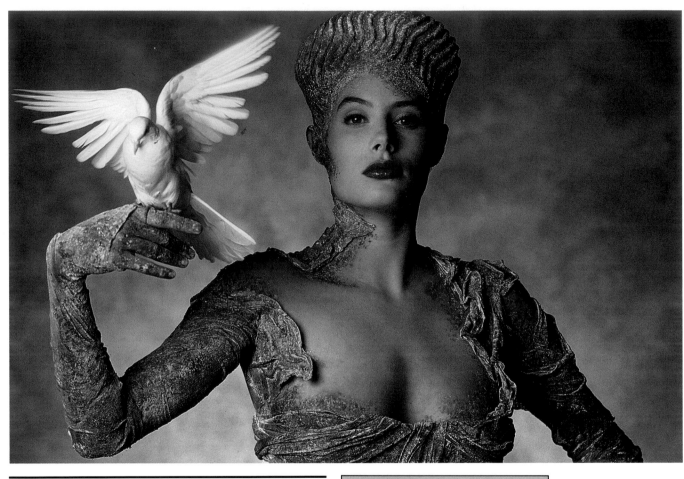

© Struan

Title: Untitled

Purpose/Client: Cover for *Creative Source Annual '88* (9th edition)

Camera: Nikon F3

Lens: 105 mm Nikkor

Film: 35 mm KODACHROME 64 Professional Film (Daylight)

Lighting: Speedotron 2400 WS packs, 2 heads; umbrella on main light, 400 WS, open head with 40 grid on background, 400 WS

Exposure: "X" at f/11

Dick Zimmerman

"The client wanted to communicate a strong, sensuous, and mysterious woman—a free spirit—who could spontaneously throw a fur coat over an undressed body, jump into her Corvette, and perhaps be waiting for her boyfriend at an undisclosed destination. I photographed this in daylight at about 4:00 p.m. The sun was not in the correct position for the proper background; a mirror was the only source of front light. The sun was behind, lighting the car and her hair. Because I used a mirror to reflect the bright sun, the model was unable to look at the camera without squinting; thus the side look, which in a way added to her mystery."

Dick Zimmerman

Title: Mystery Rendezvous

Purpose/Client: Fashion shoot

Camera: Hasselblad

Lens: 200 mm

Film: 120 EKTACHROME 64 Professional Film (Daylight)

Lighting: Available light, with mirror reflector, #1 soft R filter, Niko LMC-Sky 67 filter

Jock McDonald

"This photograph was taken as an analogy of form: the texture of the vase repeated in the texture of the fabric on the model. Simplicity is paramount. There was no filtration or retouching in this photograph."

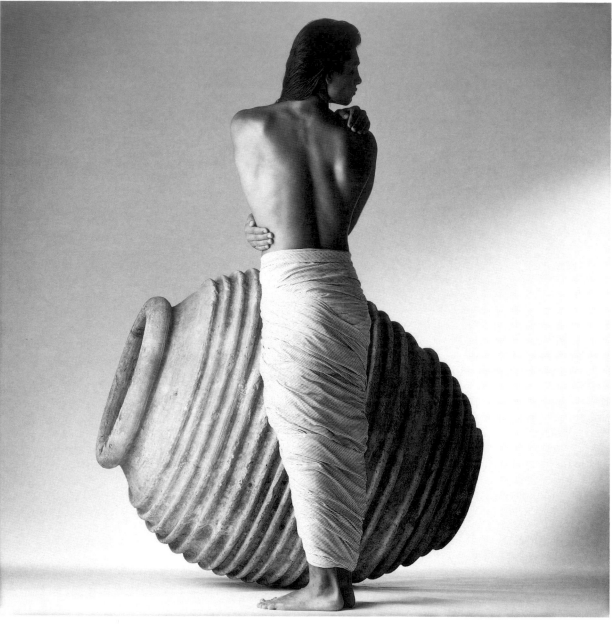

Title: Vase

Purpose/Client: Britex calendar to promote fabrics

Camera: Hasselblad

Lens: 120 mm

Film: 120 KODAK PLUS-X Pan Professional Film

Lighting: Main light—Broncolor softbox, 1600 WS; background light—reflector with grid spot

Exposure: 1/125 second at f/6

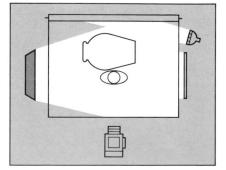

Ken Nahoum

"I was given only five minutes to do the shot as the star smashed the screen."

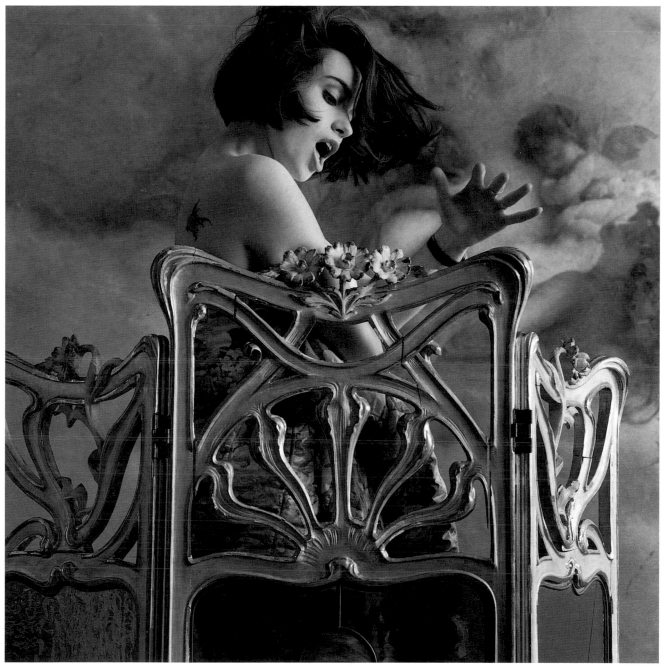

Title: Beatrice Dalle

Purpose/Client: Vanity magazine

Camera: Hasselblad

Film: 120 KODAK TRI-X Pan Professional Film

Lighting: Four to five strobes

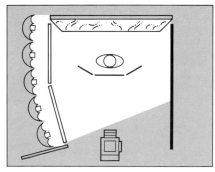

James Caulfield

"There was no client other than the designer from whom we borrowed the clothes. I used a Harrison #3 fog filter. The illumination was natural light—the setting sun coming through the windows. I bounced one strobe off the ceiling and walls to fill in shadows and soften the contrast."

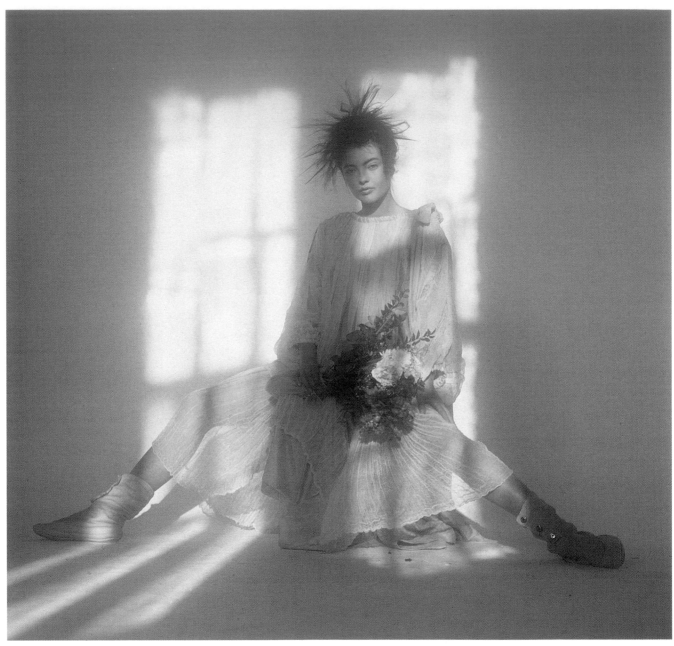

Title: Woman Holding Flowers

Purpose/Client: Portfolio

Camera: Hasselblad

Film: 120 KODAK EKTACHROME 64 Professional Film (Daylight)

Lighting: Speedotron black-line strobes

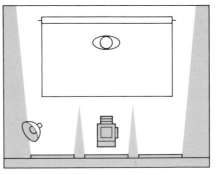

James Caulfield

"The client wanted only to make an abstract fashion statement; the rest was left up to me. There was no retouching, no filtration, and no special technique."

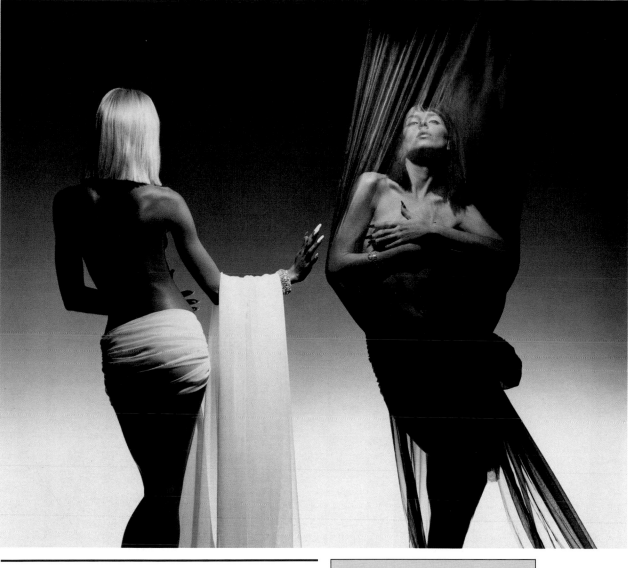

Title: Chicago Art Institute Poster

Purpose/Client: To publicize annual Art Institute fashion show in Chicago

Camera: Hasselblad

Lens: 150 mm

Film: 120 KODAK PANATOMIC-X Professional Film

Lighting: Speedotron black-line strobes

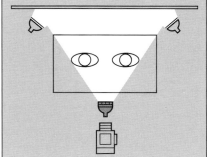

James Caulfield

"There was no client, no retouching, no filtration (other than color compensation), and no special technique. Lighting was tungsten on daylight film with a CC20B filter. The model was lying on the background, flat on the floor. Lighting came from high overhead."

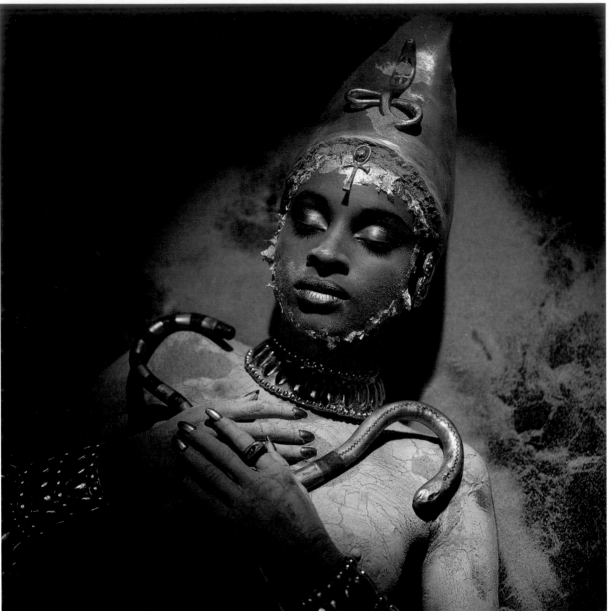

Title: Egyptian

Purpose/Client: Self-promotion

Camera: Hasselblad

Lens: 250 mm

Film: 120 KODACHROME 64 Professional Film (Daylight)

Lighting: One tungsten ellipsoidal spot, 1000-watts

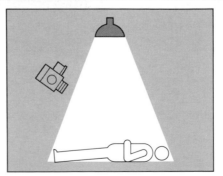

Neill Whitlock

"This photograph is one in a series for a magazine based in Dallas called *Detour.* The story was on lingerie gifts for Valentine's Day. I was trying to approach lingerie in a very romantic—but natural—way. I used available light."

Title: Detour 1988

Purpose/Client: For *Detour* magazine article

Camera: Nikon F3

Film: 135 KODAK T-MAX 400 Professional Film

Lighting: Available light

Bill Tucker

"This photograph is one of a series of illustrations that we did for special introductory pages of the Sears catalog. The challenge here was to show the client's products (towels, shower curtains, bathroom rug, and accessories) in a storytelling situation that allowed the young Chico and the dog to be spontaneous and natural."

Title: Untitled

Purpose/Client: Illustrate Sears line of bathwares

Camera: Hasselblad

Film: 120 KODAK EKTACHROME 64 Professional Film (Daylight)

Lighting: Dyna-Lite heads, 750 WS and 250 WS

D.W. Mellor

"I used Comet strobes in a Chimera as a side light with a fill card. I hand-painted the background myself."

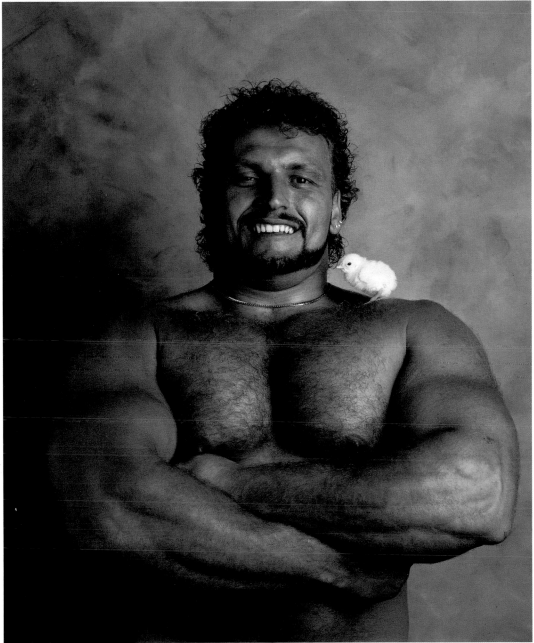

Title: Muscle Man

Purpose/Client: Self-promotion

Camera: Sinar

Lens: 210 mm

Film: 4 x 5 KODAK EKTACHROME 64 Professional Film / 6117 (Daylight)

Lighting: Two Comet strobes, 2400 WS, 5000 K

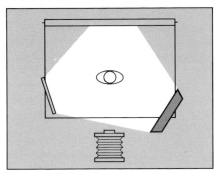

Bill Werts

"I had stepped outside my studio for a look at the daylight one afternoon when a street person came up and asked me for a quarter. I was immediately inspired by the character and appearance of the man. I invited him into the studio to take his picture. As I was setting up my lights, I came up with an idea to use an electric shaver as a prop. The light source was a light box placed just outside the frame at the side, giving a heightened sense of drama and bringing out the fantastic texture in his face. I placed a fill card on the right side just close enough to add the slightest bit of detail in the shadow area. The print was toned with KODAK Sepia Toner."

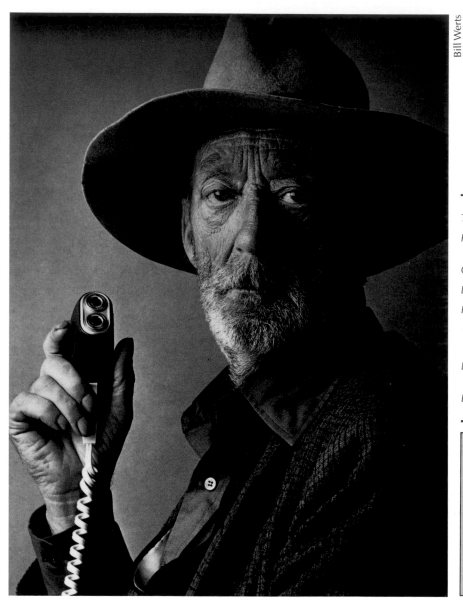

Bill Werts

Title: Old Man

Purpose/Client: Self-promotion based on inspiration

Camera: Nikon F2

Lens: 105 mm Nikkor

Film: 35 mm KODAK TRI-X Pan Professional Film (rated at ISO 1200, processed in KODAK HC-110 Developer)

Lighting: Two Norman Heads, 400 WS, each in a 4 x 4-foot light box

Exposure: 1/60 second at f/8

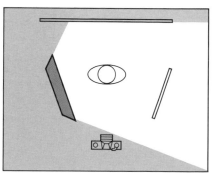

Sam Campanaro

"Our stylist from New York City, Mariza Escobedo, photographed several punks from Greenwich Village. Max was selected because he was cooperative and receptive in accepting our suggestion to dye his hair three different colors—green, blue, and purple. The background was vinyl covering with a rough stucco design. We then spray-painted the graffiti in colors to match the model's hair and jacket. The clothing and jacket decorations were selected from the model's possessions. Max did not allow us to disturb any of his pins or decorations on his jacket."

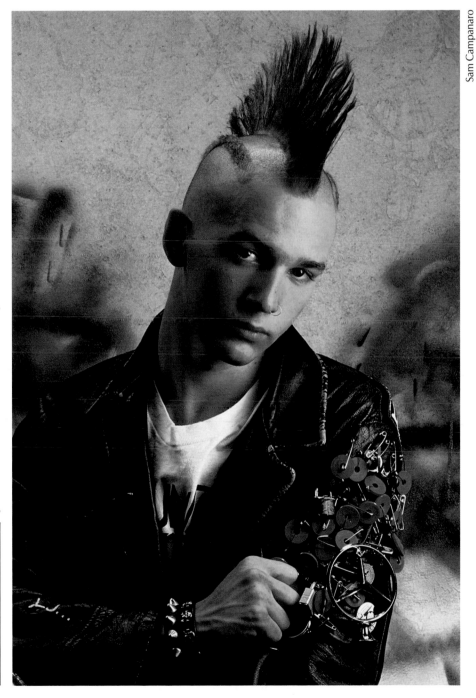

Sam Campanaro

Title: Max

Purpose: Product announcement exhibit

Camera: Nikon F-3

Lens: 135 mm Nikkor, f/2

Film: KODAK EKTAR 25 Professional Film

Lighting: Venca electronic flash, 1:3½ lighting ratio

Exposure: 1/60 second at f/5.6

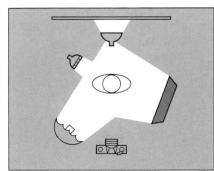

Interiors And Exteriors

Architectural photography is in demand regularly. Corporations use it for annual reports, for displays showing their facilities, and for advertising. Architects often want records of their accomplishments. Real-estate sales people use photographs to sell property and show buildings for lease. Government offices need record photographs of urban-renewal projects, rehabilitation projects, new buildings, and so on. Hotels need photographs for advertising. The list continues—but the important point is that the opportunities in architectural photography are many.

INTERIORS

You many be called upon to record two types of interior photographs. The first is the "straight" room photograph. You may have to record the entire room for a furniture advertisement, an interior decorator's record, a hotel advertisement, an editorial assignment, or some other purpose. Sometimes you may have to record only a section of the room. These photographs require you to show the subject matter as true to life as possible.

A large-format camera may not be vital for photographing some interiors. You are usually not dealing with strong vertical lines, such as the sides of a tall building, when you shoot inside a home. A tripod that you can elevate to six or seven feet or use at a low level will help prevent converging interior walls. You can also use a Hasselblad SWC/M with a 38 mm Biogon CF lens that is fully corrected for curvilinear distortion and has a 90 degree angle of view. Never use a lens like this below eye level for an interior, because the closest detail will invariably be the floor. Raising the

camera a foot or two above eye level changes the scale, perspective, and impact of the carpet and floor patterns dramatically, and avoids distortion of coffee tables, planters, and other low objects near the floor. Don't forget to include a small stepladder in your location equipment so that you can still see through the viewfinder after elevating the tripod.

You can record most of a room, even if you are working in a confined space, by using a wide-angle lens. However, be careful about distortion at the edges of the scene when you use extreme wide-angle lenses close to a wall. If the natural shapes and forms of the furniture or other objects are important to the picture, you may have to change the angle of view or move items to a different position. Sometimes you can create a better impression of a room's decor by moving key objects to form a new foreground. If you are shooting the interior of a large multi-level building, a view camera may be necessary to avoid converging lines.

In the second type of interior photography, the client allows you to be more creative—when the architecture is unusual and a dramatic photograph is in order. For example, the late architect Frank Lloyd Wright designed the inside of New York City's Guggenheim Museum in the shape of a conch shell that spirals upward and can be captured dramatically from the ground floor with a fisheye lens or attachment. With conventional lenses, you cannot capture the full impact of the museum's design. Your client may not be selling the building, but may simply need the photographs for brochures or promotional pieces. In this case the visual distortion is acceptable and may even be desirable. This can apply to exterior photography as well.

In other instances, you can give a slight downward shift to a perspective-control wide-angle lens to exaggerate the foreground and create impact while not changing the perspective of the building extensively. The result appears closer to what the eye would perceive.

EXTERIORS

Photographing the exteriors of buildings is relatively simple. In most cases you can use available light. You may need the swings and tilts of a view camera to obtain correct perspective, or you can use a 35 mm camera or roll-film camera if the client isn't concerned about perspective. When necessary, you can use perspective-control lenses on some 35 mm and roll-film cameras.

The time of day that you photograph a building will depend on your client's needs. Does your client want a dramatic evening photograph for a hotel advertisement? Keep in mind that a rain-slick street can add attractive reflections that enhance photographs. Or is it important to show an entrance of the building that catches direct rays of sunlight only at a particular time of day? Perhaps your client is an architect and it's important to show construction detail; sidelighting can sculpt and shape a building. Photographing on an overcast day can give soft, even lighting if you simply want a record shot and details are unimportant. You may want to try photographing under several different lighting conditions and to your client options.

Photo on opposite page by Abby Sadin.
© Abby Sadin, SPG.
Technical information on page 155.

At dusk, at dawn, or after dark, a building illuminated by floodlights, moonlight, and its own interior lighting can be captured beautifully with a time exposure. The mixture of types of light can add interesting colors to the photograph. Another technique is to make a double exposure: one at dusk to capture the detail and deep blue color of the sky; the second after dark to record the building lights.

You can even use daylight or tungsten film without corrective filtration, since it's acceptable to see nighttime exposures of buildings with many different types of illumination.

ABSTRACTS AND PIECES

While most of your assignments will require you to record an entire building, there are times when you can create unusual results by isolating sections or details. An interesting archway, a stairway design, or even an abnormal angle can make a strong photograph. Making a detail such as a cornice or decorative fixture more prominent can project a feeling about the origins or the current atmosphere of a hotel or other building.

Look for reflections in the building's exterior if it features glass, steel, or some other reflective surface. Or if the building you are recording is reflected on the surface of a nearby structure, photographing the reflection on the building could make an interesting approach. Water is another good source of reflections. Look for a viewpoint that shows a lake, river, or harbor reflecting the subject. At other times you may find a pool, a fountain, or even a puddle that reflects the structure. A photograph of the reflection or, when possible, the reflection and the original structure together, can be quite effective and unusual.

Lighting in Interiors

The biggest challenge in photographing interiors is lighting. Lighting from a variety of sources of different color temperatures such as daylight, fluorescent lights, and tungsten lighting can make film choice and exposure difficult. When possible, maintain control of the lighting yourself by using supplementary lights.

For example, suppose you have a combination of daylight and tungsten light filling a room. One approach is to use strobes to build the interior illumination to a level that matches the light coming from outside, and use daylight film to record the scene. Some photographers will even take along low-wattage blue bulbs and place them in existing room lamps. Be sure that the wattage of any bulbs you substitute is correct for the sockets and that the lampshades can handle them.

If strong window light is pouring into the room, you can use daylight film and keep the room lights on. Aim for proper exposure of the interior, and you will obtain a warm feeling from the tungsten room lights. You can use this approach only if accurate color of the fabrics and furniture is not essential.

Fluorescent lighting requires correction filters. When there is a combination of light sources including fluorescent, try to eliminate all but one type and correct accordingly. When you can't avoid the mixture of light sources, use additional lights so that one type of light predominates, and expose for that source. A room without windows or an isolated section of a room without windows is the easiest to photograph.

You can use several approaches for mixed light sources. All depend on the intended use of the photographs and the final look you want to achieve. The choice is yours.

NOTE: When you increase lighting in a room, be sure you will not diminish the interior designer's concept. Many times a restaurant is purposely dim to create a romantic mood. When you boost the light level in the room, even the color of the walls and fabrics may look different.

Furniture

When you photograph an entire room, illuminate each important piece of furniture. Whether you are in a client's home, a rented room, or a corner of your studio, light each piece carefully and then study the whole setting to be certain the overall illumination is even. If, however, you want to feature one piece in the room, you may want less light falling on other objects. Check your lighting in different sections of the room with your light meter to be sure you'll obtain the results you want. Based on meter readings, the featured piece should be at least one stop brighter than the other pieces.

Be alert to the angles and shapes of furniture. Sometimes an interior is best recorded from the entrance or from one side of the room. At other times, moving the camera higher or lower on the tripod gives you a more effective angle with the furniture as a design element. Study the curve of a couch or the arm of a chair, the relationship among the items in the room, and the other angles that present themselves as you work. Look at them from different heights through your viewfinder. Watch for reflections from shiny surfaces that may detract, and for fabrics in which you may have to emphasize or downplay the texture. Also watch for cords from household lamps and similar distractions.

Avoid distortion from wide-angle lenses. It may actually be better to create extreme distortion by using an extreme wide-angle lens than to shoot with a slightly wide-angle lens and obtain an almost normal, but uncomfortable, view. You may find that such planning and effort can result in more exciting images than you originally anticipated.

INDOOR/OUTDOOR PHOTOGRAPHS

At times you will want make a midday photograph of an interior that includes a window view. If you expose for the brightness and color temperature of the indoor illumination, the outdoor view will appear overexposed and blue. In this case you also can use strobes, but light the interior to provide approximately 1/2 stop less illumination than the outdoor lighting. When you expose for the indoor scene on daylight-balanced film, the outdoor view will appear slightly overexposed and quite natural. This is much easier to accomplish when the outdoor area is in open shade rather than in bright sunlight.

If you want to obtain an accurate rendition of an outdoor view through a window, or maintain the warm feeling from the room lights, use flash only as bounce or fill light. Do this by stopping down the camera lens one or two stops more than indicated by the flash calculator dial.

Another technique for lighting indoor scenes that include a window is to block out all natural daylight, and simulate light pouring in through the window with strobes set up outdoors. This gives you full control over your lighting. You can vary the amount of light pouring in, depending on the mood you want to create in the photograph.

Sometimes when you are photographing the outside of a building you will want to show part of the interior as well. In theory, creating the same lighting conditions outside and inside should work. However, it is more difficult to shoot from the outside in.

Bright sun can cause reflections off the glass windows. Making electronic flash two stops dimmer than the outdoor lighting is easy; making it two stops brighter, for a reverse effect, calls for sixteen times the power output!

The easiest approach is to work near dusk or dawn. There will be enough light to define the exterior clearly, but it will be close enough to the interior illumination for you to expose both easily. If you use a daylight-balanced film, you will capture the beautiful colors of the sky and a warm glow from the interior lights. Tungsten film can be very effective after sunset, especially in winter when there is snow on the ground; the blue tones look even more intense. At twilight, use low-wattage bulbs indoors to balance the natural lighting; the indoor lights still look warm on tungsten film.

INDUSTRIAL INTERIORS

Industrial interiors present several problems. Large older factories and warehouses may require extensive supplementary lighting. Because dangling cords from powerful floodlights create a potential safety hazard, you can use them safely only if few workers are present. Even taping the cords to the floor may not be adequate in a busy area.

Electronic flash equipped with slave units may be better for large interiors with lots of activity. You can attach the slaves to the walls, the ceiling, or almost anything, and avoid using hazardous cords. Whether you use floodlights or electronic flash, check for even illumination with your light meter. Also watch for unwanted shadows when you use multiple lights. The highest power output for factory interior shots is still provided by large, disposable flashbulbs in units such as the Bowens Blaster, which fires up to six bulbs simultaneously. This equipment lets you use apertures as small as f/22 in huge industrial interiors. But each exposure can cost about $20.00 and your light meter will not be useful for determining the proper camera aperture.

Plan to isolate sections of large industrial interiors. Look for interesting equipment, colors, shapes, and activities. Then move in close to photograph that particular section. This might mean focusing on a welder or a section of an assembly line, or recording a section of warehouse where products await shipment. Scanning the area for all possibilities before shooting will increase your chances for some unusual pictures.

The classic method for lighting a large industrial interior is simple. Use dramatic direct lighting for the foreground, and make sure it illuminates about a third content of the photo. Do not provide any supplementary lighting for the middle area. Devote the remaining lighting to the farthest background area (often the far wall). Light the background to a level slightly below that of the foreground to emphasize the depth of the interior.

Marshal Safron

"My style of work seeks to capture a scene as it actually looks to the viewer. Here, we have a balance of strobe fill and existing incandescent light. The artificial source of light—strobes—gives the viewer a natural feel for the space without over-lighting, a common problem. The outside exposure gives depth to the image and allows the light to look natural. I accomplished this effect with a slight time exposure of two seconds."

Title: Breckenridge Hilton Hotel, Breckenridge, Colorado

Purpose/Client: Interior design firm

Camera: Toyo

Lens: 90 mm

Film: 4 x 5 KODAK EKTACHROME 64 Professional Film / 6117 (Daylight)

Lighting: Four Norman AV 2000 WS strobes; two at 2000 WS and two at 800 WS

Michael Merle

"I wanted to document interior space, but at the same time, to make sure the glamour and subtlety of that interior came through. The dark walls on either side needed more light than usual to balance the light-colored rug and table as well as the pink room in the background. The placement of the camera was crucial to the symmetry of the composition. Too high or too low, or too far to one side or the other, would throw off the doorway-table-rug axis. This shot was symmetrical in nearly all its elements with one notable exception—the windows in the background room."

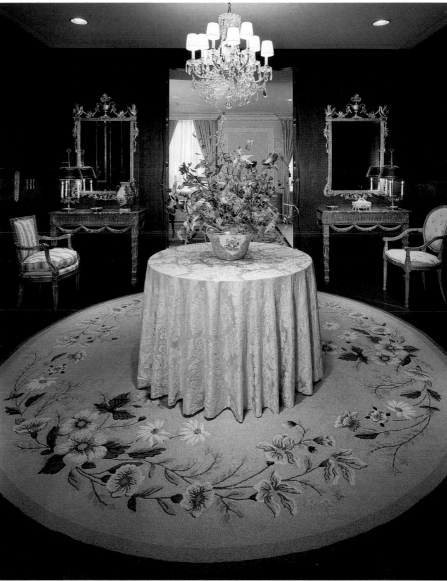

Title: Foyer/Round Rug/Table

Purpose/Client: *To document interior space and to advertise designer, designer's sources, or both*

Camera: Horseman 450

Lens: 90 mm, f/45, SW-Nikkor

Film: 4 x 5 KODAK EKTACHROME Professional Film / 6118 (Tungsten)

Lighting: Five lights; three 600 WS Omni lights; two 200 WS Mini Moles, all 3200 K

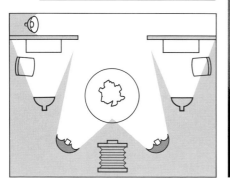

Jim Sims

"This photo is one from a series for a bank's annual report. The concept behind the series was for the bank to salute an area of Houston in which the bank had been located for several decades. (The bank had been acquired recently by a holding company.) I took this photograph in the entry arch of the Sallyport building of Rice University. The technique: to be in the right place at the right time and look at the lighting in an unusual way."

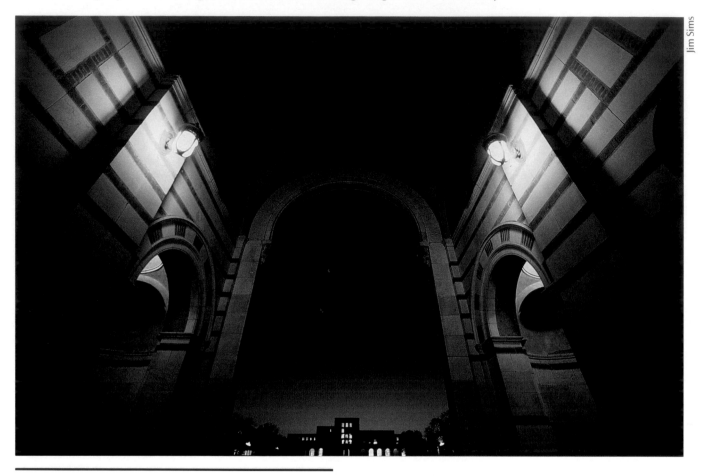

Jim Sims

Title: Sallyport, Rice University

Purpose/Client: Annual report

Camera: Nikon F2T

Film: 35 mm KODACHROME 64 Professional Film (Daylight)

Lighting: Available light

Abby Sadin

"A large, conical-shaped atrium serves as the lobby of this building; it sits on the corner and gives a nice panoramic view of the surrounding buildings. I aimed my camera down and shot the reflection of the architectural detail in the floor. This was an extra shot I did for myself while documenting the building architecturally for Skidmore, Owings, and Merrill. I enjoy doing simple detail shots that explain the essence of the design."

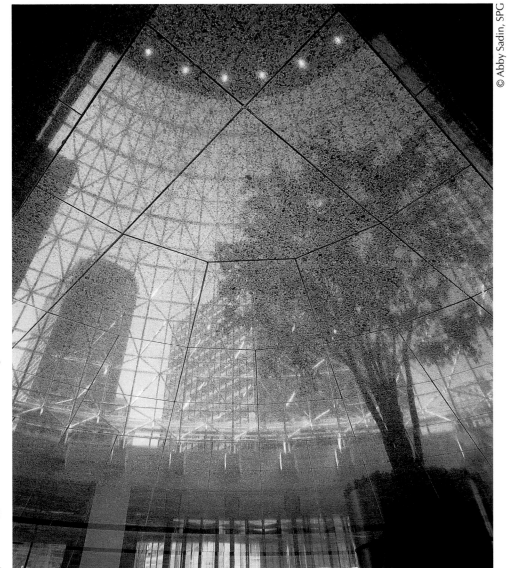

Title: Floor Reflection, 525 W. Monroe

Purpose/Client: Additional shot on architectural assignment—Skidmore, Owings, and Merrill

Camera: Sinar f

Lens: 90 mm Schneider Super-Angulon

Film: 4 x 5 KODAK EKTACHROME 64 Professional Film / 6117 (Daylight)

Lighting: Available daylight with CC10M filter

Abby Sadin

"The country club was recently restored to the elegance of the 20's and 30's. The ghosting images of the dancers were essential to create a sense of an era gone by. I used a tremendous amount of strobe to fill in the background. I also put a spot on each of the three areas where the strobes would stop. Once we got started, I realized the stop action of the strobes was giving too harsh a ghosting. I wanted something softer for the two side images that were closer. I stopped down and went for a time exposure. We brought the modeling light of the strobe head up close to the models and had them sway back and forth slightly to create the 'blurred movement' effect. We also turned on the chandelier lights to create a warm glow against the daylight."

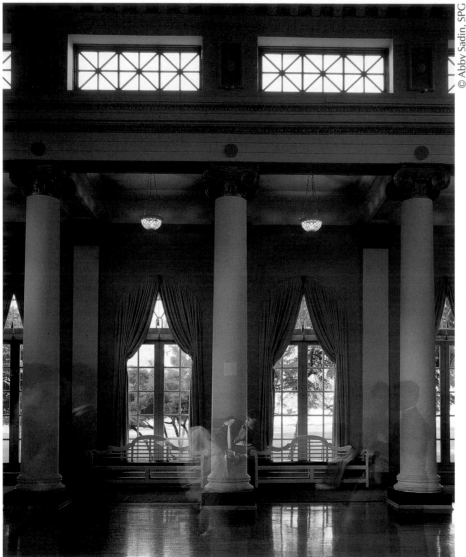

Title: Dancers, South Shore Country Club

Purpose/Client: Self-promotion

Camera: Sinar f

Film: 4 x 5 KODAK EKTACHROME 100 Professional Film / 6122 (Daylight)

Lighting: Three 2400 WS strobes, two 1600 WS strobes, two 1200 WS packs, seven heads

Abby Sadin

"I took this shot on location at Glessner House, an historically restored house that serves as the home of the Chicago Architecture Foundation. I worked to create the flavor of a period piece. One of my favorite details in the photograph is the way the flowers on the table almost blend into the wallpaper. That was very tricky to get just right. I also needed to convey the sense of a bright, light-filled, morning room. The room was actually very dark, so creating that impression was not easy. Seeing outside to the green was also important to the final effect. I achieved the proper lighting balance by controlling the strobes."

Title: Glessner House, Wallpaper

Purpose/Client: Product shot for the wallpaper company

Lens: 150 mm Rodenstock

Camera: Sinar f

Film: 4 x 5 KODAK EKTACHROME 100 Professional Film / 6122 (Daylight)

Lighting: Balcar strobes, three packs, 2400 WS, five to six heads

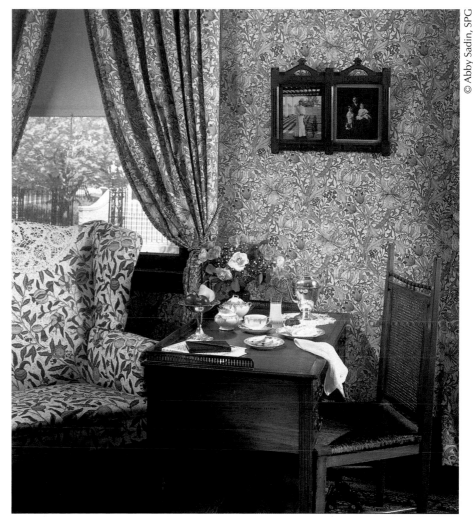

Joseph G. Standart

"The location was chosen for its scale, grandeur, and elegance. Designer Bill Walters redressed a library to be a bedroom. Because the location had 40-foot-high windows, we were able to wait for the late-afternoon sun to stream through a window as our main light. I used two strobes as fill lights to pick up the shadow areas. Because the client was concerned about correct product color, I balanced my two strobe lights (using ¼ CTO filters) close to the color of the sunlight. I then used a No. 82B filter over the lens to bring the warm light back to about 4700 K. I left the light a little warm for effect."

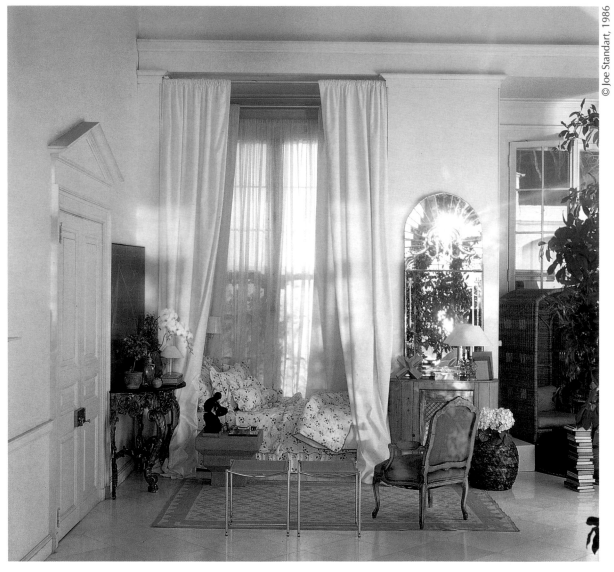

Title: Martex

Purpose/Client: National ad and semi-annual sales brochure for Martex sheets

Camera: Hasselblad

Film: 120 KODAK EKTACHROME 64 Professional Film (Daylight)

Lighting: Two packs, 800 WS

Ben Altman

"The green light comes from a single mercury-vapor floodlight on the tower. The yellow is sodium-vapor light. The misty effect comes from the thick drifting snow and the long exposure. I shot several sheets of film, but only this one had a pleasing distribution of mistiness. The lens vignette at the top adds to the mystery by darkening the irrelevant detail and completing the framing."

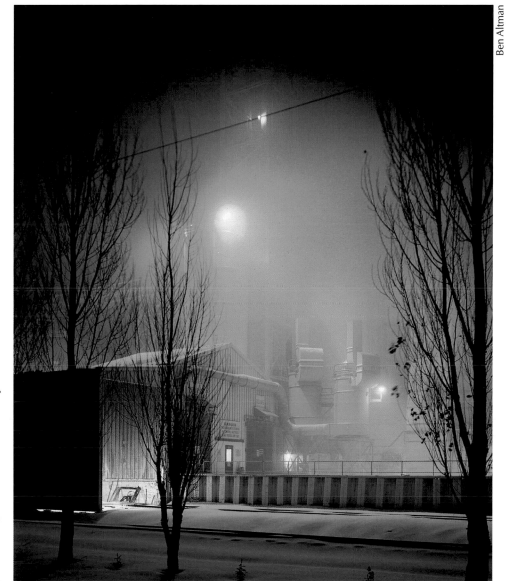

Ben Altman

Title: The Green Shot

Purpose/Client: For my commercial/industrial portfolio

Camera: Sinar

Lens: 135 mm

Film: 4 x 5 KODAK EKTACHROME 100 Professional Film / 6122 (Daylight)

Lighting: Ambient

Exposure: 8 seconds at f/16

Eric Oxendorf

"This building was erected amidst controversy, and when completed, the design was a bit radical for the location. Therefore, the clients wanted me to romanticize the building and to subdue its color. It was a difficult location—squeezed between two older buildings. One evening, an approaching storm front gave me the desired situation (long exposure and rapidly moving high-altitude clouds). Moving auto headlights added to the scene. I actually wanted the sky and cars to distract attention from the building. Using Type L film added to the blue of the sky and created the desired contrast."

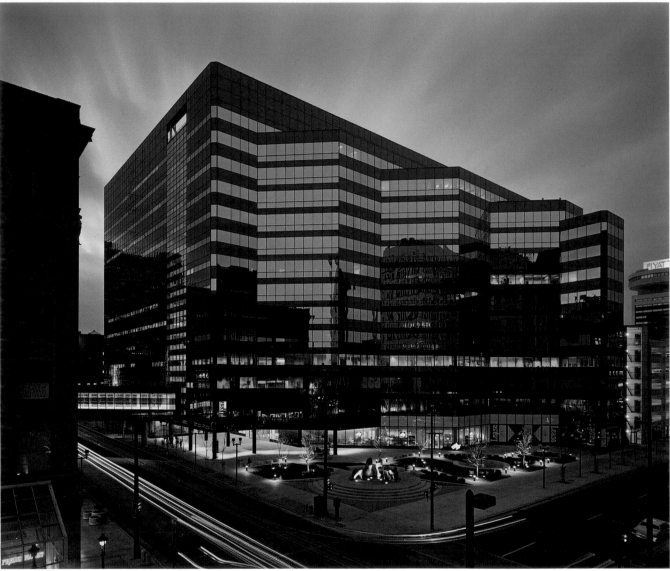

Title: Reuss Federal Plaza

Purpose/Client: Magazine article and rental brochure

Camera: Sinar f +

Lens: 75 mm Rodenstock

Film: 4 x 5 KODAK VERICOLOR II Professional Film / 4108, Type L

Lighting: Existing light

Eric Oxendorf

"Because of the poor quality of light in the room, I used a 1000-watt quartz-halogen light as a fill/main light. I chose this light source because there were already 3200 K lights in the room. Placement of the light was crucial to avoid shadows from the hanging light fixture and glare from light bouncing off the artwork on the walls. I had to use enough light to show detail in the black lacquered tabletop. Originally, I wanted more symmetry in the composition. I removed the photographic artwork print on the right. However, this revealed a badly yellowed wall fabric, probably due to executive smoke."

Title: Executive Dining Room

Purpose/Client: Architectural firm's promotional piece and design competition entry

Camera: Sinar f +

Lens: 65 mm Rodenstock

Film: 4 x 5 KODAK VERICOLOR II Professional Film / 4108, Type L

Lighting: One Lowel Tota-light, 1000-watt, 3200 K

Jack Boyd

"To balance these different light sources, I employed a multiple-exposure/filtration technique. Using a color-temperature meter, I measured each light source separately. I isolated or turned off all light sources except one, starting with the tungsten. I fixed a KODAK WRATTEN No. 80C Filter over the lens, and determined an exposure time of 60 seconds by using instant film. I turned off the tungsten lights, and turned on the fluorescent lights. I used a CC40M filter and and a WRATTEN No. 81EF Filter for these lights. I again determined my exposure time of 30 seconds by testing with instant film. The third exposure was nine seconds with only the neon lights turned on and no filter. The picture needed no retouching."

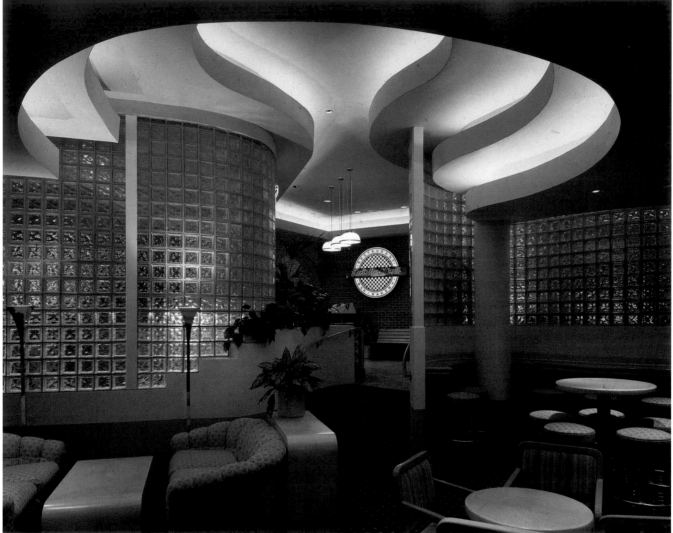

Title: Katella Deli/Bar area

Purpose/Client: Interior view for designer, Hatch Brothers, Inc.

Camera: Toyo

Lens: 90 mm

Film: 4 x 5 KODAK EKTACHROME Professional Film / 6118 (Tungsten)

Lighting: Mixed existing light sources including fluorescent, tungsten, and neon. One 10-inch, 250-watt Smith Victor studio light behind a glass block.

Exposure: Multiple at f/22

Al Teufen

"I was assigned to take interior photographs of this particular country house. This still life was shot in the dining room of the house. These are all very early country items that were gathered from the homeowner's collection. I used a two-second exposure, with modeling lights turned off, to bring the candle to a nice glow."

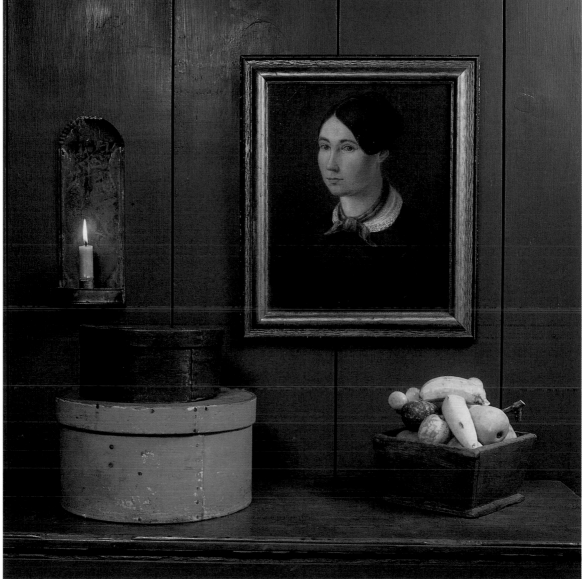

Title: Early American/Still Life

Purpose/Client: Antique still life for *Colonial Homes* magazine

Camera: Hasselblad

Film: 120 KODAK EKTACHROME 64 Professional Film (Daylight)

Lighting: Balcar strobes, two heads, 5500 K, CC05Y + CC025R filters

Exposure: 2 seconds with modeling lights off

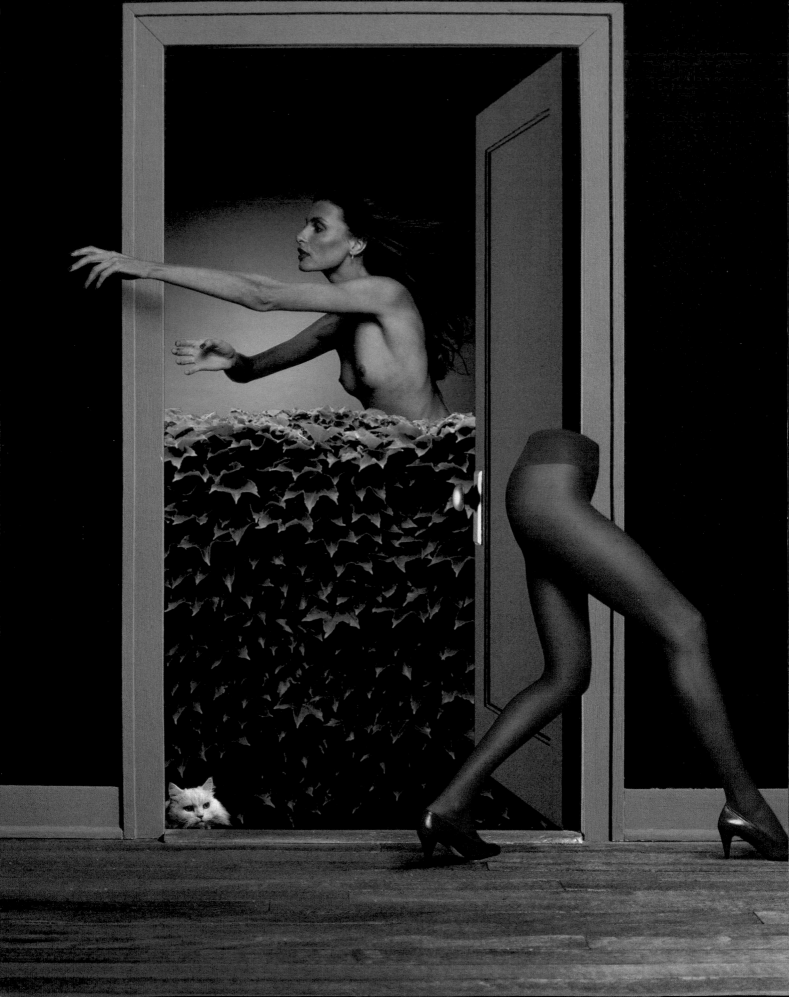

High-Tech

High-tech photography includes advanced camera and darkroom techniques, such as in-camera masking, image manipulation with computer graphics, and stripping in images during printing. High-tech images are usually colorful and graphic, and almost always have a futuristic look. Many art directors familiar with image manipulation in video now expect similar effects from still photographers.

You can store a video image digitally on a computer, and manipulate it in many ways. In the past few years, the power of such "paintbox" systems has been increased to the point where manipulation and retouching of a digitized 35 mm slide is practical. Previously, the resolution was very limited (a fraction of the recording capability of film). But more recently, resolution has been greatly improved, particularly when the image is recorded on 4 x 5-inch film for use in litho printing.

Several primary effects available from computer programs may be of interest to you:

One-point perspective takes part of an image and squeezes it one way (it is usually done twice), to create the feeling of "planes" floating in space).

Two-point perspective gradually reduces the image detail in scale toward a vanishing point. It is used often with the vanishing point actually inside the image area—the shot becomes a triangle with the image detail either rushing out toward you or streaming into infinity.

Skew turns the image of a rectangle into a parallelogram, slanting everything in the area you select—like creating oblique lettering.

Rotate turns any portion of an image by a specified number of degrees.

Other basic commands include **flip** (create a mirror image), **invert** (reverse all tones), **duplicate** (make a copy of a selected area and offset it slightly), **zoom** (enlarge a small portion), **drag and repeat** (create a trail of overlapping copies of a subject by moving it across the screen), and a whole range of color posterizing effects from the familiar large digitized squares to subtle alterations in tonal scales.

Detailed photographic retouching is now possible on-screen, and you can remove entire elements of an image. You can delete a car from a green field simply by dragging a rectangular box around it by using the computer mouse and pressing the delete key on the keyboard. To fill in the background, a special program reads all the adjacent shades of green and "paints" matching shades smoothly into the blank space. Some programs even allow you to sample a different part of the image (for example, green grass with yellow buttercups) and fill another area with the same pattern. This is called **cloning.** At the extreme, such computer retouching enables the artist to combine photographs, change the scale or position of individual elements, create entirely new objects, and treat a photographic original as freely as a gouache painting. You can feed the output into an on-line page makeup system so that it is never even viewed as film; it is recorded directly in the form of color separations for litho printing. The preview of the image will probably be a color laser or ink-jet print.

HIGH-TECH IMAGERY

Most of the effects introduced in video graphics systems are now so familiar that they have established parallels in photography—zoom and neon-glow lettering for title slides, for example.

Photography still has the advantage of much higher resolution and superior color palettes. A subtle, graded background glow in digital form is difficult to handle; a photographer can make one in a few minutes with a light and couple of filter gels. Realistic starbursts of light are difficult to draw, either with an airbrush or on a computer screen; once again, a photographer can create superb starbursts by making pinpricks in black seamless and placing a lightly-scratched acrylic filter over them.

High-tech photography uses the idiom of the computer graphics world—perspective grids, dragged zooms, stepped and repeated images, simplified contrast scales and color palettes. The most vital elements in the high-tech image-maker's world are a fully blacked-out studio equipped with an extremely stable and rugged 4 x 5-inch camera, and a duplicating rostrum camera.

Double and multiple exposures are essential for most high-tech shots. With a view camera, you can photograph several different subjects in turn, marking their positions accurately on the ground glass. Some photographers even take their cameras out on a clear night to photograph the full moon at different sizes and in different positions, and then store their film holders in the refrigerator with the positions and exposures marked for future double-exposure opportunities.

Photo on opposite page by Ryszard Horowitz.
© Ryszard Horowitz, 1988.
Technical information on page 156.

A multi-exposure works best with a solid black background, and most high-tech studios are painted matte black throughout. Tungsten light often works better than electronic flash because action is seldom involved and tungsten film is better for subsequent rostrum-camera work.

In the studio, the high-tech photographer will often rely on his or her own artwork and model-making skills, or hire outside help. You can have entire sets built with false perspectives, using props such as floorboards that get progressively narrower. You can use preprinted backgrounds with four-way graded tones that create visual tunnels, monofilament line to suspend objects above backdrops, and place colored gels over lights to reduce images to the primary colors.

Much of the rest of the work is done in the darkroom, on the rostrum, and by the retoucher. Some effects, like glowing grid lines, can be photographed conventionally, or you can have them added at a duplicating stage by using line artwork, filters, and by movements available on the rostrum copying stand. Some rostrums are computer-controlled to create zooms and other effects like spiral step and repeat; others are simply very accurate manual copying benches that include a precision 4 x 5-inch or pin-registered 35 mm camera.

Since all high-tech images are different, and the effects created rely heavily on the photographer's imaginative use of techniques, study the examples here for ideas. Many custom labs and art studios can help you create high-tech effects by using your conventional studio shots as a starting point, but these services are costly. You can also buy many visual effects in the form of library slides for front-projection or for addition at the litho printing stage. You do not have to be a multi-exposure or rostrum expert to come up with the goods when a client wants this kind of work.

Steve Myers

"This composite image, taken from three camera sets, uses an in-camera masking system made for us by Warren Condit of Condit Manufacturing. I exposed the discs with a single direct overhead light. Then I removed the special holder from the first camera, and exchanged the frisket in the darkroom. I exposed the second earth set in register with the disc image on the same piece of film, using a single strobe through a blue gel above the horizon. Finally, I exposed the 'stars' on a third set consisting of a small two-foot-square strobe light bank and black paper punched with holes for stars."

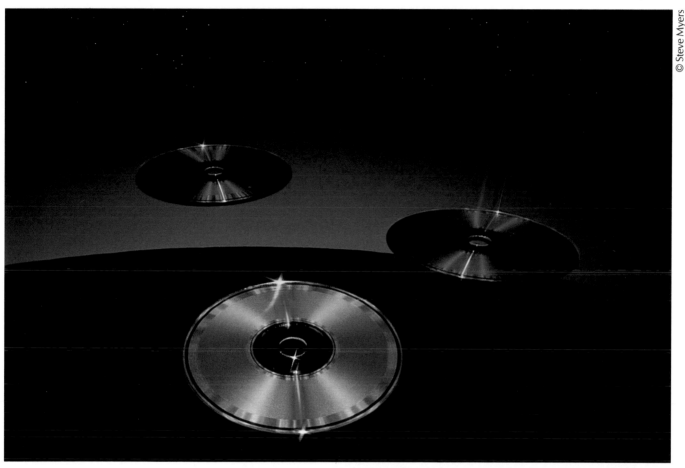

© Steve Myers

Title: Flying Discs

Purpose/Client: Textbook illustration

Camera: Deardorff

Film: 8 x 10 KODAK EKTACHROME 64 Professional Film / 6117 (Daylight)

Lighting: Tungsten-halogen, 1000-watt, 3200 K corrected for 5000 K; and Speedotron strobe, 2400 WS, 5500 K

Alan Zenreich

"The first of several photographs showed the pawn-shop trumpet, which I enclosed in a Plexiglas 'tent' to minimize seams in the reflections. I also photographed a hand holding the trumpet to use as a guide for doing the computer graphic of the hand. A black-and-white print of the hand shot was placed on a digitizing tablet. Using a computer 'paint' program, I traced the shape of the hand and added extra touches. I also used the computer to draw the multicolored splash image. These computer images were photographed with an image recorder. Finally, I photocomposed the three images (trumpet, computer hand, and computer splash) onto a single sheet of 8 x 10 KODAK EKTACHROME Duplicating Film, using KODALITH Film overlays with pin registration."

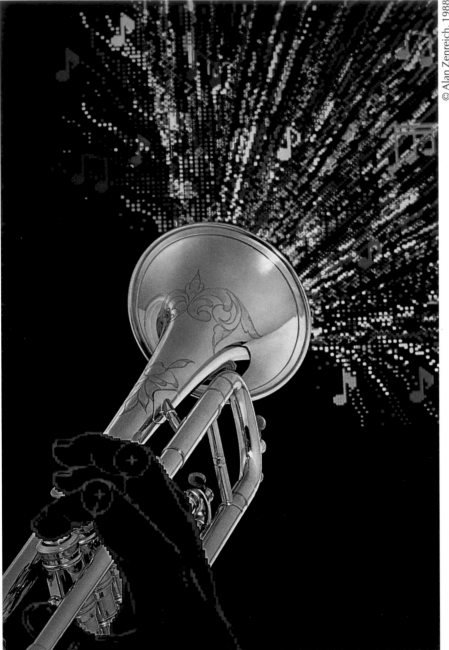

© Alan Zenreich, 1988

Title: Trumpet

Purpose/Client: Hammermill paper advertisement

Film: 8 x 10 KODAK EKTACHROME Duplicating Film 6121

Lighting: Strobes

Pete Turner

"I actually photographed the Orange Mountain foreground on the TV screen in the Libyan Desert by the light of oil burnoffs. I photographed the marbles, which work quite well as interesting planets, in the studio. These two photos were combined in an optical printer on KODACHROME 40 Film / Type A. I shot the Toshiba TV screen with the tube removed. Both the TV shot and the planetary assembly were input into a Hell Chromacom computer and digitized. The image was fine-tuned on a video terminal where 'planets' were rotated and 'stars' were added. A laser print was pulled for client approval before color separations were made."

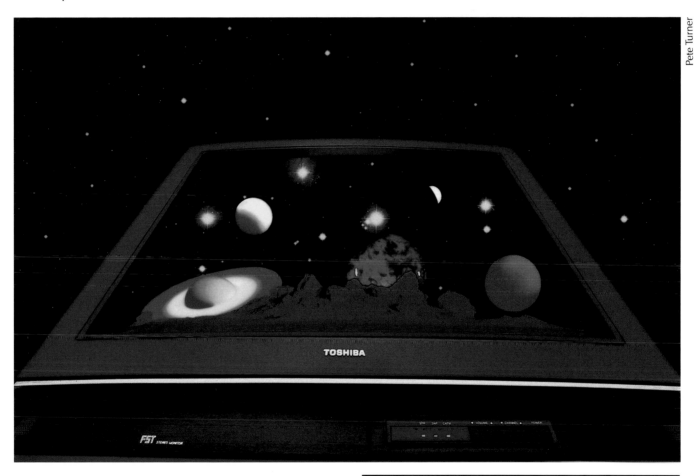

Title: Toshiba TV/Planets

Purpose/Client: Magazine advertisement for Toshiba TV

Camera: Nikon

Film: 35 mm KODACHROME 40 Film / Type A

113

Michel Tcherevkoff

"This image was designed to illustrate the concept 'The Standard of Excellence in Training for Technical Professionals.' To create a state-of-the-art, high-tech feeling, I constructed an oversized egg, broke it open, and inserted a separate image of lasers and light beams. I lit this transparency from behind and framed it with three golden star bursts. For the surface, I used a sheet of black Plexiglas to delicately reflect the golden glow of the background."

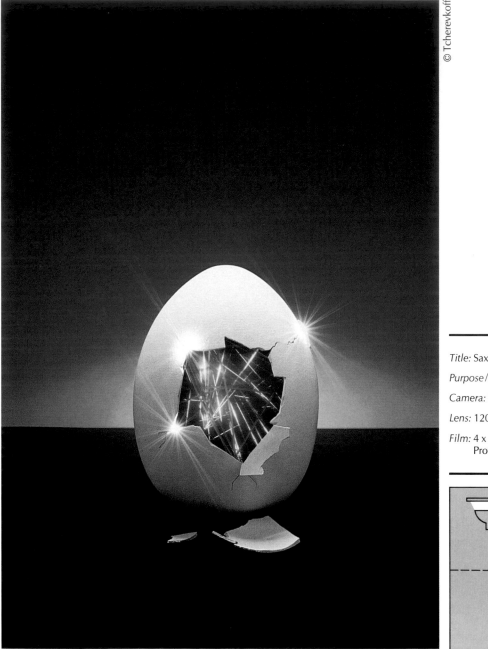

© Tcherevkoff

Title: Saxton Egg

Purpose/Client: Poster advertising

Camera: Sinar p2

Lens: 120 mm

Film: 4 x 5 KODAK EKTACHROME 100 Professional Film / 6122 (Daylight)

Michel Tcherevkoff

"One thousand ping-pong balls were airbrushed blue and pasted onto a clear Plexiglas sheet. This base was supported by two sawhorses. A hole was cut into the surface for the model's head. By experimenting with splashing, throwing, and airbrushing varying shades of blue and magenta onto a large Plexiglas dome, we were able to achieve a convincing surface for the 'planet' that would be suspended above the model's head. I used a mannequin head (measured with calipers to approximate the model's dimensions) as a stand-in for the model while I arranged the floating balls. Each ball was attached to an individual piece of armature wire nailed to a wooden support that would be hidden from the lens by the model's head. Three Dyna-lite heads with blue gels added a glow to the horizon. The bank light lit the model's face while a Speedotron strobe covered by a magenta gel lit the overhanging planet from behind the model's head. Finally, a small Dyna-lite unit underneath the Plexiglas surface added a glow to the ping-pong balls."

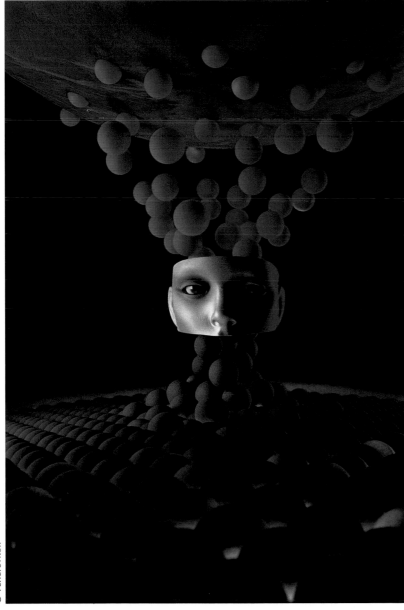

© Tcherevkoff

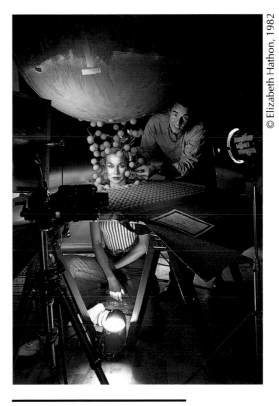

© Elizabeth Hathon, 1982

Title: Woman's Head with Ping-Pong Balls

Purpose/Client: Self-assigned stock photo

Camera: Nikon F2

Lens: 28 mm

Film: 35 mm KODACHROME 25 Professional Film (Daylight)

Lighting: Three Dyna-lite heads, 16-inch-square bank light, Speedotron strobe, a small Dyna-lite unit

Bruno

"We needed a head that was futuristic (android-like) and that would also look human. I commissioned an artist to sculpt this head. It was a multi-step process: sketches, clay molds, instant prints of molds until the right one was selected. Then the head was cast in Plexiglas. The photograph was made with four separate exposures. The first captured the head with diffusion and gels over the light source. The second double-exposed the scratch-resistant lens over the original head. The third added the glow around the lens. The fourth involved a star setup. I then moved the camera to create a shooting-star effect."

Title: Pink Seiko Head

Purpose/Client: Trade ad to introduce Seiko scratch-resistant lens

Camera: Deardorff

Film: 8 x 10 KODAK EKTACHROME Professional Film / 6118 (Tungsten)

Lighting: 250-watt ECA photolamp, 3200 K

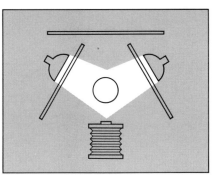

Bruno

"Rather than using original parts (only 0.16 cm), I had a miniature sphere built with oversized chips. This set, constructed in perspective, had foreground pieces as wide as four inches narrowing to half-inch pieces in the rear. For the first shot with a 300 mm lens, I placed the chips on a Plexiglas sphere that was bottom-, back- and side-lighted. I double-exposed the glow to accentuate the horizon. I then inserted the film into another camera with a 165 mm lens to expose 'stars' created by shining light through pinholes in a sheet of black paper. Finally, I transferred the film to a third camera with a 210 mm lens for a shot of a moon map with crater names painted over."

Title: Circuit World

Purpose/Client: Trade advertisement for Mepco/Electra stressing reliability of products

Camera: Deardorff

Lenses: 300 mm, 165 mm, 210 mm

Film: 8 x 10 KODAK EKTACHROME Professional Film / 6118 (Tungsten)

Lighting: 1000-watt quartz, 500-watt ECT photolamps, 3200 K

Ezio Geneletti

"The background is a computer graphic printed in size of 80 per 100 cm. The print of the bridge is fixed in front of the background. There was no retouching."

Title: Correspondent Banking

Purpose/Client: Advertising illustration

Camera: Sinar p

Film: 4 x 5 KODAK EKTACHROME Professional Film / 6118 (Tungsten)

Lighting: Profotospot, 2800 WS, 5600 K

George B. Fry III

"This project was intended to give the feeling of working on a new Hewlett-Packard touchscreen. We shot through an HP touchscreen shell to convey the feeling of being inside the computer looking out. I added a green gel to the front light to suggest that the terminal actually was lighting the foreground. I shot the data on the screen later and added it to the transparency in the darkroom."

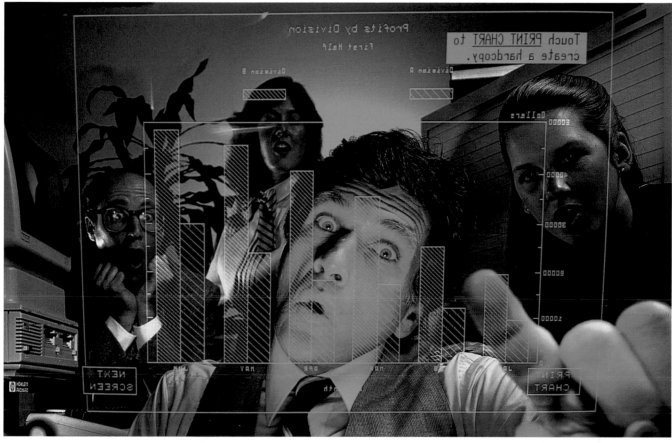

George B. Fry III

Title: H.P. Touchscreen

Purpose/Client: Consumer catalog for Hewlett-Packard

Camera: Sinar p

Lens: 90 mm

Film: 4 x 5 KODAK EKTACHROME 100 Professional Film / 6122 (Daylight)

Lighting: Balcar strobes, 5500 K

Exposure: 1/60 second at f/32.5

Michael Marchant

"This illustration consists of two exposures—the female and the candle-stick, and the skull and the background—that were merged in the dark-room. I used the dye transfer process of photomechanical reproduction, utilizing chemical bleach creative retouching by Simon Bell of London, to create 'photodye surrealism.' An 'English Rose' symbolizes the twilight of British rule in India. In a moment the red Death will snuff out what remains of the red, white, and blue candle. Lady Baille, who is a buyer of my candles, loaned me her carved, ebony Indian jardinie're which I restored and transformed into a candlestick holder. Lady Baille suggested the title of the photo and I then allowed my imagination to flow on."

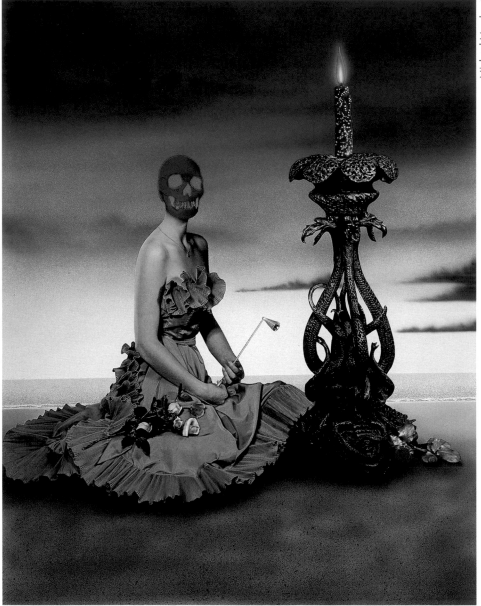

Michael Marchant

Title: English Rose

Purpose: To experiment with the KODAK Dye Transfer Process

Camera: Toyo G

Lens: 150 mm Symar

Film: KODAK EKTACHOME 100 Professional Film / 6122 (Daylight)

Lighting: Two Bowens strobes with umbrellas

Exposure: 1/125 second at f/22

Walter Wick

"This triple exposure on a single sheet of film required setting three cameras. I photographed the bolt 'floating' against a blue background with camera #1. I made a drawing of the bolt on the ground glass of camera #1 with a china marker. Then I attached that same ground glass to camera #2. With the drawing as a guide, I positioned the circuit board on a black background to fit within the area of the bolt. I then fit the ground glass on camera #3, and positioned stars on a black background where they wouldn't overlap the area of the bolt."

Title: Bolt with Computer Parts

Purpose/Client: To illustrate a story about high technology in orbit for *Fortune* magazine

Camera: Toyo

Film: 8 x 10 KODAK EKTACHROME 64 Professional Film / 6117 (Daylight)

Lighting: Speedotron strobes, 2400 WS, 5000 K

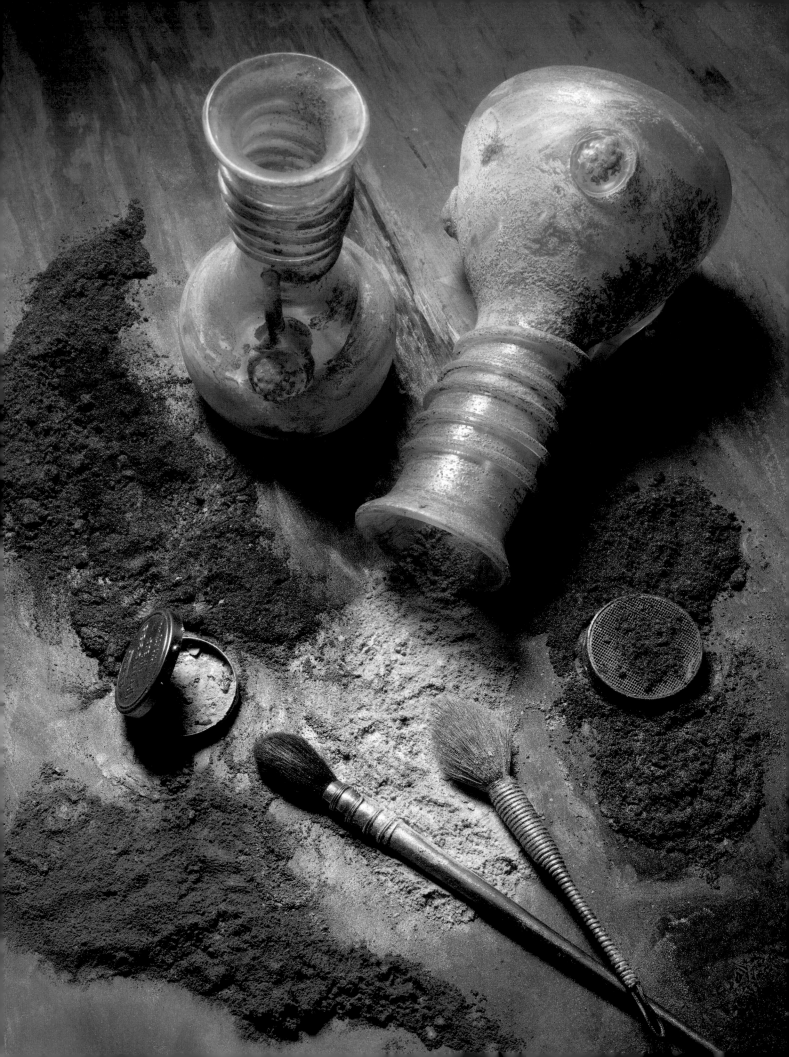

Other Products

A good professional photographer can handle almost any type of product photography, whether it's for direct-mail advertising, magazine advertising, newspaper advertising, a catalog, or a promotional piece. Whatever the application, here are some tips to help you improve your work.

A HYPOTHETICAL PRODUCT APPROACH

Imagine that your client has asked you to photograph a compact stereo system. It is a self-contained unit with a dual tape recorder, CD player, five-band graphic equalizer, and AM/FM stereo radio along with two small detachable speakers. It is portable and inexpensive.

Review its features. There is a small row of slide switches for the graphic equalizer, a row of red LEDs to signal the volume level, some knobs, and some other tiny lights that illuminate the controls when you turn on the system. Your job is to make a photograph of the stereo that's as exciting as possible while it shows all the features.

Set up the background with seamless paper scooped down onto a double sawhorse table with a strong, plywood top. Place the compact stereo on this setup and carefully tape the cords so that they do not show. (It's helpful to stock a few plywood tops, some with holes cut into them so that you can hide cables.)

The angle of view is important—the designers have assumed that this unit will always be viewed from the front and from slightly above, so the most interesting controls have been placed near the top. The designers have imagined that it will not be viewed from directly overhead, so the top itself is not a focal point. One very important part, the tape deck, is near the bottom.

Start with the graphic equalizer. An equalizer allows you to adjust the sound to the best balance for the room in which you are playing the music. The stereo is shipped from the factory with the sliding controls all set at zero. However, when an equalizer is in use, you will move the knobs independently as you listen to the sound. When you have adjusted them, their positions will form a curve. Make such a curve so that the use of the equalizer is obvious in the photograph.

Clean the entire unit before shooting. Furniture polish will enhance the surface. Remove any lint and bits of packing material from the front covering on the speakers. Place the speakers near the edges of the set and use a wide-angle lens up fairly close so that the speakers appear larger and more dramatic.

There may be thick, reflective plastic on the unit, and the dual-cassette windows may be dark, smoked plastic. Insert a pair of light-colored audio cassettes so that they show through the plastic. Place a CD on the CD player, with the plastic cover raised enough to show the hinged cover and the CD. Avoid showing brand names.

You may also have to reflect a black flat or black fabric into the windows and onto the shiny surfaces of the unit. This will prevent other objects from being reflected by the shiny

surfaces. Use dinky lights or mirrors to add streaks of light across the speaker cloth. This provides form and texture to an area that would otherwise be a dark void.

Check for reflections by looking through the ground glass as you are adding lights. When you set up your final lighting, make certain that each plane or surface of the stereo system is discernible. This may be difficult if many of the surfaces are dark and the controls are shiny-bright. Each plane and feature must be delineated, but none can dominate.

Use a second set of eyes. Have your assistant critique the setup. Your assistant should review everything from the lighting to any minor problems, such as masking tape visible in the picture, a pencil left on the set, or some other blunder. Is the hole you punched in the seamless paper to hide the cord visible? Can you see the piece of wood propping up the unit? Only when everything seems right should you take the photograph.

Plug in and turn on the unit. Raise the volume to a level that will light several of the LEDs. These are likely to be dim, so you may need to make a double exposure to show the lights effectively. You know how to calculate the exposure for electronic flash or tungsten light. The best way in a case like this is to set the optimum working aperture (perhaps f/16) and adjust the flash output or shutter speed accordingly. To estimate the exposure for the LEDs, adjust your modeling lamps on the flash units until the effect seems equal to the output of the LEDs. Figure your exposure in seconds with f/16 for the aperture—perhaps a four-second exposure.

Make your two exposures in the darkened studio with modeling lights off. The first will be the flash exposure. Then expose for four seconds without flash (for the LEDs). Be sure to bracket your exposures. Never change the aperture between the two exposures; with many lenses the image appears to shift slightly when you change the aperture and it can affect depth of field.

After shooting, check the set again through the viewfinder or ground glass. Did anything move? If there is a problem, reshoot. If there is no problem, leave the setup until you have checked the processed film. While this is a hypothetical assignment, the approach is typical of what you should do with product photography.

SHOOTING ON LOCATION

Product photography is often done on location. For example, if you photograph luggage, you might show it lined up near an airplane, perhaps with a model in the scene. Or you could decide to photograph it in the lobby of a luxurious hotel—near a well-dressed couple registering at the check-in desk. In an outdoor scene you might present the luggage in the middle of an uninhabited jungle or by the edge of a deserted highway. In most cases, your client will ask an art director to provide you with a sketch or a description of the location.

Outdoors you will have to deal with available light. Since you must usually show the name and features of the product, you'll want to make sure it's well lighted. This means you may need to use reflectors or fill lights. You may want to block out the sunlight and illuminate your subject completely with strobes to maintain full control of the lighting.

Generally, the camera angle should be low enough to draw the viewer's eye to the product. For the luggage photograph, the camera might be on or near the ground. You might use a wide-angle lens up close to increase the apparent size of the luggage. Of course, luggage used as carry-on bags on an airliner must meet certain size limitations. However, a close-up taken with a wide-angle lens can give the

impression that a particular brand is bigger than normal, even if the viewer knows this is not true.

Many times a manufacturer or client will want to appeal to a particular audience. The luggage example is aimed at the frequent traveler, the business person on the go, or the couple with money who live or want to live a luxurious life style. However, a different approach might show the luggage being placed in an old car by a college-age boy or girl as parents say goodbye. This approach portrays the luggage as part of a rite of passage as Norman Rockwell paintings were used by advertisers for almost 50 years to convey similar messages.

In other assignments, you may need to create a fantasy setting, such as photographing a toy truck climbing over rocks outdoors. By shooting from a camera angle below the rocks, you can make the rocks look like boulders and the toy truck like a real truck. The fantasy is meant to appeal to small children, who might see the photographs on a box in a toy store, or in an advertisement in a children's magazine.

The mood created to appeal to a parent would be totally different. Your task might be to depict the happiness of the child, and the love the child feels towards a parent who provided the toy. For example, you could show the child at play, beaming happily up at the parent. Or the child could be cuddling a doll while looking up contentedly from the parent's lap. The message to the parent is that buying the toy would make the child very happy and increase the child's love for the parent.

No matter what the product, though, remember that the location simply enhances the image—it is not the main subject. The primary focus in the photograph must be on the product.

Another type of photography is straight product photography for catalogs. The techniques are not fancy, and involve few, if any, props. It is a straight sell meant to show the product—not to evoke emotions.

STUDIO PHOTOGRAPHY OF PRODUCTS

You may be asked to handle two types of studio product photographs. The first is the record photograph. This is a photograph that shows the product and its features in a simple, straightforward manner. To show all details clearly, the lighting is simple and the background is usually just white seamless paper. Your clients will use such photographs for in-house records, order catalogs, and other similar uses. The photograph is not meant to inspire the viewer to go out and buy the product.

If you have ever glanced at catalog books used by large product wholesalers such as tire dealers, automobile-parts suppliers, and the like, you have seen these straightforward photographs of products. A page may include one or more photographs of a particular tire tread design. Then the rest of the page will show the different types of tires in stock. The photograph is a guide to help the catalog user.

If the products you are recording are all similar, you can mark the background paper where you photographed the first product, remove that product, replace it with the next one, and photograph it. You don't have to move the camera or lights again unless a reflection, hot spot, or unwanted shadow appears. This is the kind of work for which it's a good idea to quote "per shot" prices rather than daily or hourly rates.

Many large commercial studios are set up to turn around this type of work efficiently. For example, photographers recording fabric swatches for catalogs will frequently use a large board on which they arrange six or more swatches. The photographer will place the fabric to show what the manufacturer wants. It may be flat to show the texture, or it may have a slight fold known as a "pooble" to give it thickness and softness that would otherwise not be apparent. Once the board is filled with swatches, the photographer records it with 8 x 10-inch film. After processing, the images of the individual swatches are cut out and stripped into the page layout.

In contrast, the photograph used to promote product sales must be far more than a record. This is the image that must inspire consumers to buy your client's product.

THE SALES EFFECT

Keep in mind the sales effect of the product you are photographing. What makes this product important to the consumer? What will the consumer see in the product that will affect the decision to make a purchase? What is the layout of the advertisement and does the layout enhance the product's appeal?

For example, suppose you are photographing an electric lawn mower. Most lawn mowers operate with gasoline, a fuel that is both messy and potentially dangerous. Manufacturers of electric lawn mowers want to stress the relative safety and cleanliness of their products. This means that you must include the power cord in your photograph, showing not only how it operates but obviously stressing the fact that you are offering an electric lawn mower. Any layout that does not show the power cord will probably not meet your client's approval because the potential buyer will miss the main selling point.

Does the product have metal parts or a shiny surface? If it does, then you must make certain it is absolutely clean. When you place the product on the set, be sure not to create handling marks. In fact, some photographers polish the product on the set, and then make minor adjustments for positioning of small products with chopsticks. You can use them to grasp and adjust objects as small as a pea. An alternative to chopsticks is cotton gloves, but many photographers do not use them because they dull the sense of touch.

Most products do not look their best resting directly on seamless paper. You will usually have to prop them up. One exception is food. A plate of food or a cup of coffee propped at an angle will most likely spill! However, tilt tools, jewelry, and other objects for more interesting angles and better lighting control. Any time you build a set, save the scrap material. Keep blocks of 1 x 2s and 2 x 4s and any other materials you use. You can use these as blocks or shims for propping or positioning objects. Styrofoam blocks work well too.

You can use a hot glue or Tacky Wax for propping up both large and small objects. One precaution, though. Be careful when you use these products under hot lights, because they may become soft and not hold the object any longer.

Another approach is to use a loop of gaffer's tape, sticky side out, to hold an object. It is strong, and you can remove it easily without leaving any marks. Avoid using other types of adhesive tapes; they can become sticky and messy under hot lights.

THE SHOOTING TABLE

The simplest set for small products is a 4 x 4-foot piece of plywood mounted on two sawhorses. You can design the sawhorses with legs of different lengths so that you can make the set higher or lower as necessary. The plywood table is effective because you can nail wood to it for holding props and you can cover it with seamless paper or other materials—cutting a standard roll of seamless paper (107 inches wide) in half is a simple way to obtain the correct width for covering the table. You can use a staple gun to fasten fabric or other materials. The wood is light enough to transport easily, yet heavy enough not to buckle under the weight of heavy props.

Commercial shooting tables have opal acrylic surfaces, often post-formed into a scoop for infinity backgrounds, and are constructed so that you can position lights underneath them for shadowless lighting and translucent effects.

Exploded Views

Equipment manufacturers often require exploded views. Let's imagine a set of tools as the subject. The tool set includes 24 different ratchet heads, 12 screwdrivers, 10 different pairs of pliers, and numerous other items. You are faced with a 60-piece unit, along with the tool case, which you will have to arrange and record. You can use an exploded view to show just how much value has been squeezed into this special offer. It is your job to make all the items as attractive as possible to the consumer. Every piece has to show.

An exploded view can take two or three days to shoot. Among the challenges you may face is dusting the objects each day, because overnight enough dust will accumulate to dull the shiny surfaces. With a small brush carefully remove the dust before you take the photograph. You can try to cover the set each night, but it may be difficult to remove the material without disturbing the arrangement.

You will need an assistant to position the tools while you are looking through the viewfinder. Unfortunately, view cameras show an inverted image, so your directing can be somewhat tricky. Fortunately, after you have worked together for a while, your assistant will be able to anticipate your needs.

Once everything is arranged, make your lighting adjustments by using small spot lights or tiny mirrors, or whatever other techniques are necessary. You are now ready to take the photo.

Using Dummy Products

Before you photograph a perfume bottle under tungsten lights or flash units with high power modeling lamps, remove the liquid. The hot tungsten lights can heat the volatile elements in the perfume and cause the bottle to explode. Instead of perfume, use water mixed with yellow food coloring. In addition, make a reflector by covering the outside of the back of the bottle with aluminum or gold foil. It will help illuminate the liquid inside the bottle.

Expensive perfume requires different handling. It is one thing to dump out perfume that sells for a couple of dollars a bottle. It is something else when the product is extremely expensive. The answer—and it works for other products that may need special care—is to use a dummy for the setup and focusing. This can be an empty bottle or any other object that allows you to work effectively within the client's layout. You can even use three pennies to mark a specific area where the bottle base will go, then focus on a penlight or cigarette lighter placed in the center of your mark. When you substitute the subject, your focus will be sharp.

Always use dummy products when the item you are photographing is volatile, will melt, or will spoil if it's exposed to the heat of the lights. Expose the real object to the heat only for the actual photographs, a time period so short that it should not create problems.

A photograph without a prop may be boring. A photograph with too many props will leave the viewer wondering what the subject is. Keep props simple. If you are shooting an elegant dinner setting, try placing a single rose in the center. Or you may want to use fruit or vegetables. Just be certain that your props are flawless.

Always remember your job is to sell the product. The photograph you take must excite the viewer into wanting the item your client is trying to sell.

MULTIPLE SETS

Keep in mind that product photography allows you time. You have time to arrange the setup, time to check the photos, and time to correct mistakes. This is not to say that you should tie up your equipment while waiting to see the results from one shoot. Instead, you can arrange several studio setups simultaneously.

Ideally you will want to have at least three working sets. You will be preparing one set for future shoots. The second set is the one on which you are currently working. And the third set is the one you've already used, which you're keeping in position until you see the results after processing.

Once you have completed one product photograph, mark the spot where your tripod was, and measure the distance from the camera to the floor so that you can reset it at the same height if necessary. Then move your camera to the next setup and keep on working. Do not strike the first set until you see the results. If a reshoot is necessary, move the tripod back to the marked location, set the camera at the proper height, and take the new photos. Or simply keep two or more tripods on hand and you won't have to borrow the tripod for the next shoot; you can leave it in place until you see the results.

Remember that it is reasonable to expect about a 10-percent rate of jobs that require reshoots. Working this way will keep the client from seeing your mistakes and keep your cost of reshooting to a minimum.

FRONT AND REAR PROJECTION

You can use simple front projection for everything from showing texture on a surface to putting a child's face on a rubber ball. Project a slide (an existing image or something you created) onto the surface of a subject, allowing it to follow the contours of the subject. You need only a standard projector and tungsten film. Use a light meter for reflected-light readings and bracket your exposures.

You can also use strobes that come with holders and metal pattern masks. You can focus the strobe lens to create a spotlight effect and project patterns obliquely with the pattern masks. The brightness of the pattern depends on the adjustment of the strobe lens and the ambient light in the room.

True front projection is done with a special projector that accepts 35 mm or roll-film slides. It has a beam-splitter device that enables it to project the slide along the axis of the taking lens

of a camera mounted on the equipment. If you use a special projector screen as a background, the image is reflected back into the lens. The effect is highly realistic.

Rear projection also provides realistic effects. You place a translucent rear-projection screen behind the subject. You then use an ordinary projector with a wide-angle lens for tight quarters. Project the slide normally—it will appear reversed. If this is unacceptable, simply reverse the slide before you project it.

Place your subject in front of the screen and carefully light it so that no light falls on the screen. Take a reflected-light reading from the screen, then from the main subject. Increase or decrease the light falling on your subject until it matches that of the screen, or to create whatever lighting ratio you want.

This technique usually requires long exposures. Use tungsten film and tungsten lighting for best results. Rear projection allows you to record your subject in a totally different environment. You can have a model on the moon, create the sun rising behind a product, work seemingly around the world, create unusual effects, and do almost any other trick with this approach.

The difference between front and rear projection is that front projection puts the image on both the subject and the screen. Rear projection puts it on the screen only. You can use both front- and rear-projection effects with two projectors, using front projection for the main subject. By moving the projectors closer or farther away from the subject or screen, you can balance the light level until the total effect is even.

No matter what route you choose, experiment constantly. You may not always have the budget or the time to experiment when you are working for clients. Take the time between assignments to improve your photographic abilities. You will gain skills that translate into more sales.

Paul Hoffman

"A test day was used to figure out platform and ladder placements, exact camera placement and lens, proper time of day to shoot, type of filtration, fill, and proper fit of the Levis to the statue. Two months later, blustery spring days arrived with clear blue skies and broken clouds. The shoot crew consisted of a stylist, an assistant, and myself. The Levis were split up the front and taped into position with double-stick gaffer's tape holding the denim to the statue's contours. The sun between 1:30 and 2:30 p.m. provided a perfect main light, warmed slightly with an 81A filter and polarized to saturate the sky. A gold card was handheld in front and below to bounce light onto the baseball and cupped upper hand."

Title: Statue Wearing Levis

Purpose/Client: Presentation to Levis and self-promotion

Camera: Hasselblad

Lens: 250 mm Sonnar

Film: 120 KODAK EKTACHROME 100 Professional Film (Daylight)

Lighting: Daylight with 81A filter, polarizer, and gold-card fill

Michael Furman

"We wanted to show running shoes in an interesting composition for an editorial spread in a general-interest magazine. We tried to capture the lightness, excitement, and style with the aggressive angles and attitudes."

Title: Flying Sneakers

Purpose/Client: Editorial

Camera: Nikon F2

Lens: 15 mm Nikkor

Film: 35 mm KODACHROME 64 Professional Film (Daylight)

Lighting: Dyna-Lite strobes, 5000 K

Exposure: f/22

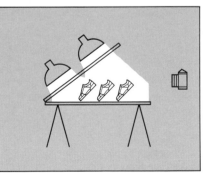

Michael Furman

"This photo introduced a new Revlon product. I photographed the image sideways so that the ribbon would hang in a natural, graceful curve."

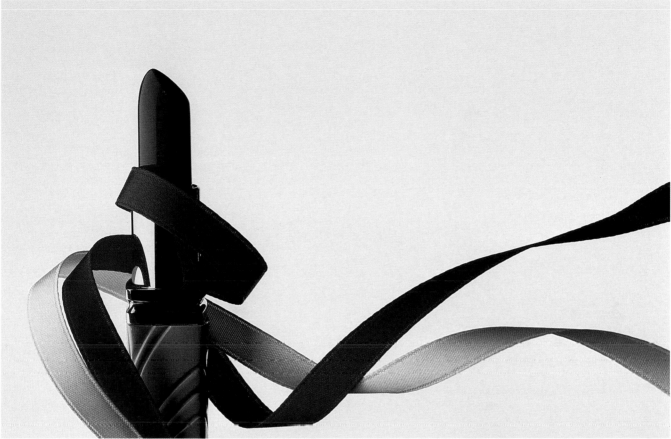

Title: Lipstick with Ribbon

Purpose/Client: Point-of-purchase display

Camera: Nikon F3

Lens: 105 mm Micro-Nikkor

Film: 35 mm KODACHROME 64 Professional Film (Daylight)

Lighting: Dyna-Lite strobes, 5000 K

Exposure: f/32

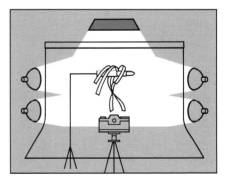

Michael Furman

"To illustrate a dry cleaning solvent for dishes, we photographed outdoors in a sand dune with an extreme wide-angle lens to create greater depth."

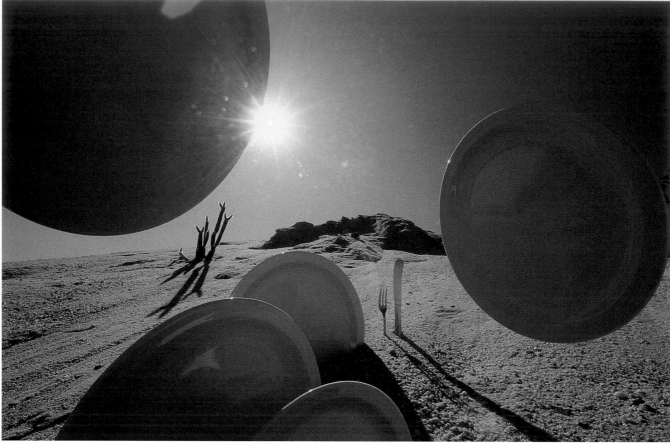

Title: Dishes in the Desert

Purpose/Client: To describe a dry cleaning product for dishware

Camera: Nikon F2

Lens: 20 mm Nikkor

Film: 35 mm KODACHROME 64 Professional Film (Daylight)

Lighting: Daylight

Exposure: f/22

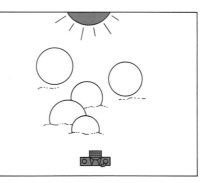

Oudi

"I shot the 6 x 6-foot set—painted backdrop and painted mountains on cardboard and plaster of paris—with an 8 x 10 camera. Then, I shot each piece of luggage individually with a 4 x 5 camera to give distance perspective. The background photo required four umbrellas. I shot each piece of luggage with one head with a seven-inch reflector from above and a silver cardboard reflector directed on the front. The six shots were then stripped together in accordance with my layout. I designed the shot with space and freedom in mind, something to relate to vacations."

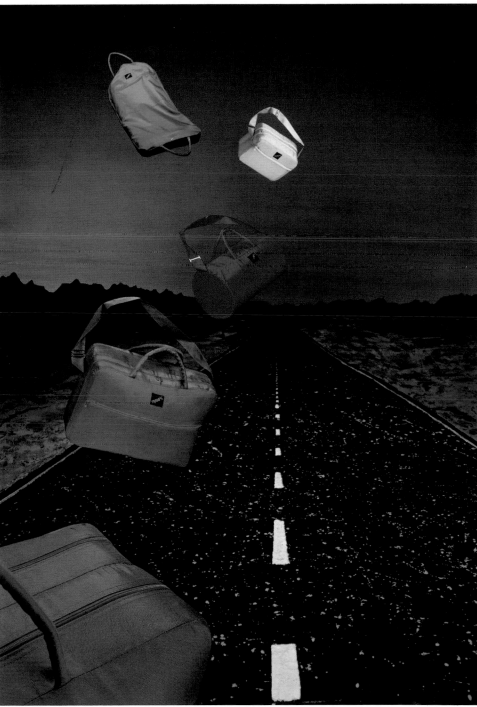

Photo and Design by Oudi

Title: Flying Luggage

Purpose /Client: Tramps Luggage
 advertising

Camera: 4 x 5 Cambo, 8 x 10 Fatif

Film: KODAK EKTACHROME 100
 Professional Film / 6122 (Daylight)

Lighting: One head with seven-inch
 reflector

Bill DuBose

"The client request was 'Use three pair of sunglasses without models.' The concept was developed in collaboration with my wife/stylist. The set was a six-by-twelve-foot sandbox, custom-built, laid out, and designed on camera. Styrofoam wigheads were cut in half and sprayed with glue to hold the sand. One ton of sandblasting sand (half fine and half coarse) was mixed roughly to create blending contrast. We lit the set with a special-effects light bank built from foam core that could be converted to multiple configurations. I placed bright, shiny, gold reflector strips on two sides to add a golden edge to the light. I used king-size bed sheets as broad fill on both sides of the lens to hold maximum detail in the shadows and the product."

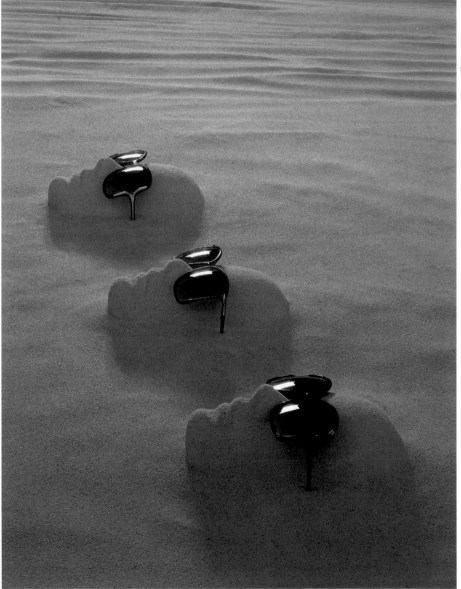

© Bill Du Bose, 1984

Title: Sand Faces

Purpose/Client: Product-sales-catalog cover and regional trade ad for Renauld International.

Camera: Calumet Commercial View

Film: 4 x 5 KODAK EKTACHROME 64 Professional Film / 6117 (Daylight)

Lighting: Speedotron, main light 2400 WS, fill lights 1200 WS each

Exposure: Maximum power, 12 to 15 flashes at f/64

Christopher C. Gould

"I liked the soap and how it was translucent. The brush just seemed to lie on the bar nicely. I cut a small hole in the background and placed the bar of soap over it. The photo is double exposed. The first exposure used top light, clean and crisp. The second exposure was the bottom light only, with heavy diffusion. The light from below and the diffusion filter (actually a plastic 'alligator' bag stretched over the lens) gives the bar the glow. The top light keeps the image of brush and background nice and sharp—simple."

Christopher Gould

Title: Soap Bar

Purpose/Client: Self-promotion

Camera: Deardorff

Film: 8 x 10 KODAK EKTACHROME 64 Professional Film / 6117 (Daylight)

Lighting: Ascor strobes with soft box, 5000 WS (top), 2000 WS (bottom)

Exposure: Double

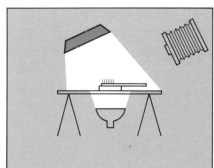

Bruno

"I found an old plastic container in the shape of a heart that I thought would be a nice theme for this Valentine's Day card. I wanted the background to be unusual and romantic. I was looking for a dark surface, but not one that was totally black. The use of lace over a piece of black Plexiglas allowed the highlights to show through. The heart and candy alone were not interesting enough, so using a combination of optical glass and diffusion material, I created the right mood for this shot."

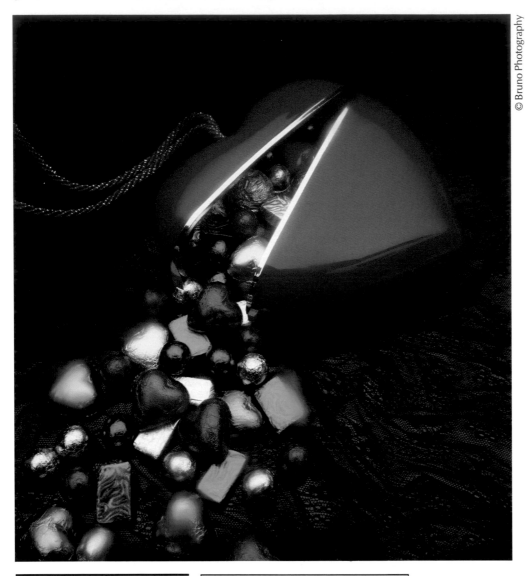

Title: Heart with Candy

Purpose/Client: Valentine's Day card for card company

Camera: Calumet Cambo

Lens: 210 mm

Film: 8 x 10 KODAK EKTACHROME Professional Film / 6118 (Tungsten)

Lighting: 5000-watts quartz, 3200 K

Bruno

"The plane had to look authentic, and this new secret bomber was not yet designed. Using pieces of various model airplanes plus pieces of our own design, we created a model that was appropriate for the ad. The best approach was to have an oversized miniature made and to create a whole environment around it with smoke machines, colored gels over light sources, and an overhead spot to accentuate and dramatize the plane."

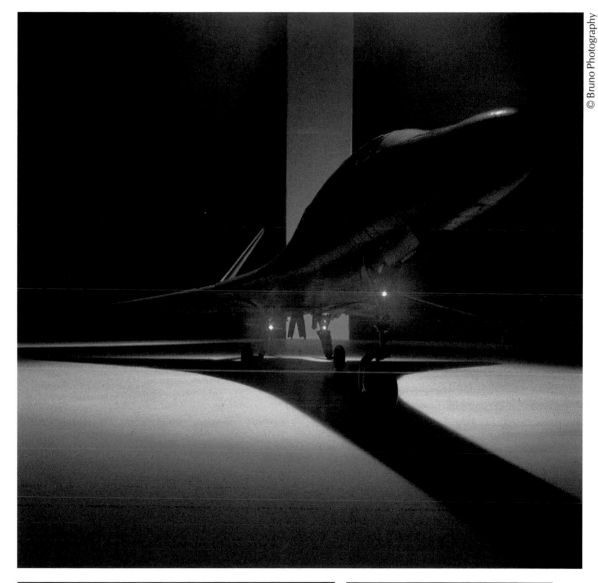

© Bruno Photography

Title: Airplane in Hangar

Purpose/Client: Trade advertisement to sell materials for designing airplanes from Amoco's Performance Products Division

Camera: Nikon

Lens: 20 mm Nikkor

Film: 35 mm KODAK EKTACHROME 160 Professional Film (Tungsten)

Lighting: 200-watt FEV photolamp, 3200 K main light source; 250-watt ECA photolamp

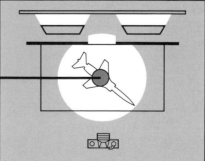

Carl Zapp

"The shot is actually two photographs stripped together. One is the atomizer, and the other is the spray. I set the atomizer on an eight-inch shelf with material draped over it. The main light was on the front left side. The fill card on the right and the light bank above primarily provided highlights on the gold part of the atomizer. Back lights provided the glow in the background, adding dimension. For the spray, I used an artist's airbrush. I set it up at an extreme angle to foreshorten the spray and make it look wide in a small area. A silver card behind the atomizer gave it some translucence."

© Carl Zapp

Title: Atomizer

Purpose/Client: Self-promotion

Camera: Toyo G

Lens: 240 mm

Film: 8 x 10 KODAK EKTACHROME 64 Professional Film / 6117 (Daylight)

Lighting: Speedotron strobes

Exposure: f/64

Bill Werts

"First we designed our interpretation of a water booth with gauges and water valves. The stainless-steel back wall gives the set a clean, clinical feel. For shooting, we created a two-foot-high wooden platform and water-holding tank. It was lined with plastic and equipped with a pump to remove the water. A steel grate was placed on top to support the bike and to become the floor of the set. We placed the light bank between the water fixtures and the back wall of the set. It created a feeling of drama by backlighting the water and rim-lighting the bike. We placed a white foam core wall in front of the bike to give just enough detail to show the product. To lend credibility to the testing-room concept, we added a technician as a final touch."

Bill Werts

Title: Yamaha Water Test

Purpose/Client: Advertising illustration for Yamaha touring bikes

Camera: Sinar

Lens: 300 mm

Film: 8 x 10 KODAK EKTACHROME 64 Professional Film / 6117 (Daylight)

Lighting: 5 x 12-foot light bank, eight strobe heads at 2000 WS

Exposure: 1/125 second at f/32

Mickey McGuire

"I set up the skeleton with the pieces to be 'x-rayed' on a black cloth background. I also placed the car body with wheels on a black background on a separate set. I controlled the lighting on the 'shell' to allow parts of the skeleton to show through without conflicting shell highlights. Such highlights would confuse or obliterate the desired visual when I double-expose the two scenes, in register, on the same piece of film. I set and tested lighting and color balance individually. Then, I tested the balance of exposures for effect. (Too much exposure on the skeleton, and it looks like it was pasted over the shell. Not enough exposure, and the skeleton doesn't show.) The right combination produces an image of what appears to be an all-glass automobile with its normally hidden parts revealed."

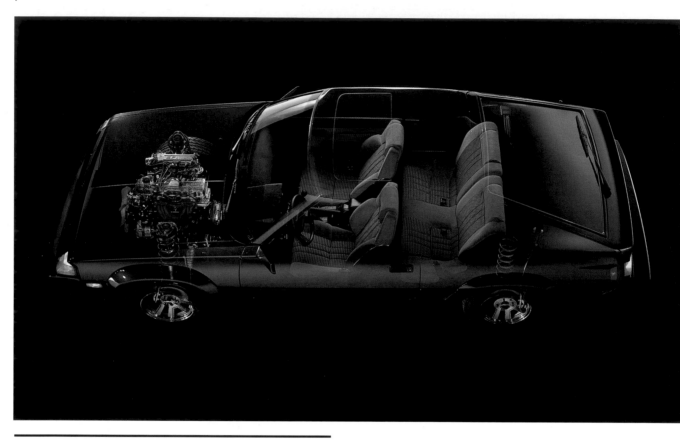

Title: Toyota "X-Ray" Techniques

Purpose/Client: Dealer brochure on mechanical features of Toyota Celica

Camera: Burke and James

Lens: 305 mm

Film: 8 x 10 KODAK EKTACHROME Professional Film / 6118 (Tungsten)

Lighting: Many 3200 K spot and soft lights, mostly reflected in "shell" set and direct in "skeleton" set

Exposure: Double, 10 to 15 seconds at f/32

John Campos

"I used club soda and flat black Formica to simulate ocean surf on rocks. The main difficulty of this shot was lighting several different edges of the knife blade separately and keeping detail in the knife handle. A second problem was controlling the path of the soda and the timing. There were only two to three seconds after pouring the soda before the bubbles would dissipate. After setting the image in the camera, I used two lights: one for the knife handle and one for the side light. These two lights bounced off the silver reflectors to light up the knife and the surf. I also angled the surface slightly to give the cohesive round quality at the edges of the soda."

Title: Surf

Purpose/Client: Self-promotion

Camera: Toyo

Lens: 240 mm Nikkor

Film: 8 x 10 KODAK EKTACHROME 64 Professional Film / 6117 (Daylight)

Lighting: Speedotron 2400 WS pack, top light at 1200 WS, side light at 1600 WS

David Zimmerman

"The surface was Plexiglas. The leaf was underlit with a goboed light. The handle on the blusher brush was translucent plastic. The droplets were water. In all, a fairly straightforward shot."

Title: Blusher Make-up

Purpose/Client: Self-promotion

Camera: Toyo G

Film: 8 x 10 KODAK EKTACHROME 64
Professional Film / 6117 (Daylight)

Lighting: Norman strobes, 4000 WS

Jim Krantz

"The first problem was to isolate the scene with tight light to hide the areas around the scene that do not appear clean or orderly. I suspended a small portable soft box above the metal die and tools. There was no gel on this light. The next consideration was to light the worker in a dramatic way that would express strength. A diffused reflector with a spot grid illuminated the worker; the spot grid intensified light in a very directed area. The machine needed to be dark to contrast with the sparks and the worker. I captured the intensity and illumination of the sparks flying off the sanding wheel with a 2-second exposure on a darkened set. The fourth light is the blue-gelled strobe head illuminating the background."

Jim Krantz

Title: Tooling Dies

Purpose/Client: To illustrate the fact that the product is hand-made and crafted to specific requirements of customers

Camera: Sinar

Lens: 90 mm

Film: 4 x 5 KODAK EKTACHROME 64 Professional Film / 6117 (Daylight)

Lighting: Three Broncolor 304, 1600 WS each, 5300 K, one light with blue gel

Exposure: 2 seconds

Chip Forelli

"For this photograph, I decided to use sidelighting to bring out the texture of the envelopes. This type of lighting setup allowed some of the light to go through the flaps of the envelopes, giving them a translucent quality. The only reflector I used was at the top left to bounce light back onto the flap of the top envelope. The surface was very thin rice paper on a black card. I found it important to shield the lens well because of the angle of the sidelight. The diffuse light source gave me a very soft, even light—the type of light I prefer."

© Chip Forelli, 1987

Title: Envelopes and Daisy Petals

Purpose/Client: Self-promotion

Camera: Deardorff

Film: 8 x 10 KODAK EKTACHROME 64 Professional Film / 6117 (Daylight)

Lighting: One 14 x 18-inch light bank with one Speedotron flash head, 2400 WS, diffused with 1/8-inch translucent white Plexiglas

Exposure: f/45, six pops (open flash)

Chip Forelli

"I found that sidelighting worked well with this photograph. The light has a chance to be both reflective and translucent. It is reflecting off the pearls, ribbon, and surface, and it is going through the silk scarf. In order to bounce light back onto the pearls inside the box, I placed a white card inside the cover of the box. The surface had to be dust-free because everything shows up with sidelighting. I used one silver reflector at the bottom right to bounce light back onto the pearls as they curved away from the main light. The surface is rough-textured board."

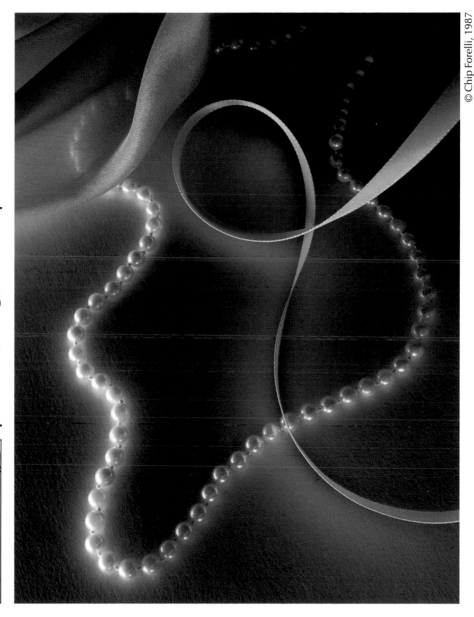

Title: Pearls and Ribbon

Purpose/Client: Self-promotion

Camera: Deardorff

Film: 8 x 10 KODAK EKTACHROME 64 Professional Film / 6117 (Daylight)

Lighting: One 24 x 30-inch light bank with two Speedotron flash heads, 4800 WS, diffused with 1/8-inch translucent white Plexiglas

Exposure: 1/3 second at f/45, four pops (open flash)

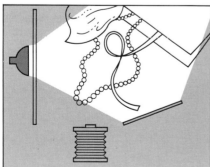

Richard Fukuhara

"We were given a black-and-white layout. We suggested that a color (gel) light would complement the information panel below the image. For the background, double-stick tape was used to attach the cables to the table. The circle cables were tape-mounted on illustration boards, and the other cables were taped or weighed down to keep their shape. The key light was a Bron Hazylight unit, and the fill from the left was a Bi-tube Balcar unit projected through diffused material with a blue gel."

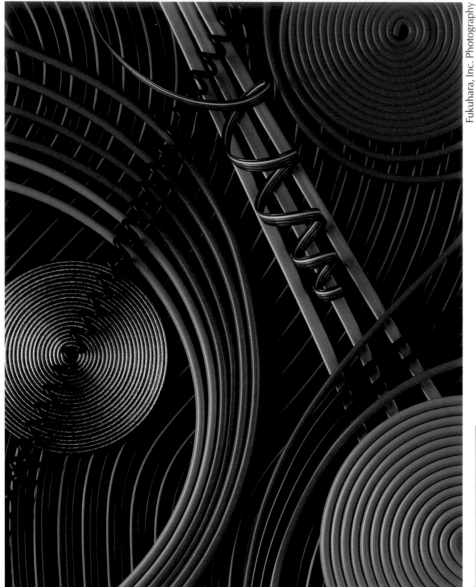

Title: Cables

Purpose/Client: Divider page for facilities brochure

Camera: Sinar p

Lens: 360 mm

Film: 4 x 5 KODAK EKTACHROME 64 Professional Film / 6117 (Daylight)

Lighting: Bron Hazylight 6000 WS, single-head Bi-tube Balcar 4800 WS

Exposure: 1/60 second at f/32

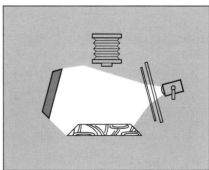

Jim Huibregtse

"Soap bubbles have a short life (about 15 seconds). They are clear for the first ten seconds, and after their surface has thinned, they develop colors. We had to produce all the bubbles simultaneously, wait for them to develop color, and shoot just before they popped (two to three seconds). The bottle incorporates a circular-shaped vial, which works well visually with soap bubbles. I placed the bottle on a KODAK DURAFLEX Tray that was painted black. I placed a small mirror directly under the glass 'bubble' of the bottle to reflect light through the yellow liquid. I added water to the tray and raised it to half the height of the bottle. I used a soft diffused light source to cover the entire reflective surface of the bottle, water, and bubbles."

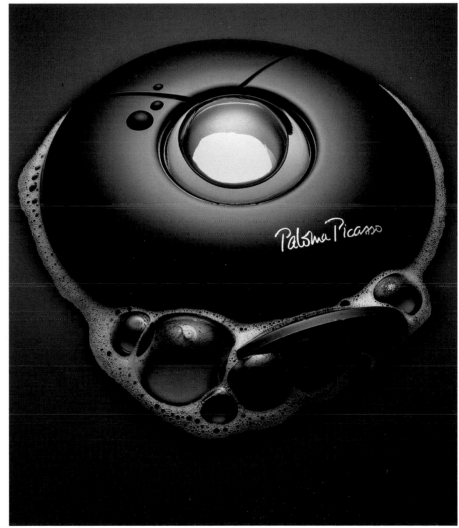

Title: Paloma Picasso

Purpose/Client: Self-promotion

Camera: Sinar p

Lens: 165 mm

Film: 8 x 10 KODAK EKTACHROME 64 Professional Film / 6117 (Daylight)

Lighting: Strobe, 6000 WS, 5500 K, CC05R filter

Rob Gage

"Two images were combined on the computer to depict the necessary feeling. One shot consists of the rocks extending to the bottom of the image. The skyline and fog make up the other shot. A computer placed the fog among the rocks. The woman's upper body was shifted so that it would not block the front of the vehicle."

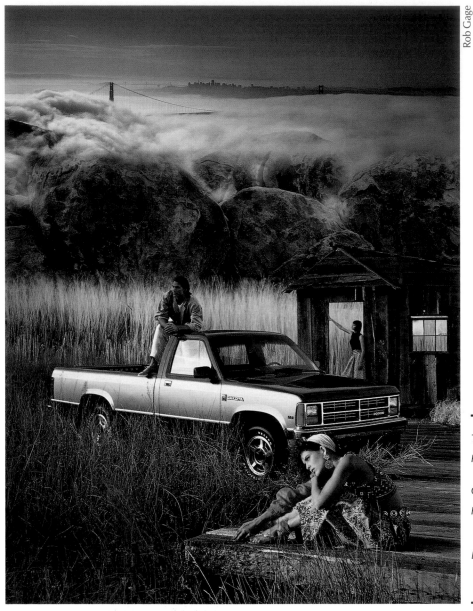

Rob Gage

Title: Dodge Multi-Image

Purpose/Client: Dodge California advertisement

Camera: Mamiya 6 x 7

Film: 120-size KODACHROME 64 and KODAK EKTACHROME Professional Films (Daylight)

Lighting: Strobe for wheat through window and door, warm gel, natural light

Ron Katz

"The client gave me complete creative freedom. I wanted to produce a visually appealing ad, leaving room for ad copy below. One problem was holding the depth of field with the necklace and the ring. I decided to use two tiers of textured paper, dropping the ring height to the same level as the necklace."

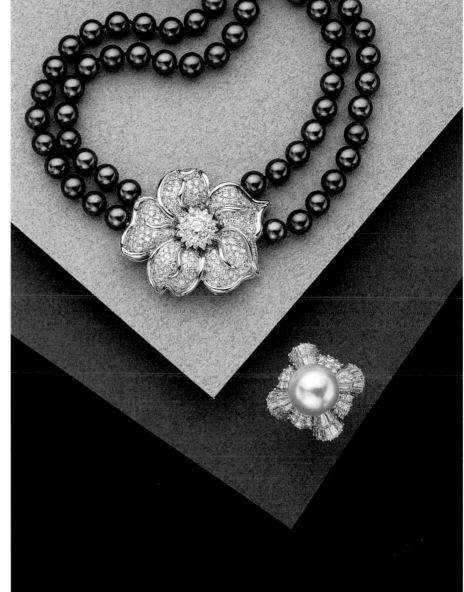

Title: Black Pearls and Rose Necklace

Purpose/Client: Consumer/trade magazine ads for European Jewelry of Toronto

Camera: Sinar p

Lens: 300 mm Apo-Ronar

Film: 8 x 10 KODAK EKTACHROME 64 Professional Film / 6117 (Daylight)

Lighting: Broncolor 12 x 18-inch box light, 2400 WS, with mirror reflectors

Exposure: 1/30 second at f/45

Jock McDonald

"This photograph was originally conceived as an outdoor location shot. The main problem with shooting on location was the difficulty of emphasizing the light on each element in the photograph. With everything in place outdoors, the shot looked like a cheap easel advertisement. I solved the problem with the more controlled lighting in my studio. The image was designed and composed to give a sense of dramatic energy and dynamics: the easels searching for the canvases and the canvases searching for the easels."

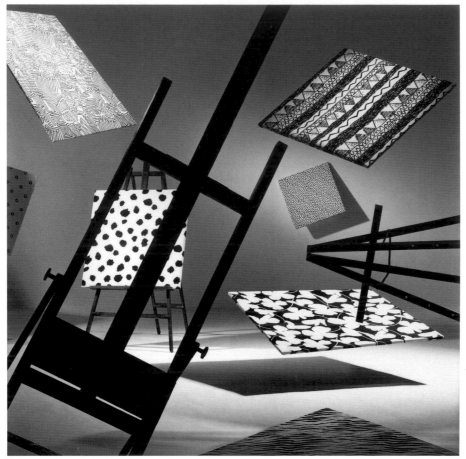

© Jock McDonald, 1988

Title: Flying Easels

Purpose/Client: Britex Calendar
photograph

Camera: Hasselblad

Lens: 120 mm

Film: 120 KODAK T-MAX 100
Professional Film

Lighting: Five Broncolor strobes with
reflectors, 1600 WS

Exposure: 1/125 second at f/22

Hans Neleman

"I made this photograph to illustrate oils for the food section of *The Observer.* I used backlighting and mirrors."

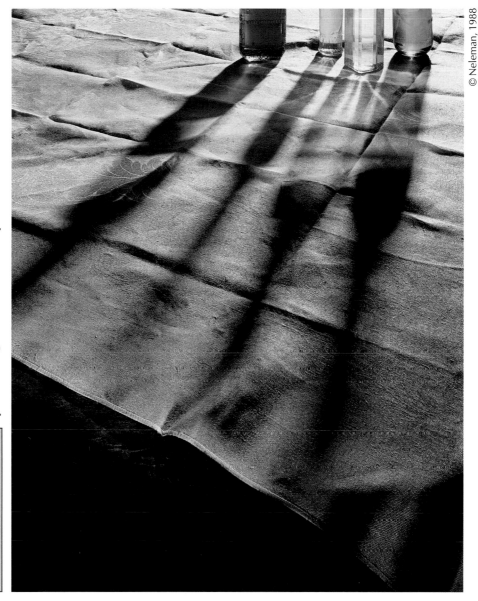

Title: Oils

Purpose/Client: The Observer color supplement, Great Britain

Camera: Sinar p

Film: 8 x 10 KODAK EKTACHROME 64 Professional Film / 6117 (Daylight)

Lighting: Balcar strobes, 2400 WS with No. 81A filters on lights (Pyrex cover)

Michael Ruppert

"The client wanted a beauty shot of the bottle. I decided to keep the composition simple and monochromatic to enhance the color of the liquid. The bottle was mounted by its back corner on a wood surface with hot glue. I then covered the surface with black construction paper. The main light was a soft-box on the left side of the set with foam-core fill on the right to give highlights to the metal cap. I bounced light from the soft-box off a piece of white Kromecote paper, tilted back at an angle to give a more interesting highlight through the bottle. I attached a piece of gray paper to the edge of the wood surface to form the base at the bottom of the shot."

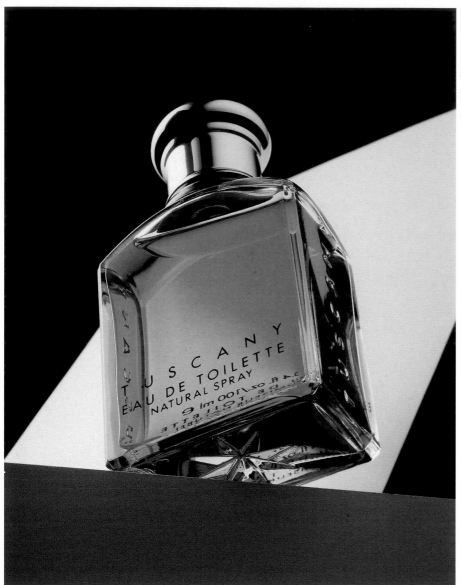

© Michael Ruppert, 1988

Title: Tuscany

Purpose/Client: Regional ad to introduce Tuscany fragrance

Camera: Sinar p

Lens: 90 mm

Film: 4 x 5 KODAK EKTACHROME 64 Professional Film / 6117 (Daylight)

Lighting: Chimera soft-box, Norman 4000 WS pack, one 4000 WS head

Exposure: 1/125 second at f/45 (pushed + 1/4 stop in processing)

Sam Haskins

"The image is a sandwich using one color and one black-and-white image. The wall with windows is a miniature set approximately 15 inches high. The black-and-white figure was printed on bromide paper and rephotographed on transparency material for the sandwich."

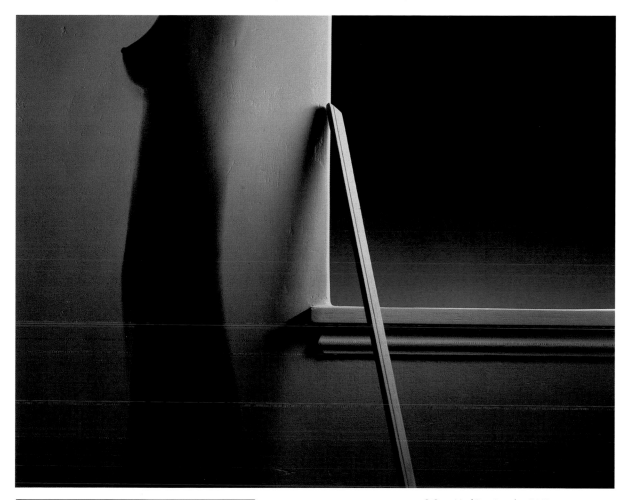

Title: Window, Blue Series

Purpose/Client: Part of an exhibition in Tokyo entitled, "The Best of Sam Haskins"

Camera: Pentax 6 x 7

Film: 120 KODAK EKTACHROME 100 Professional Film and KODAK TRI-X Pan Professional Film

Lighting: One 2000 W tungsten spotlight, one 100 W tungsten spotlight; converted to daylight for color shot using blue gels

Additional Technical Information

George Kamper, front cover

"'Fish Bowl' was shot on 8 x 10 KODAK EKTACHROME 100 PLUS Professional Film in two stages. Lighting was with a Hosemaster on the flowers in the bowl sitting on a black background, mixed with a softbox from the side. The fish were placed in a very narrow glass tank and photographed with a variety of gels and strobes. The separations and original printing were done by Flower City Printing in Rochester, N.Y. Additional outputs and computer enhancements were done by Chromagen Digital Imaging, Rochester, N.Y."

Title: Fish Bowl
Purpose/Client: Self-promotion
Camera: Arca Swiss
Lens: 355 mm

Steve Hogben, page 4

"This photograph presented unique lighting and camera techniques that I use frequently when shooting from indoor to outdoor into another room. I balanced the indoor and outdoor lighting with the shutter speed, f/stop, and multiple pops with the strobes using KODAK EKTACHROME 64 Professional Film / 6117. This technique requires a very sturdy tripod, and even the slightest camera movement will cause multiple imaging (ghosting)."

Title: none
Purpose/Client: feature article in magazine
Camera: Sinar
Film: 4 x 5 KODAK EKTACHROME 64 Professional Film / 6117 (Daylight)
Lighting: Balcar strobes, 2400 WS, 2 packs and 4 heads, 5500 K

Christopher Lawrence, page 16

"Exposure is critical with glassware. Dust can become problematic on the surface of the glass or water and it is difficult to remove from the water. Each shot requires practice to make the waves on the surface of the water."

Title: Susaki Crystal
Purpose/Client: For showroom, Sasaki crystal
Camera: Cambo
Film: 4 x 5 KODAK EKTACHROME 64 Professional Film / 6117 (Daylight)
Lighting: Norman P2000D power pack, Norman heads and reflectors

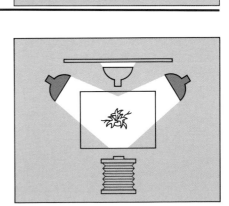

Bruno Photography, page 19

"I was searching for unusual flowers and liked miniature orchids. When photographed, they could be blown up to appear oversized. I could not get the position of the flowers to work for each shot, so I plucked each petal and hot glued each one to achieve the right composition. Obviously, I had to hot glue them quickly and just moments before the shooting, or the flowers would have wilted and died. The vase is also miniature—5½ inches in height. I used a graduated background with a gel over the light source."

Title: Crystal vase with pink flowers
Purpose/Client: Card company. Originally self-promotion
Film: 8 x 10 KODAK EKTACHROME Professional Film / 6118 (Tungsten)
Lighting: 3200 K, 250 ECA, 500 ECT

Dirk Douglass Photography, page 19

"This shot was self-promotional. We used two lights: one directly behind and one under the blinds with a blue gel on it. We dropped salt into inexpensive champagne to create bubbles. The inexpensive champagne worked best."

Title: Champagne Glass
Purpose/Client: Self-promotion
Camera: Toyo
Film: 4 x 5 KODAK EKTACHROME 64 Professional Film / 6117 (Daylight)
Lighting: Speedotron strobes, 2401A UV-coated tubes

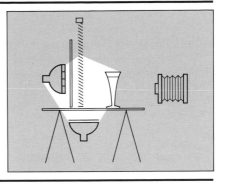

David Zimmerman, page 20

"The set was designed to enhance the 'shell' pattern of the silverware. The mystery of the set is strengthened through the low-key background and the dry-ice fog. The 'seascape' set was built in a 20 x 24-inch acrylic tank using one inch of water. In order to keep the lighting on the silverware soft and free of hard lines and reflections, I installed a very large sheet of white acrylic touching the back end of the tank just out of camera view. I tilted the acrylic forward over the silverware until it touched the barrel of the lens. A single light graduated the entire surface of the acrylic giving the silverware its soft, graduated appearance."

Title: Silverware on Rocks
Purpose/Client: Self-promotion
Camera: Toyo G
Film: 8 x 10 KODAK EKTACHROME 64 Professional Film / 6117 (Daylight)
Lighting: One 16-inch strobe

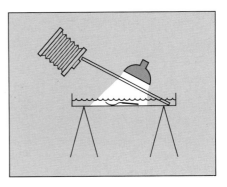

Tony Curatola, page 21

"I forced the perspective as much as possible. I achieved the background color by backlighting a piece of purple Plexiglas. I used the halo effect to create greater depth. The problem with using Plexiglas is that everything in front of it reflects off the glossy surface. I rolled down black velvet in front of the Plexiglas. I exposed the watches with a small light bank and used reflector cards. I then rolled up the black velvet and made a backlighted exposure of the watches on the Plexiglas. I used a strobe head with a spot reflector and diffusion material. No filtration was necessary, and no retouching was done."

Title: Two Watches on Purple Background
Purpose/Client: Publicity photo for a new line of watches for E. Gluck Corporation
Camera: Omega
Lens: 90 mm
Film: 4 x 5 KODAK EKTACHROME 64 Professional Film / 6117 (Daylight)
Lighting: One light bank and one strobe head, 2400 WS
Exposure: Double

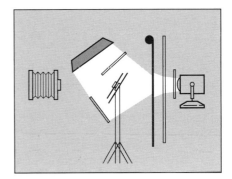

Nick Vedros, page 26

"The final photograph is a composite of four shots. The first shot showed the model in a business suit. The second, his forehead and eyes with his eyebrows raised. The third, his nose and mouth. The fourth, his teeth. To exaggerate the size of his smile, we stretched the corners of his mouth with dulled fish hooks attached to monofilament line and controlled them by small articulated arm clamps. The hooks and line were retouched out. To minimize paper thickness at the overlap seams, the prints used by the retoucher to assemble the final image were made on single-weight KODAK POLYFIBER Paper."

Title: Big Mouth
Purpose/Client: Dental care program for Blue Cross and Blue Shield
Camera: Hasselblad 500 ELX
Lens: 40 mm and 120 mm macro lenses
Film: 120 KODAK T-MAX 100 Professional Film (Daylight)
Lighting: Two Comet Power Packs CX-244A, 5000 K. Three lights (one Plume Wafer and two heads with reflectors on a white background)

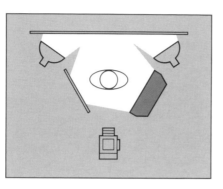

Hans Neleman, page 36

"I photographed the various flours for *The Observer* to illustrate an article about flour for the food section. I placed the camera horizontally over the subject with soft lighting from the left and a spotlight from the right."

Title: Flour
Purpose/Client: Color newspaper supplement
Camera: Sinar p
Lens: 240 mm
Film: 8 x 10 KODAK EKTACHROME 64 Professional Film / 6117 (Daylight)
Lighting: Balcar strobes, 2400 WS with No. 81A filters on the lights (Pyrex cover)

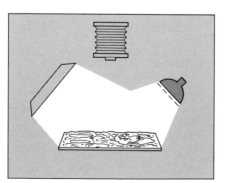

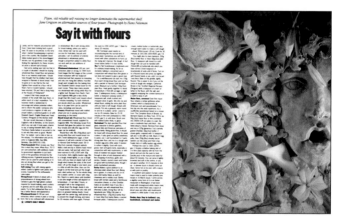

Diane Padys, page 50

"The food person I worked with on this project wanted to display a warm country-kitchen feling with early-morning light. The set was propped with worn furniture to reflect the mood. Since the soup was such a strong color, we wanted to complement it with other strong colors in the flowers. The lighting used on this set was different. We used a roll of black seamless paper and directed light through rips torn in the paper, letting light fall only in the areas wanted. We used a soft bank light as overall fill for the set."

Title: Borscht Soup
Purpose/Client: Illustration for a food book
Camera: Sinar
Lens: 300 mm
Film: 8 x 10 KODAK EKTACHROME 100 Professional Film / 6122
 (Daylight)
Lighting: Two raw heads with no reflectors, one large soft bank
 light for fill and a white reflector card.
Exposure: 1/30 second at f/45

Butch Hirsch, page 68

"I wanted to show my ability to shoot editorial jobs and still hold my style. The car added to the fashion statement. I chose a lens that would enhance the scene by compressing it and allowing the model to jump out of the picture. Because of the distance between the model and myself, I had to hide a walkie-talkie out of view so that I could give her and my assistant directions. As the sun went down, the wind caused problems and made the reflectors difficult to hold in position."

Title: Woman Against Red Chrysler
Purpose/Client: Self-promotion for 1987 Black Book
Camera: Nikon
Lens: 600 mm
Film: 35 mm KODACHROME 64 Professional Film (Daylight)
Lighting: Available light; late afternoon for warm color temperature

Abby Sadin, page 92

"We had a tight budget for this shoot. Instead of building a set, we found a showroom in the Merchandise Mart that would lend itself to the fantasy setting we wanted. We draped the chiffon from a bar and pole cats. Behind the chiffon was a window that added a little blue-colored back light. We used a fan low in the foreground to create the long-exposure movement of the chiffon on the floor. It was important to me that the angles of the walls mimic the angles of the head of the light. I also liked the contrast of the soft drapery against the hard shapes of the lights. I filtered by about CC5B and CC5M."

Title: Atelier Lamps
Purpose/Client: Product shot for Atelier International lighting
Camera: Sinar f
Lens: 121 mm Schneider
Film: 4 x 5 KODAK EKTACHROME Professional Film / 6118 (Tungsten)
Lighting: 3200 K quartz lights, photogenic inky lights, 200 W and SV SA
 scoops, 100- and 200-watt bulbs, gelled with minus straw to
 convert to 3200 K

Ryszard Horowitz, page 108

"Appolonia in search for her legs was created for a self-promotional poster for my studio. It is a photo composite made up of five different images: upper torso, legs, cat, green hedge, miniature room set. The legs and the torso belong to the same photograph I made as part of a commercial assignment. It was not until a visit to my friend's house south of Paris, where I photographed the beautiful green hedge in his backyard, that the idea for the final image materialized."

Title: Appolonia
Purpose/Client: Self-promotional poster
Camera: Various
Film: 8 x 10 KODAK EKTACHROME Duplicating Film 6121

Elizabeth Watt, page 122

"There was no client involved. The photo was part of a self-promotion. I used a single light source, and used filtration only to color-balance the film emulsion. The photo required no retouching. As with most of my photographs, I employed no tricks of photography. The elements created the interest."

Title: Cosmetic Powders
Purpose/Client: Portfolio
Camera: Deardorff
Film: 8 x 10 KODAK EKTACHROME 64 Professional Film / 6117 (Daylight)
Lighting: Speedotron strobes

George Kamper, back cover

"The Harley photo was originally used as an ad depicting true color qualities of film. It was shot on 4 x 5 KODAK EKTACHROME 100 PLUS Professional Film and cross-lit with hot lights and strobes. It was enhanced by Chromagen Digital Imaging, Rochester, N.Y."

Title: Harley Softail
Purpose/Client: Eastman Kodak Company
Camera: Arca Swiss
Lens: 210 mm

KODAK Professional Films

Black-and-White Negative Films | Sizes

Black-and-White Negative Films	Sizes
T-MAX 100 Professional Film	135, 120, 4 x 5, 5 x 7, 8 x 10
T-MAX 400 Professional Film	135, 120, 4 x 5, 5 x 7, 8 x 10
T-MAX P3200 Professional Film	135
Technical Pan Film	135, 120, 4 x 5, 8 x 10
PLUS-X Pan Professional Film	135, 120, 4 x 5, 5 x 7, 8 x 10
TRI-X Pan Professional Film	135, 120, 4 x 5, 5 x 7, 8 x 10

Color Negative Films | Sizes

Color Negative Films	Sizes
EKTAR 25 Professional Film	135, 120
EKTAPRESS GOLD 100 Professional Film	135
EKTAPRESS Plus 400 Professional Film	135
EKTAPRESS GOLD 1600 Professional Film	135
Pro 100 Film	120, 220
Pro 400 Film	135, 120, 220
Pro 400 MC Film	135, 120, 220
VERICOLOR III Professional Film, Type S	135, 120, 4 x 5, 5 x 7, 8 x 10
VERICOLOR II Professional Film, Type L	120, 4 x 5, 5 x 7, 8 x 10, 11 x 14
VERICOLOR 400 Professional Film	135, 120

Color Transparency Films | Sizes

Color Transparency Films	Sizes
EKTACHROME 64T Professional Film (Tungsten)	135, 120, 4 x 5, 5 x 7, 8 x 10, 11 x 14
EKTACHROME 64 Professional Film (Daylight)	135, 120, 4 x 5, 5 x 7, 8 x 10, 11 x 14
EKTACHROME 100 Professional Film (Daylight)	135, 120, 4 x 5, 5 x 7, 8 x 10, 11 x 14
EKTACHROME 100 PLUS Professional Film (Daylight)	135, 120, 4 x 5, 5 x 7, 8 x 10
EKTACHROME 100 PLUS Professional Film READYLOAD Packet	4 x 5
EKTACHROME 200 Professional Film (Daylight)	135, 120, 4 x 5, 8 x 10
EKTACHROME 1600 Professional Film (Daylight)	135
EKTACHROME Duplicating Film	135, 4 x 5, 8 x 10, 11 x 14, 16 x 20
EKTACHROME 64X Professional Film	135, 120
EKTACHROME 100X Professional Film	135, 120, 4 x 5, 8 x 10
EKTACHROME 400X Professional Film	135, 120
EKTACHROME LUMIERE 100 Professional Film	135, 120
EKTACHROME LUMIERE 100X Professional Film	135, 120
EKTACHROME Infrared Film	135
EKTACHROME 160T Professional Film	135, 120
EKTACHROME 320T Professional Film	135
KODACHROME 25 Professional Film (Daylight)	135
KODACHROME 64 Professional Film (Daylight)	135
KODACHROME 200 Professional Film (Daylight)	135

Directory of Photographers

Ben Altman
Sadin Photo Group, Ltd.
820 North Franklin
Chicago, IL 60610
Represented by Elizabeth Altman
 Associates
(312) 266-8661

Hank Benson
Benson Photography
653 Bryant Street
San Francisco, CA 94107
(415) 543-8153

Beth Bischoff
360 West 36th Street #65
New York, NY 10018
(212) 512-9118
Represented by Rick Wainman
 and Associates
360 West 36th Street #65
New York, NY 10018
(212) 512-9118

Jack Boyd
2038 Calvert Avenue
Costa Mesa, CA 92626
(714) 556-8332

Bruno
Bruno Photography, Inc.
43 Crosby Street
New York, NY 10012
(212) 925-2929

Sam Campanaro
Eastman Kodak Company
343 State Street
Rochester, NY 14650
(716) 724-3720

John Campos
John Campos Studio, Inc.
132 West 21 Street
New York, NY 10011
(212) 675-0601

James Caulfield
PO Box 476854
Chicago, IL 60647
(312) 278-4351
Represented by Rick Wainman
 and Associates
360 West 36th Street #65
New York, NY 10018
(212) 512-9118

Dean Collins
Collins and Associates
1310 G. Street
San Diego, CA 92101
(619) 239-0845

Tony Curatola
Tony Curatola Studio
18 East 17 Street
New York, NY 10003
(212) 243-5478

Mitchell Dannenberg
Mitchell Dannenberg Productions
261 Averill Avenue
Rochester, NY 14620
(716) 473-6720

Dirk Douglass
Dirk Douglass Photography
2755 South 300 West Suite D
Salt Lake City, UT 84115
(801) 485-5691

Bill DuBose
1345 Chemical Street
Dallas, TX 75202
(214) 630-0086

Carl Fischer
Carl Fischer Photography, Inc.
121 East 83rd Street
New York, NY 10028-0803
(212) 794-0400

Chip Forelli
Chip Forelli Studio
316 5th Avenue, 5th Floor
New York, NY 10001
(212) 564-1835

George B. Fry III
George B. Fry III Photographers, Inc.
PO Box 2465
Menlo Park, CA 94926
(415) 323-7663

Richard Fukuhara
Fukuhara, Inc. Photography
1032-2 West Taft Avenue
Orange, CA 92665-4121
(714) 998-8790

Michael Furman
Michael Furman Photographer, Ltd.
115 Arch Street
Philadelphia, PA 19106
(215) 925-4233

Rob Gage
Rob Gage Photography
789 Pearl Street
Laguna Beach, CA 92651
(714) 494-7265

Dennis Galante
133 West 22nd Street
New York, NY 10011
(212) 463-0938

Ezio Geneletti
Aurbacherstrasse 2
8000 Munchen 90
West Germany
089-48 56 48

Pierre-Yves Goavec
Goavec Photography
1464 La Playa #303
San Francisco, CA 94122
(415) 564-2252

Christopher C. Gould
Christopher Gould Inc.
224 West Huron
Chicago, IL 60610
(312) 944-5545
Represented by David Montagano
(312) 527-3283

Jim Hansen
Jim Hansen Photography, Inc.
2800 S. Main Street, Unit I
Santa Ana, CA 92707
(714) 545-1343

Sam Haskins
Sam Haskins Photographics
9a Calonne Road
London SW19, United Kingdom
01-946-9660, 946-6072
Represented by Jackie Page
O'Rourke Page Associates
219 East 69th Street
New York, NY 10021
(212) 722-0346

Butch Hirsch
Butch Hirsch Photography
107 West 25th Street
New York, NY 10001
(212) 929-3024

Paul Hoffman
4500 19th Street
San Francisco, CA 94114
(415) 863-3575

Steve Hogben
Architectural Photographics
6269 McDonough Drive
Norcross, GA 30093
(404) 266-2894

Ryszard Horowitz
137 West 25 Street
New York, NY 10001
(212) 243-6440

Jim Huibregtse
Jim Huibregtse Photography
14 Jay Street, 6th Floor
New York, NY 10013
(212) 925-3351
Represented by Nelson Bloncourt
(212) 924-2255

Richard Izui
Izui Photography, Inc.
315 West Walton
Chicago, IL 60610
(312) 266-8029

Bruno Joachim
Bruno Joachim Photography
326 A. Street
Boston, MA 02210
(617) 451-6156

George Kamper
Kamper/Sprouse/Colley
62 North Union Street
Rochester, NY 14607
(716) 454-7006

Ron Katz
Kamdar Studios, Ltd.
439 Wellington Street West
Toronto, Canada M5V 1E7
(416) 591-1188

Jim Krantz
Jim Krantz Studios, Inc.
5017 South 24 Street
Omaha, NE 68107
(402) 734-4848

Christopher Lawrence
Christopher Lawrence Studios
12 East 18th Street
New York, NY 10003
(212) 807-8028

Michael Marchant
5 Brittany Court
New Church Road
Hove, Sussex BN3
United Kingdom
(0273) 418198

Jock McDonald
46 Gilbert Street
San Francisco, CA 94103
(415) 621-0492

Mickey McGuire
Mickey McGuire, Inc.
1675 Ridgemore Drive
Palm Springs, CA 92264
(619) 325-8504

D.W. Mellor
1020 Mount Pleasant Road
Bryn Mawr, PA 19010
(215) 527-9040

Michael G. Merle
5 Union Square West, 5th Floor
New York, NY 10003
(212) 741-3801

Steve Myers
110 South Main Street
Almond, NY 14804
(607) 276-6400

Ken Nahoum
95 Greene Street, Penthouse E
New York, NY 10012
(212) 219-0592

Hans Neleman
Hans Neleman Studio
348 West 14th Street
New York, NY 10014
(212) 645-5832

Judy Olausen
213½ North Washington Avenue
Minneapolis, MN 55401
(612) 332-5009

Oudi
Oudi Photography
704 Broadway
New York, NY 10003
(212) 777-0847

Eric Oxendorf
PO Box 92337
1442 North Franklin Place
Milwaukee, WI 53202
(414) 273-0654

Diane Padys
Diane Padys Photography Inc.
PO Box 1218
New York, NY 10013
Represented by Stockland and Martel
(212) 972-4747

Nancy Palubniak
144 West 27th Street
New York, NY 10001
(212) 645-2838

Charles Purvis
Purvis Photography Ltd.
84 Thomas Street
New York, NY 10013
(212) 619-8028

True Redd & Company
2328 Farrington Street
Dallas, TX 75207
(214) 638-0602
Represented by Vikiann Gunter

Michael Ruppert
Michael Ruppert Studios, Inc.
5086 West Pico Boulevard
Los Angeles, CA 90019
(213) 938-3779

Abby Sadin
Sadin Photo Group, Ltd.
820 North Franklin
Chicago, IL 60610
(312) 944-1434
Represented by Elizabeth Altman
 Associates
(312) 266-8661

Marshal Safron
506 South San Vicente Boulevard
Los Angeles, CA 90048
(213) 653-1234

Jim Sims
Sims/Boynton Photography
2412 South Boulevard
Houston, TX 77098
(713) 522-0817
Represented by Cobb and Friend
2811 McKinney Avenue
Suite 342
Dallas, TX 75204
(214) 855-0055

Joseph G. Standart
Red Circle Studios
5 West 19th Street
New York, NY 10011
(212) 924-4545

Struan Campbell-Smith
Struan Photographic, Inc.
4 New Street
Toronto, Canada M5R1P6
(416) 923-9311

Michel Tcherevkoff
Tcherevkoff Studio, Ltd.
873 Broadway
New York, NY 10003
(212) 228-0540

Al Teufen
Al Teufen Photography
600 East Smith Road
Medina, OH 44256
(216) 723-3237

Bill Tucker
Bill Tucker Studio, Inc.
114 West Illinois
Chicago, IL 60610
(312) 321-1570

Pete Turner
Pete Turner, Inc.
154 West 57th Street
New York, NY 10019
(212) 765-1733

Nick Vedros
Vedros and Associates
215 West 19th Street
Kansas City, MO 64108
(816) 471-5488

Louis Wallach
Louis Wallach Photography, Inc.
594 Broadway, Inc.
New York, NY 10012
(212) 925-9553

Elizabeth Watt
141 West 26th Street
New York, NY 10001
(212) 929-8504
Represented by Rick Wainman
 and Associates
360 West 36th Street #65
New York, NY 10018
(212) 512-9118

Bill Werts
Werts Studios, Inc.
732 North Highland
Los Angeles, CA 90038
(213) 464-2775

Neill Whitlock
Neill Whitlock Photography
122 East 5th Street
Dallas, TX 75203
(214) 948-3117 or 948-3118
Represented by Cobb and Friend
2811 McKinney Avenue
Suite 342
Dallas, TX 75204
(214) 855-0055

Walter Wick
560 Broadway
New York, NY 10012
(212) 966-8770

Carl Zapp
Menken Studio
119 West 22nd Street
New York, NY 10011
(212) 924-4240

Alan Zenreich
78 Fifth Avenue
New York, NY 10011
(212) 807-1551

David Zimmerman
David Zimmerman Studio, Inc.
511 West 23rd Street
New York, NY 10011
(212) 243-2718
Represented by Susan Miller
1641 3rd Avenue, 29AE
New York, NY 10128
(212) 905-8400

Dick Zimmerman
8743 West Washington Boulevard
Culver City, CA 90230
(213) 204-2911

INDEX